VICTORY!

VICTORY!

PROPAGANDA CARTOONS FROM WORLD WAR II

EDITED BY TONY HUSBAND

SIRIUS

Picture research: Frances Evans

With thanks to Gerald Patejunas

This edition published in 2022 by Sirius Publishing, a division of
Arcturus Publishing Limited,
26/27 Bickels Yard, 151–153 Bermondsey Street,
London SE1 3HA

Design: Notion Design

ISBN: 978-1-3988-1779-1
AD002537UK

Printed in China

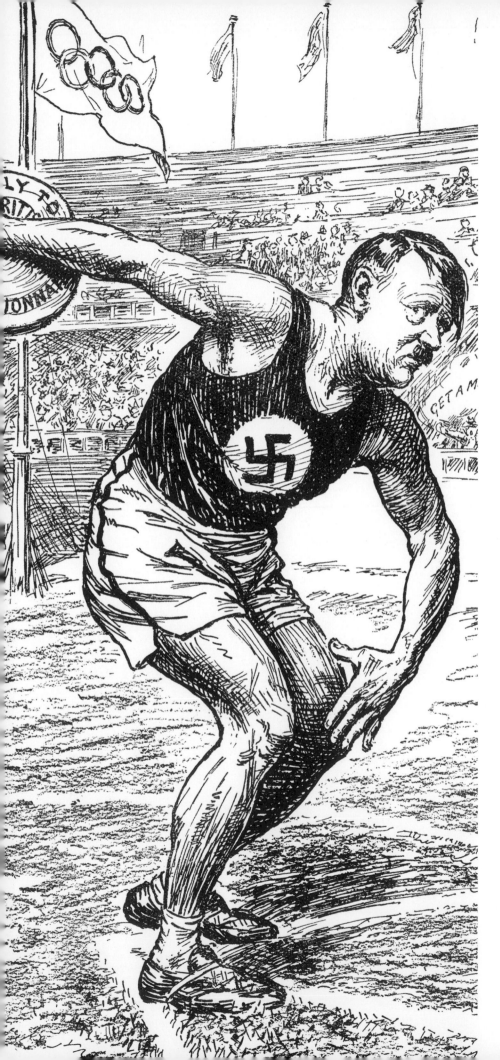

CONTENTS

INTRODUCTION

I try to imagine how it must have felt to be a cartoonist during World War II: walking to the office through the bombed streets of your city, diving for cover as the air raid sirens sounded all around you, worrying about friends and loved ones as you listened to daily news from the front.

Life must have been very up and down, with stories of the gains, stories of the losses, and, all the time, lists of the dead, the dying and the missing. You would have found yourself sitting in on the editor's conference, the latest headlines in place and only the matter of your cartoon to be resolved. You'd go to your desk to be faced with the usual blank page. What a responsibility. And what pressure there must have been. Your job was to portray the mood of a nation, to put down in drawn lines a nation's anger, fear and hope. At the back of your mind, you would know that the cartoon was what people would remember, not the headline, not the thousands of printed words, but the image.

Images define a war. They capture a moment in time and lodge it in the nation's memory. Your cartoon would have to resonate with the soldier, the sailor and the candlestick-maker as well as the airman at the front, the factory girl, the farmer and the retired banker on air raid duty.

What is so wonderful about the cartoons in this collection is how many cartoonists rose so brilliantly to the challenge. Their pens and minds were sharpened to a fine point by the responsibility put upon them by the gravity of the situation. They produced masterpieces on a daily basis. From every corner of the world, from every side of the conflict, cartoonists of every nation fired their savage, subtle barbs into the heart of the enemy. How Hitler and his henchmen must have raged at the images of them drawn

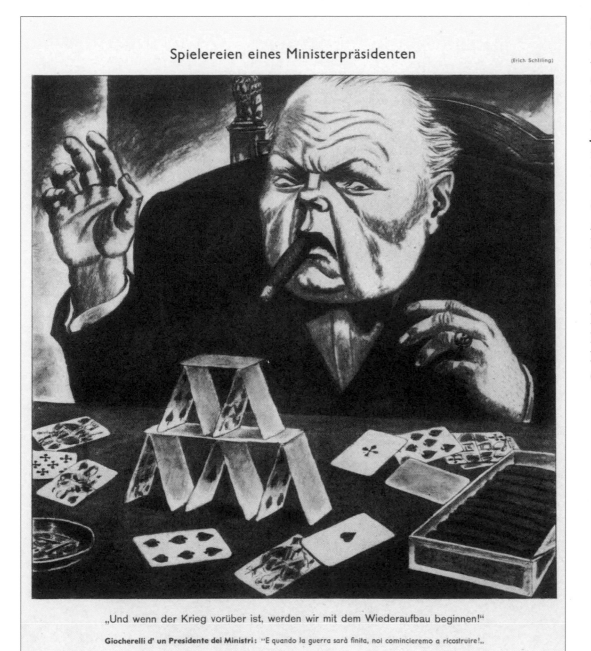

Spielereien eines Ministerpräsidenten

(Erich Schliling)

„Und wenn der Krieg vorüber ist, werden wir mit dem Wiederaufbau beginnen!"

Giocherelli d' un Presidente dei Ministri: "E quando la guerra sarà finita, noi comincieremo a ricostruire!,,

Left: 'The Baubles of a Prime Minister – When the war is over we can start the rebuilding process' by Erich Schilling, Josef Goebbels' favourite cartoonist, 1941

Opposite: Adolf Hitler by Kukryniksy, the collective name for three Russian caricaturists, Porfirii Krylov, Mikhail Kuprilianov and Nikolai Sokolov (see page 106), 1942

in foreign newspapers. Similarly, Churchill, chomping on his cigar and drinking his nightly whisky, would have sighed at the pompous, drunken fool they made out of him.

It must have been really exciting to be a cartoonist then. You were given absolute freedom to vent your rage, to provide a piece of your mind. There were practically no limits. You could characterize your enemy as graphically as you wanted. You could distort and defame anyone on the other side. Indeed it was your duty to do so.

What better way to gain revenge on the perpetrators of crimes than with your pen? I know this from personal experience; I was once beaten up by a gang of skinheads and have spent the last 30 years getting my revenge on them by drawing them as louts and buffoons in magazines and newspapers. To be able to magnify that 100 times during wartime must have been very satisfying indeed

All nations, all sides are represented in this book. It is amazing and fascinating to see how each side's artists handle the war: the British subtle, laid-

Roosevelt as seen by English cartoonist E.H. Shepard in 1940 when France had fallen and the US president had appealed to Congress for Allied supplies

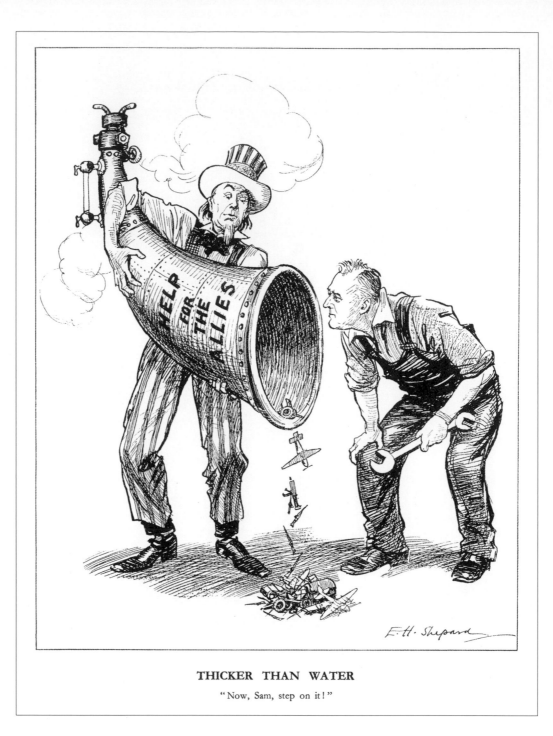

THICKER THAN WATER

"Now, Sam, step on it!"

back… tea and crumpets with the vicar, discussing progress on all fronts. The Russians, savage, satirical… Hitler the demon, as demon he surely was. There was no holding the Russians back from a full frontal assault, the pen scratching venom deeper and deeper into the paper. Cartoonists from the USA showed the ups and downs of GI Joe in a foreign country missing home comforts, while the Germans spat vitriol at anyone who opposed their plan for world domination and made scapegoats of those they had chosen to victimize.

I wonder too who was the crazy Japanese cartoonist who took time before the bombing of Pearl Harbor to draw up a leaflet to drop on the Americans. Crudely duplicated in thousands, the cartoon survived for posterity, a treacherous act by an unknown artist, but did Americans laugh at the words on the picture as we do today?

I am awed at the quality and variety of work here. From mighty historical and beautifully crafted pieces of art to the few lines scribbled quickly on an A4 sheet of paper, they all tell the tale of a moment

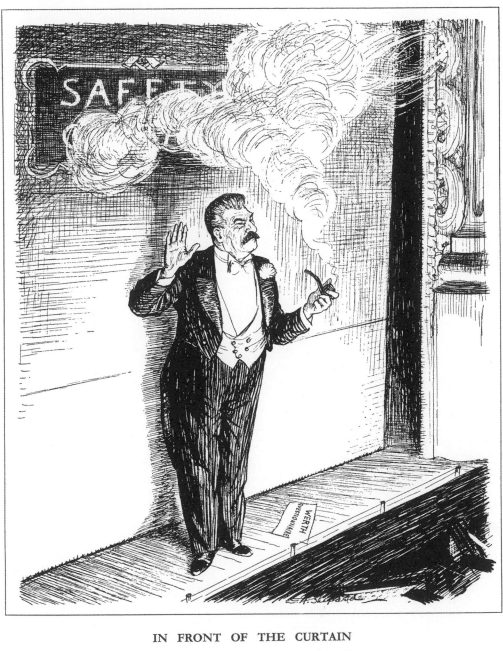

IN FRONT OF THE CURTAIN

"Please keep your seats—there's no danger."

Stalin drawn by E.H. Shepard with more than a whiff of sulphur: the Werth Questionnaire was a series of questions submitted to Stalin in 1946 by Alexander Werth of the *Sunday Times*. Stalin used his responses to paint a rosy picture of the Soviet Union as a benevolent giant with the friendliest of intentions towards its neighbours

in history. You can see during the build-up to the war that cartoonists were warning of the grim nature of events to come, the stupidity of failing to learn from history and the shock felt in the aftermath. Simply and surely within these pages, the views from all sides unfold and you can see how very similar they often were, just told in a different way. In those far-off days, cartoonists had great power. They were the stars of their newspapers and had salaries to match their status. They were much sought after and closely

guarded by proprietors who dreaded losing them to rivals. Sadly it isn't the same these days, apart from a cherished few. Cartoonists used to be very influential and much feared. As a cartoonist I envy them that. They used that power to great purpose and left us with towering, unforgettable images. If I had a hat, I'd take it off to them. Enjoy the work within these pages. It is very special.

Tony Husband

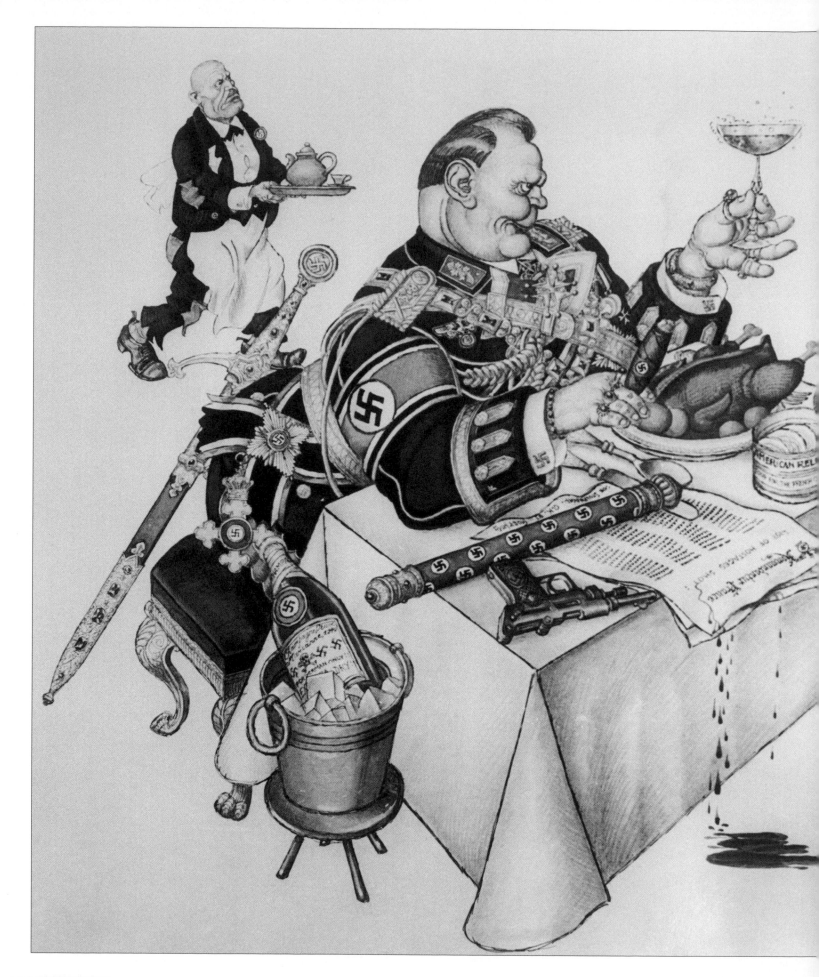

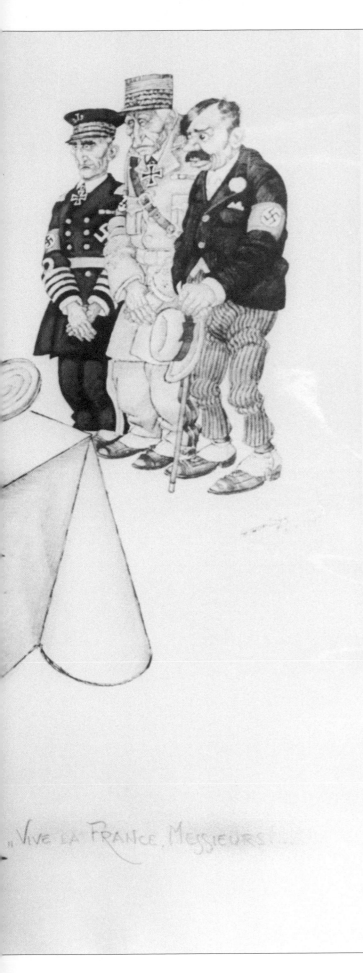

"VIVE LA FRANCE, MESSIEURS..."

'Goering's Banquet': the *Reichsmarschall* raises
his glass to Laval, Petain and Darlan, members
of the Vichy government, as a downbeat
Mussolini plays the part of waiter, 1943.
Artist Artur Szyk shows Goering feasting on
US relief rations while blood drips from a list
of the names of hostages shot in France

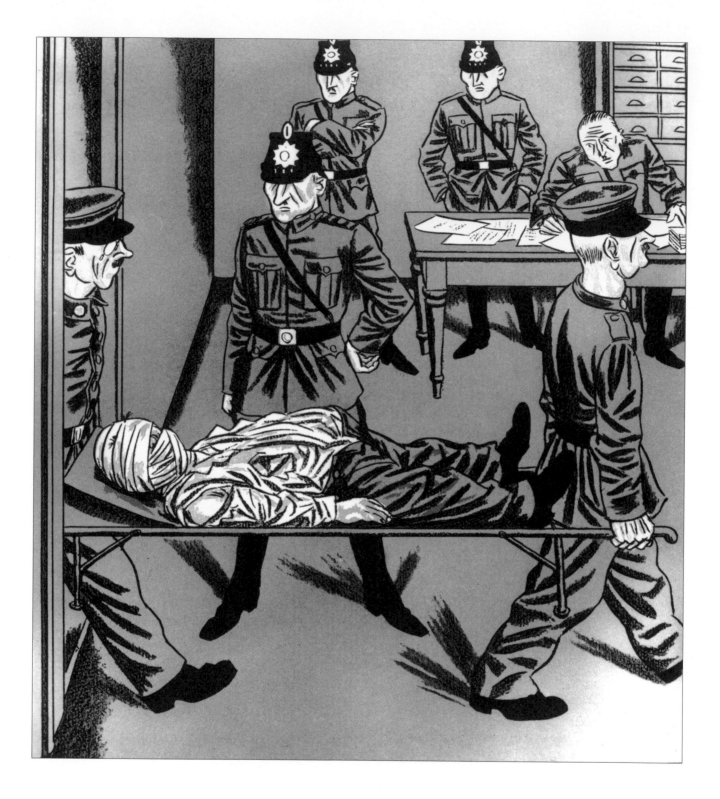

A cartoon, probably by Thomas Theodor Heine, from
Munich satirical magazine *Simplicissimus* (1927) which
shows a wounded man being carried into a police station:
'Berlin on Sunday. Was he run over by a car?' 'No,
he ran into the National-Socialists.'

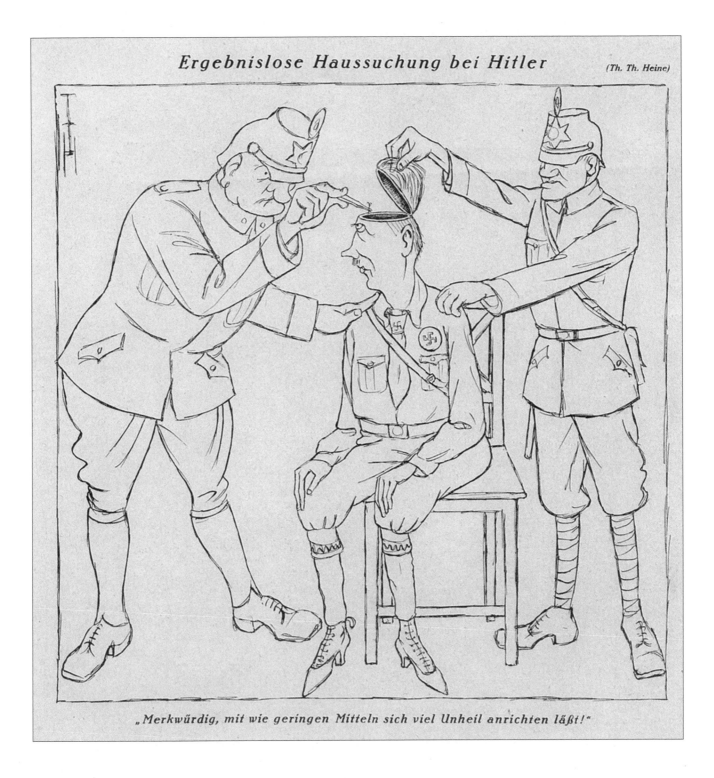

'Inconclusive Search at Hitler's Place
– remarkable how much disaster has
grown from so tiny a seed' – by Th. Th.
Heine, as he signed himself, 1930. The
artist fled Germany for Prague in 1933

Colonel Blimp, drawn by David Low for London's *Evening Standard* newspaper, was a stereotypical British figure of the 1930s, lampooned for his dim, jingoistic views. In 1943, Churchill tried to stop the making of a film about Blimp by Powell and Pressburger because the script had made the main German character too sympathetic

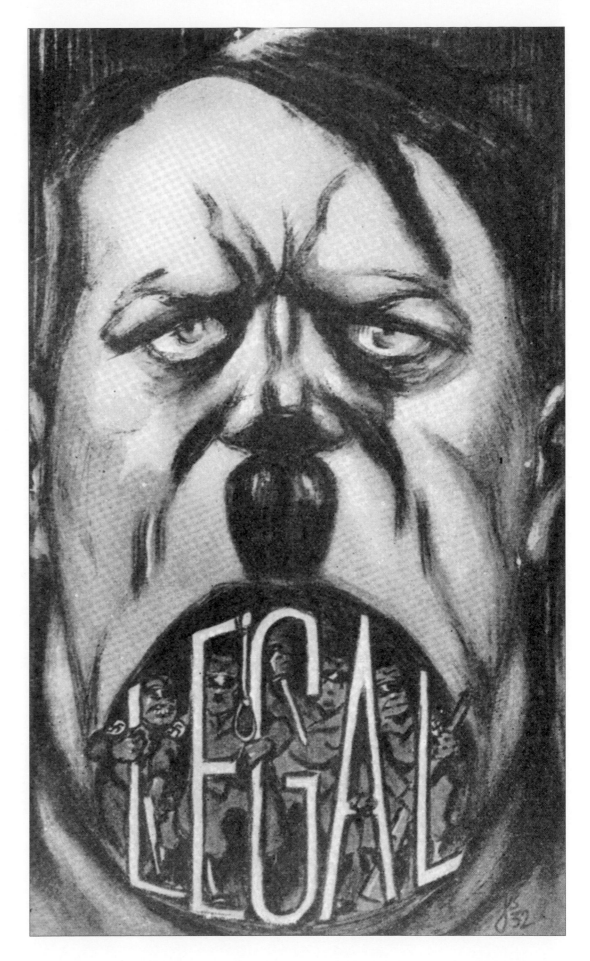

'How Mr Hitler says "legal"'(1932): in 1930 Hitler promised the National Court in Leipzig that the Nazis would keep within the law. When he became Chancellor, he systematically subverted Germany's legal system, so he could do as he liked

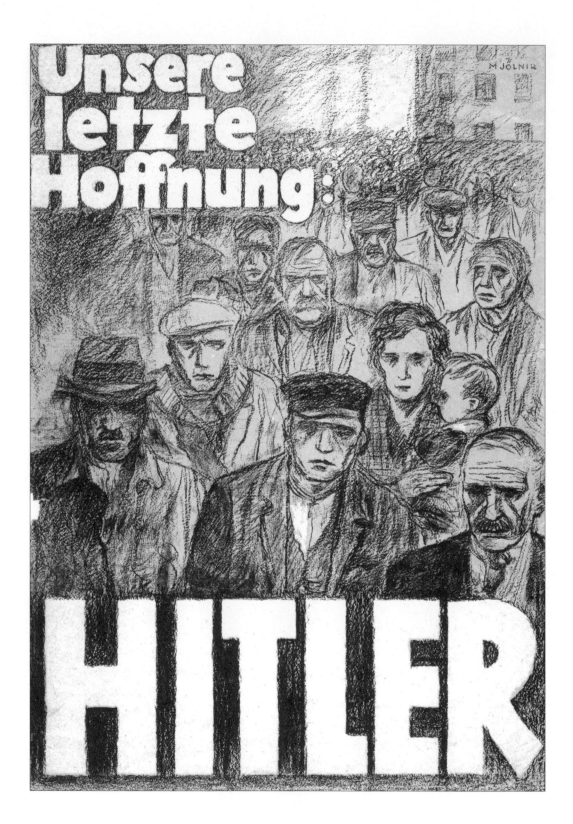

'Hitler – Our Last Hope' by Mjölnir (Hans Schweitzer), 1932. With 6 million unemployed and weaknesses in the constitution that crippled the government, Hitler was happy to present himself as Germany's saviour for the upcoming elections

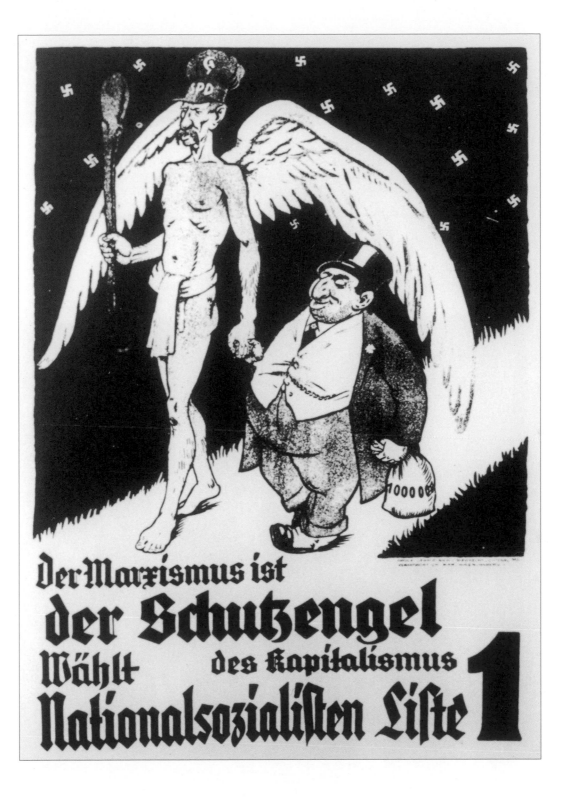

'Marxism is the guardian angel of capitalism. Vote Nazi', 1932:
a typically anti-semitic Nazi poster shows an effete Marxist-
Social Democrat angel hand in hand with a Jewish businessman
in a world where swastikas have replaced the stars

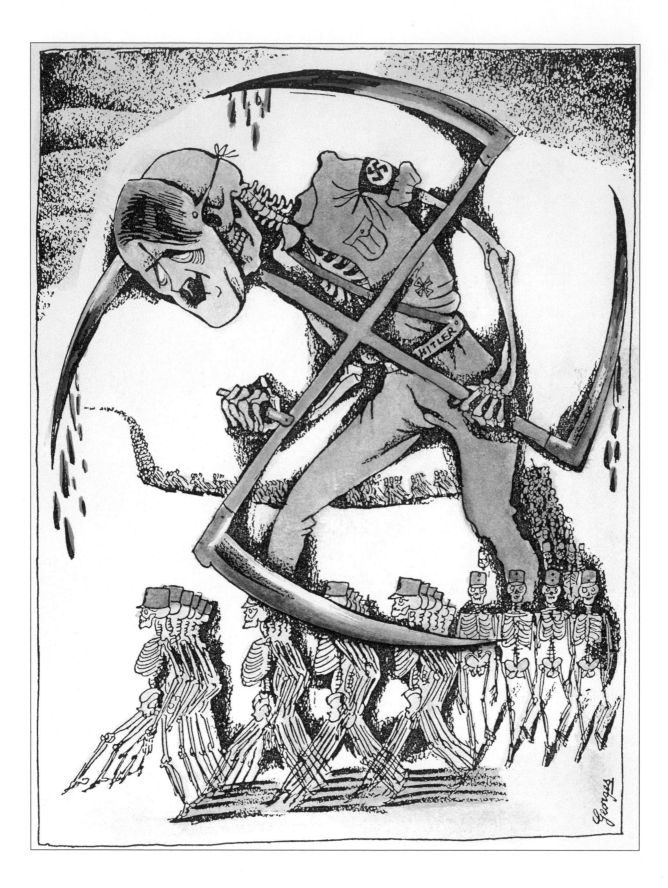

A prescient image by Georges that appeared in *The Nation*, New York
on 5 April 1933, suggesting the reality that lay behind Hitler's mask

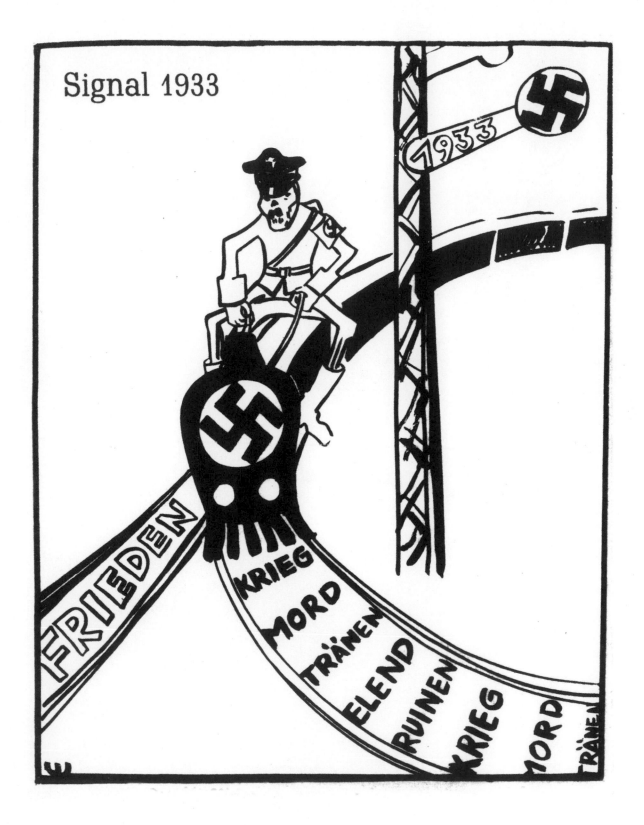

'Changing Directions', 1933, by H. Wolfe, shows Germany being sidetracked from peace by the Nazis and embarking on a route that leads to war, murder, tears, suffering and destruction

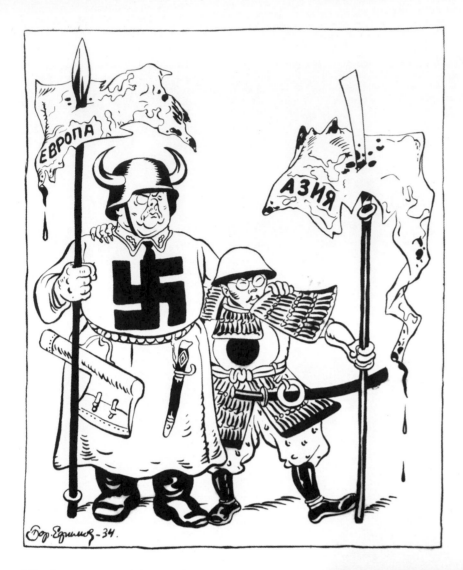

'The Partitioning of the World' by Russian artist Boris Yefimov – Germany gets Europe and Japan takes Asia, 1934

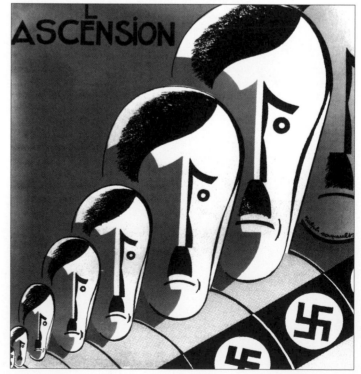

'The Rise of Hitler' by French artist Ralph Soupault from the publication *Charivari*, 1933

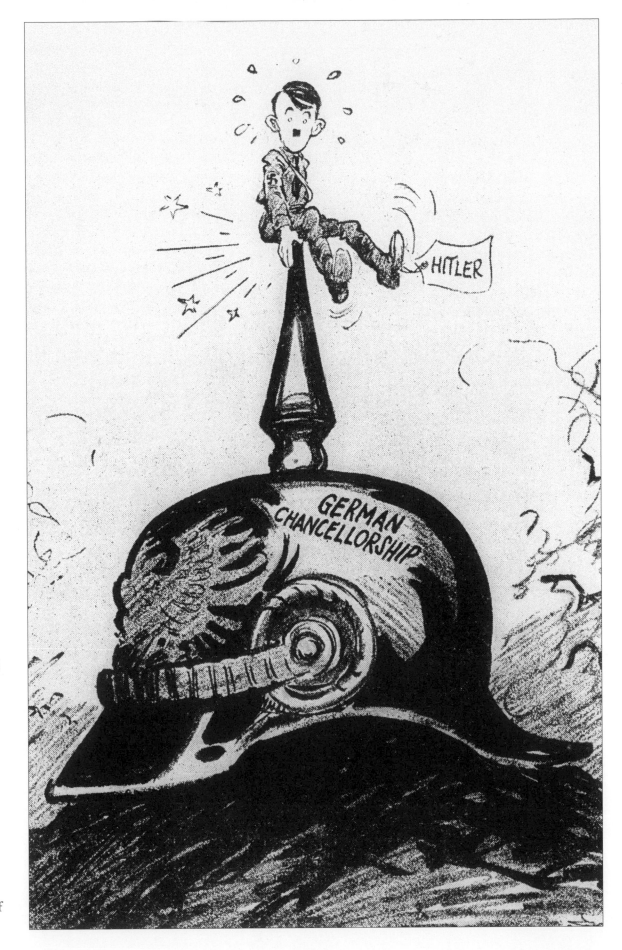

'Not the Most Comfortable Seat' from the *Chicago Daily News*, March 1933. Hitler had been elected Chancellor of Germany on 6 March, and many outside observers believed he would not be up to the job of dealing with German economic woes and the forces of militarism

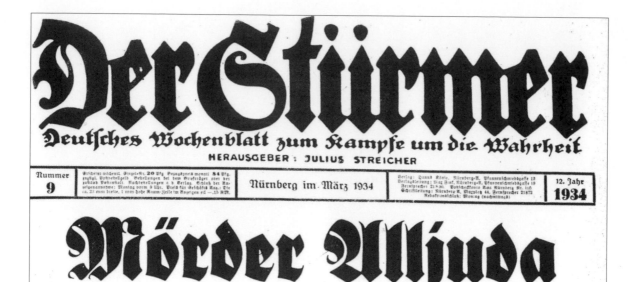

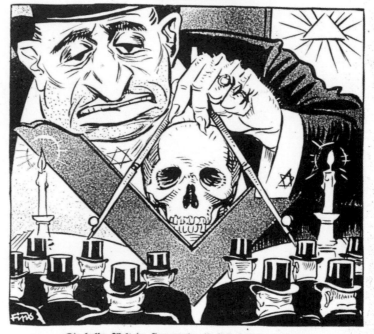

The front page of Nazi rag *Der Stürmer*, from March 1934, with a cartoon by regular cartoonist Fips (Philipp Rupprecht), complete with one of his trademark anti-semitic, anti-freemasonic cartoons – two scapegoats for the price of one!

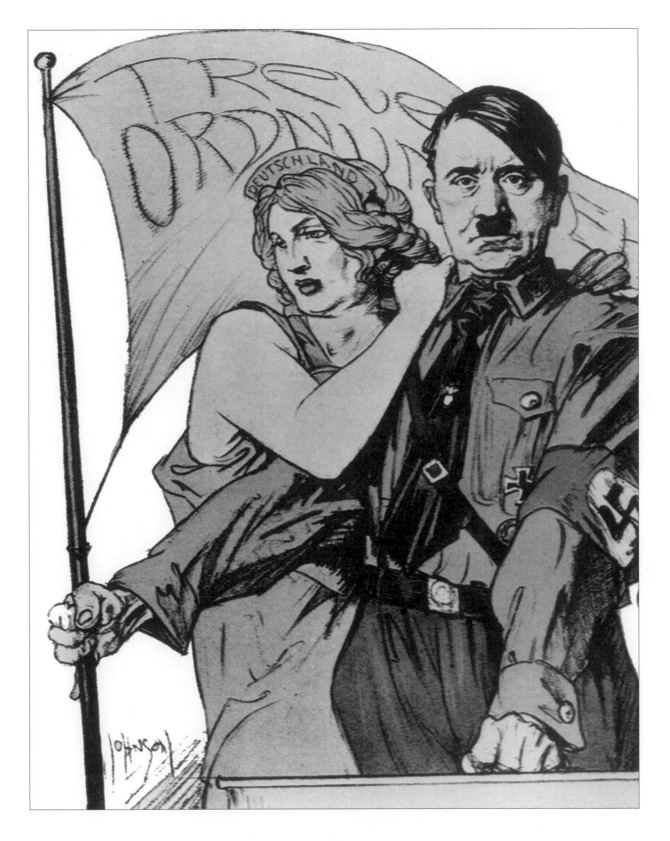

'The German people know: the greater the need, the stronger the Führer will be': this morale-boosting image by Arthur Johnson was produced after the Night of the Long Knives, when having suppressed his enemies, Hitler had arrested over 800 of his Nazi critics, about 90 of whom were killed

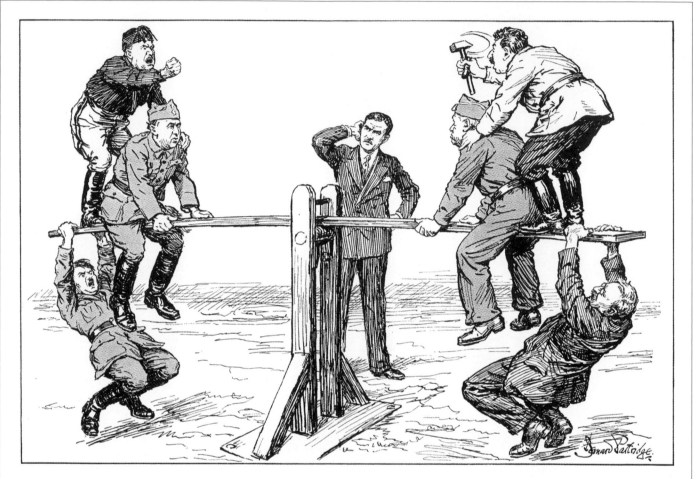

THE SPANISH SEE-SAW

Mr. Eden. "THIS MAY BE A NEW 'BALANCE OF POWER,' BUT IT CERTAINLY ISN'T 'COLLECTIVE SECURITY.'"

British Foreign Secretary
Anthony Eden stands bemused
at the main players in the
Spanish Civil War and how
they might be lining up for
conflicts to come, *Punch* 1936

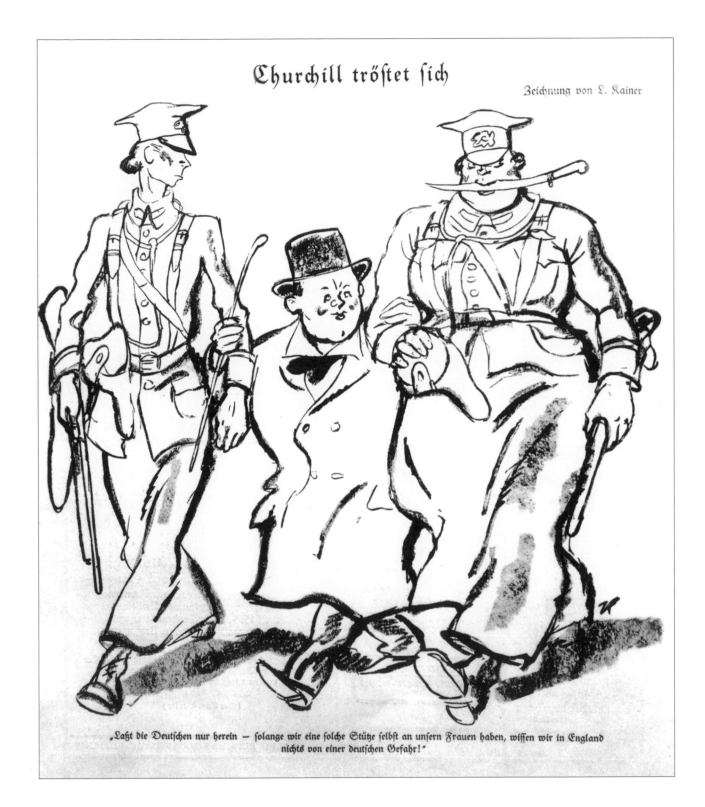

This German propaganda cartoon mocks Churchill for believing he could rely on women to protect him from the Germans (date unknown)

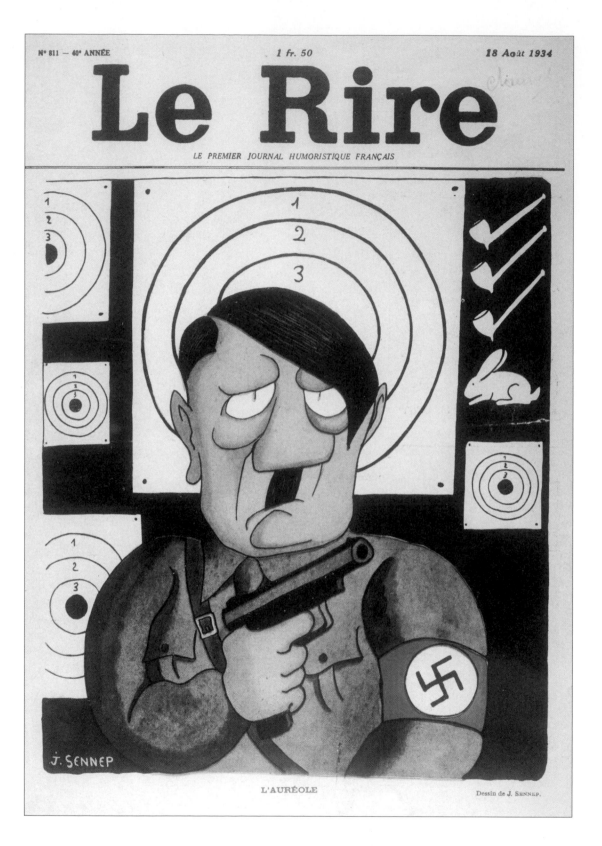

'Hitler with Halo': this was a cover drawn by Sennep (Jean Pennes) for French satirical magazine *Le Rire*, 1934. Sennep fought for the French Cavalry in World War I and later worked for *Le Figaro* where he became one of the greatest anti-Hitler cartoonists

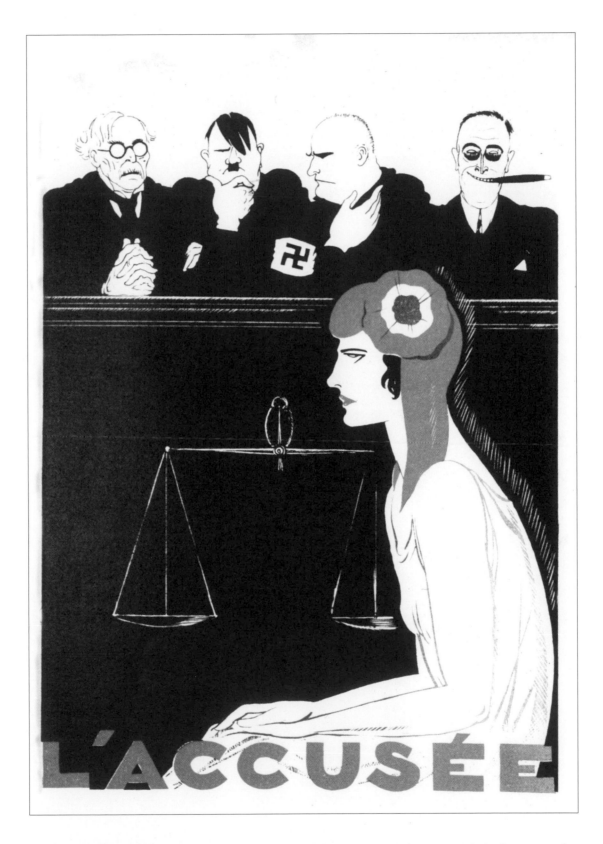

'The Accused' by ultra-nationalist French artist Paul Iribe, 1934: Marianne, symbol of France, is being judged by the great powers, represented by Ramsay MacDonald, Hitler, Mussolini and Roosevelt. Iribe blamed sneering and bullying foreigners for the political turmoil in France, along with homegrown politicians of course. Iribe was the lover of Coco Chanel, here the model for Marianne

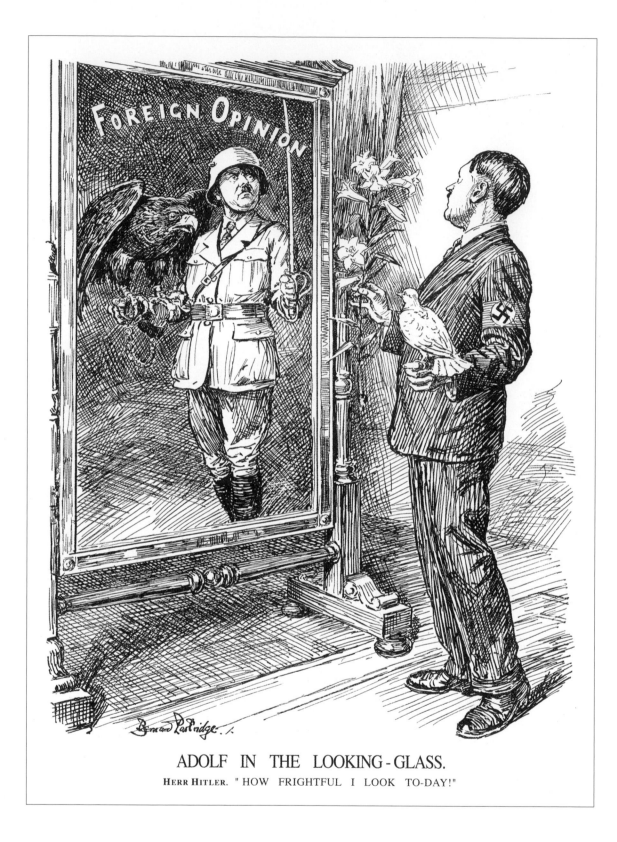

ADOLF IN THE LOOKING-GLASS.

HERR HITLER. "HOW FRIGHTFUL I LOOK TO-DAY!"

This image was produced in 1934 by Bernard Partridge
and is evidence of how anxious the British were
becoming at the turn of events in Germany

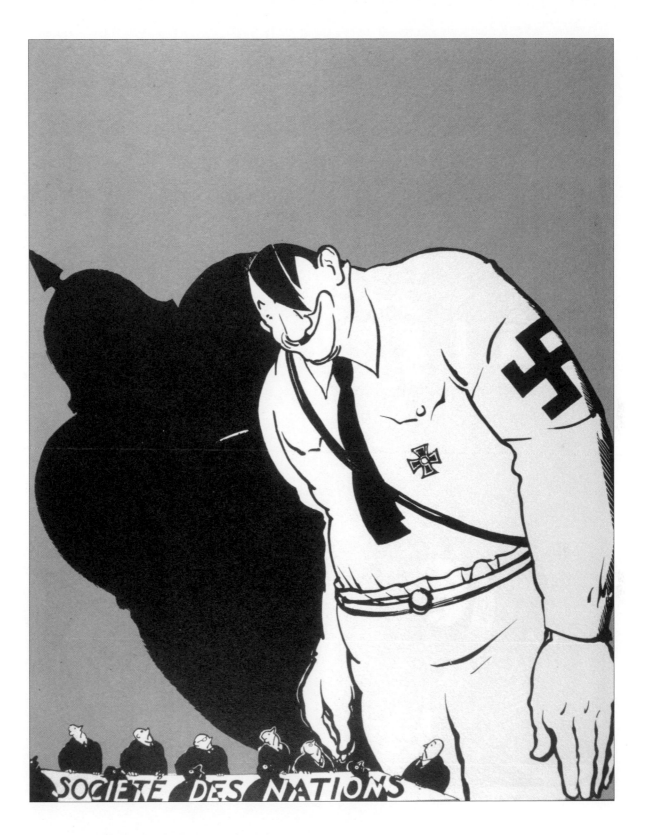

1935 and the shadow of Germany's past and present looms large over delegates at the League of Nations – Hitler withdrew Germany from that organization in 1933. This image by Paul Iribe appeared in the polemical journal *Le Témoin* (The Witness), which he founded with the financial backing of Coco Chanel

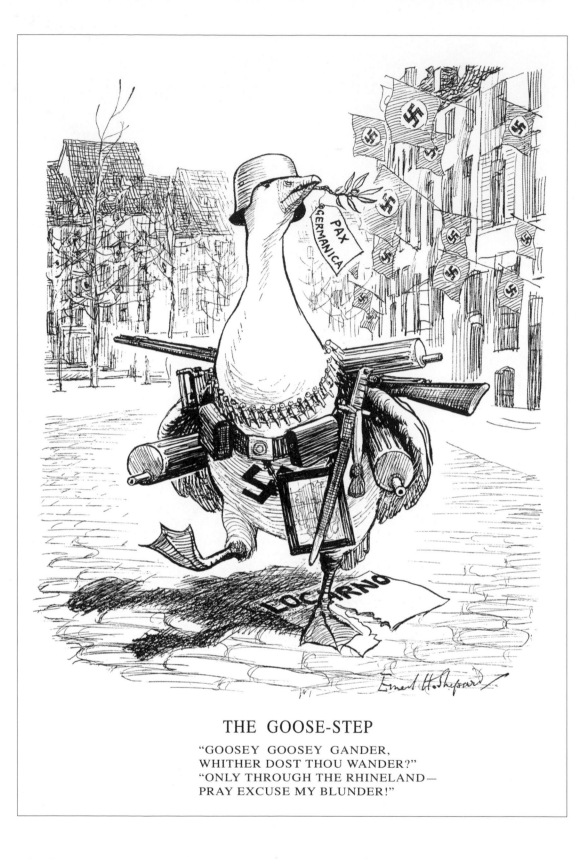

THE GOOSE-STEP

"GOOSEY GOOSEY GANDER,
WHITHER DOST THOU WANDER?"
"ONLY THROUGH THE RHINELAND—
PRAY EXCUSE MY BLUNDER!"

This drawing, by E.H. Shepard, is a comment on the remilitarization of
the Rhineland amid German demands for further expansion. The goose is
stepping all over a torn Treaty of Locarno. This document was drawn up to
preserve national borders

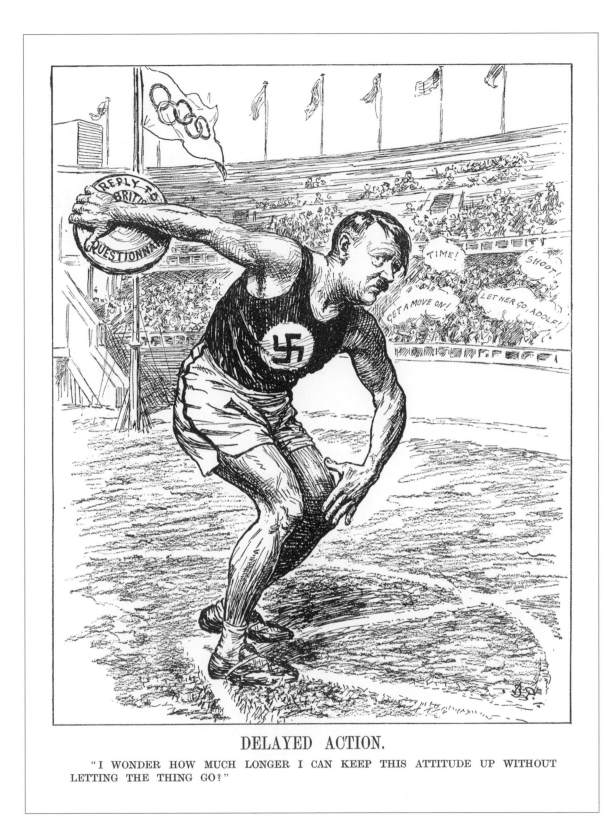

DELAYED ACTION.

"I WONDER HOW MUCH LONGER I CAN KEEP THIS ATTITUDE UP WITHOUT
LETTING THE THING GO?"

Bernard Partridge used the 1936 Berlin
Olympics to highlight Hitler's refusal to reveal
exactly what he had in mind for Europe

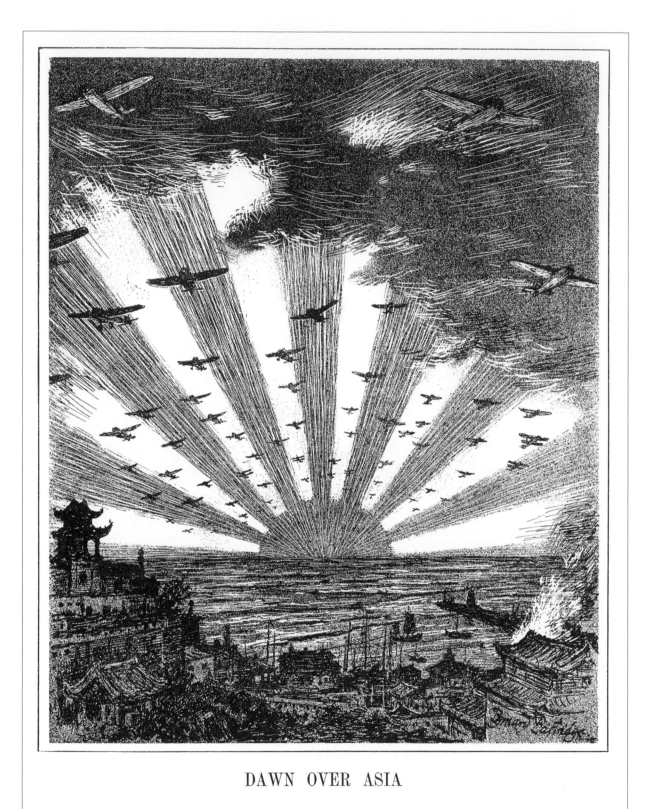

DAWN OVER ASIA

Japanese forces attacked China as a new power arose
in the East – by Bernard Partridge, 1937. The rising
sun with radiating rays was the main image on the
official war flag of the Japanese army at this time

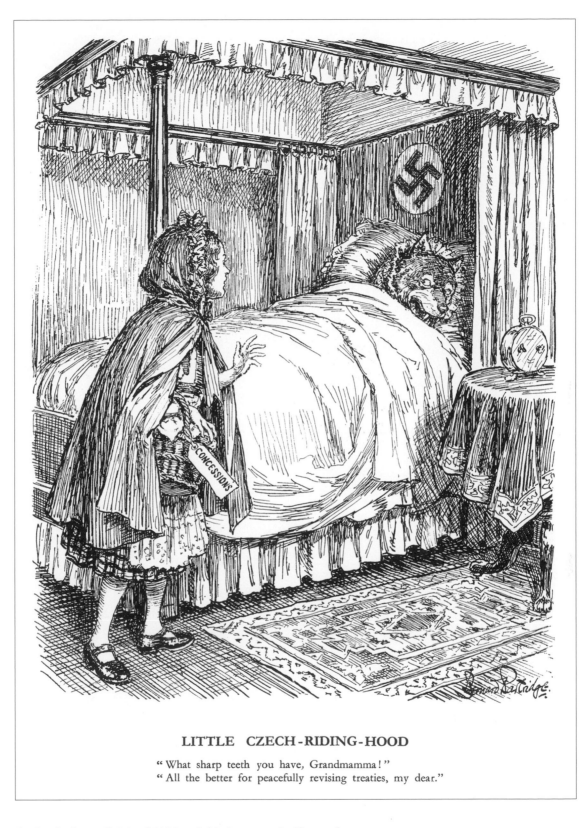

LITTLE CZECH-RIDING-HOOD

" What sharp teeth you have, Grandmamma ! "
" All the better for peacefully revising treaties, my dear."

As the Sudeten Crisis of 1938 unfolded, cartoonist Bernard
Partridge mocked Hitler's claim to want to redraw Germany's
border with Czechoslovakia by peaceful means and
highlighted the futility of the Czech offer of concessions

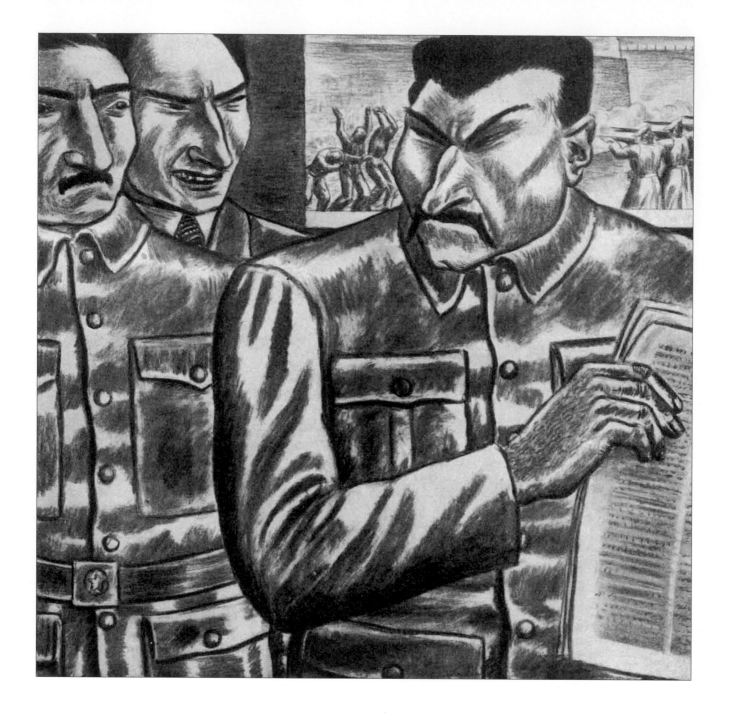

In 1938, Stalin was still seen as the arch-enemy by Nazi artist Erich Schilling in *Simplicissimus* – here, the Russian dictator is complaining about grave-diggers joining the general strike in Paris. He wouldn't ever allow such a thing himself: grave-digging was far too important for the future of Bolshevism

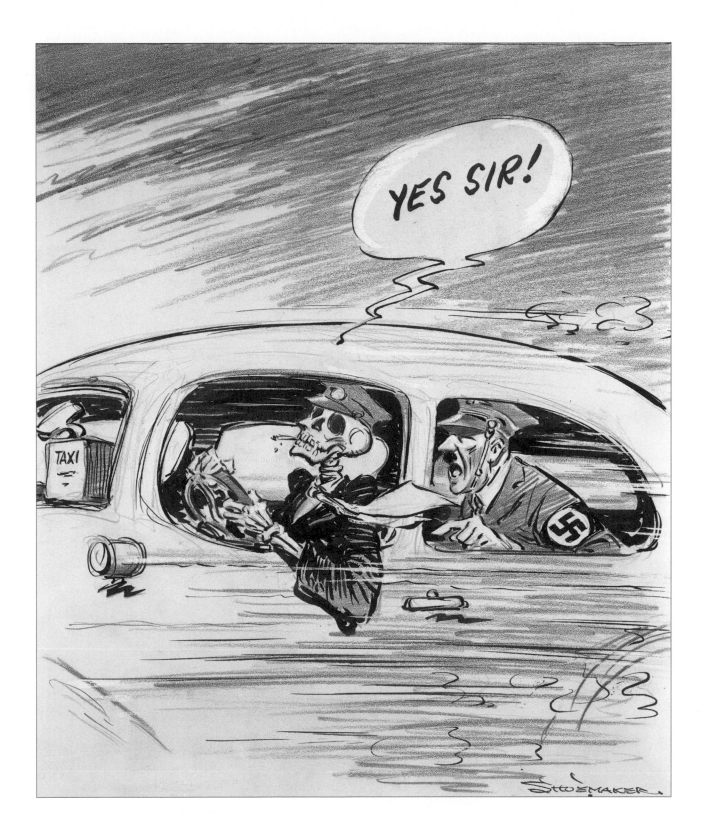

'Take Me to Czechoslovakia, Driver': Hermann Goering
called this cartoon by Vaughn Shoemaker 'a horrible example
of anti-Nazi propaganda' – from the *Chicago Times*, 1938

Pont (Graham Laidler) captured the mood of the time as the British found it increasingly hard to ignore what was happening in Europe; opposite page: he also imagined what might be going on in the minds of the Germans

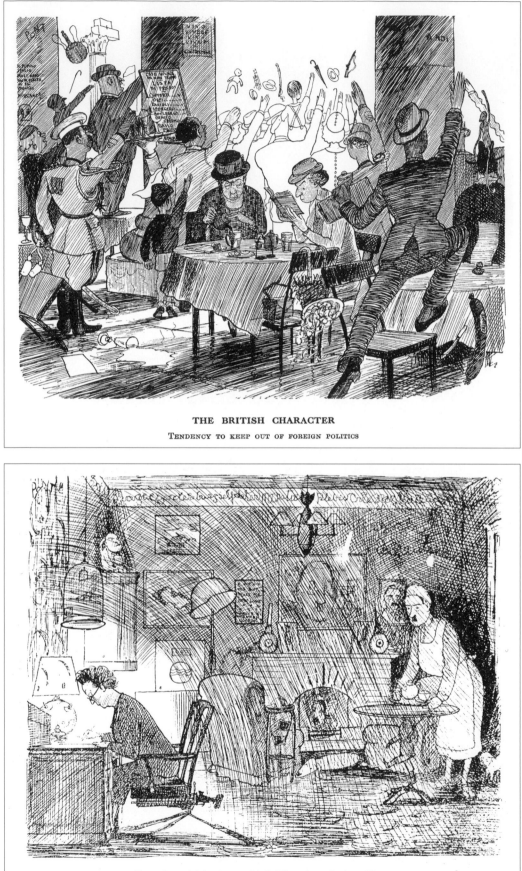

THE BRITISH CHARACTER
TENDENCY TO KEEP OUT OF FOREIGN POLITICS

"... *I am beginning to think I have been letting things worry me too much lately, because* ..."

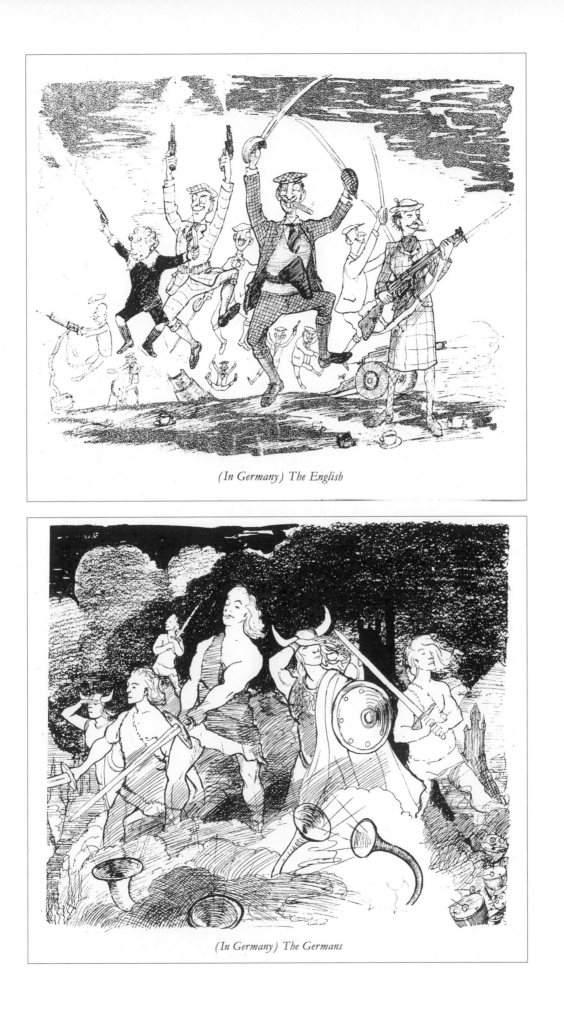

(In Germany) The English

(In Germany) The Germans

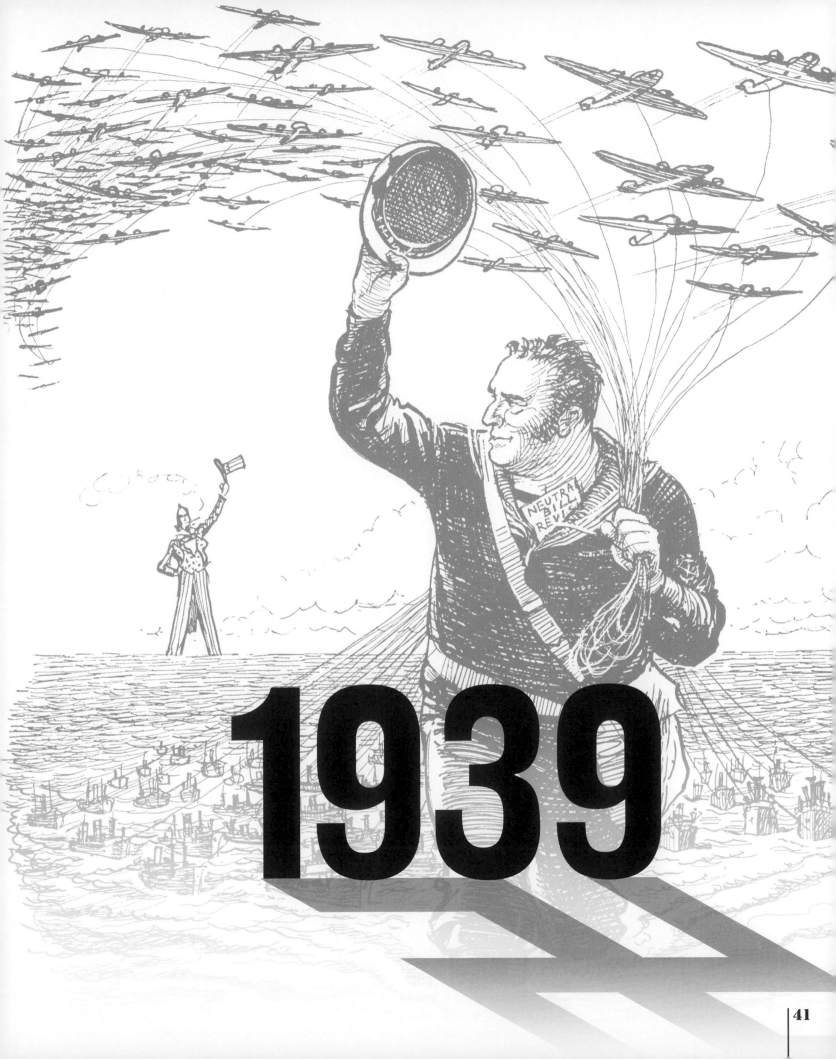

1939

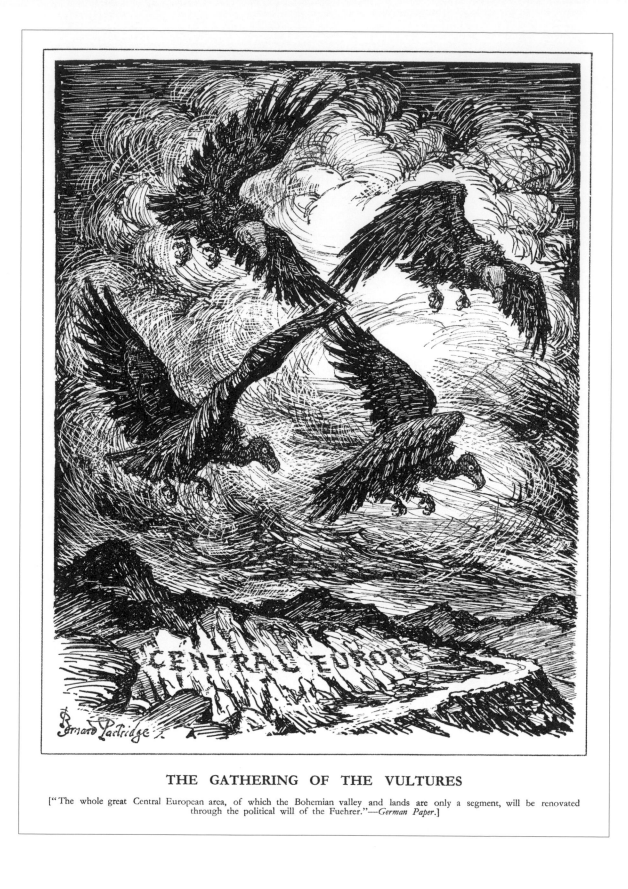

THE GATHERING OF THE VULTURES

["The whole great Central European area, of which the Bohemian valley and lands are only a segment, will be renovated through the political will of the Fuehrer."—*German Paper*.]

Bernard Partridge re-imagined the
topographical map of Central Europe

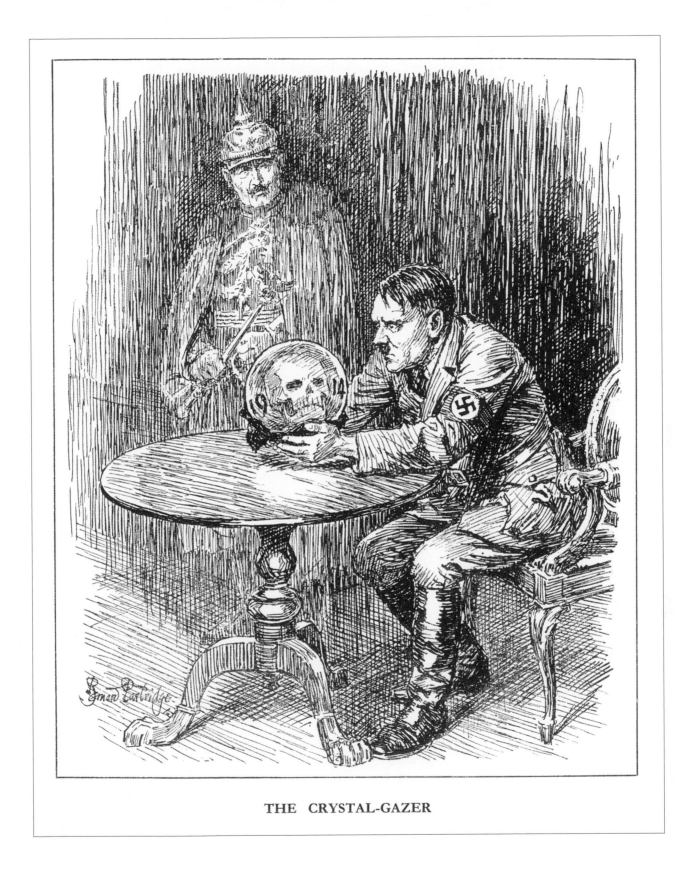

THE CRYSTAL-GAZER

Watched by the shade of Germany's past, Hitler peers
into his crystal ball and does not flinch at what he sees
– by Bernard Partridge

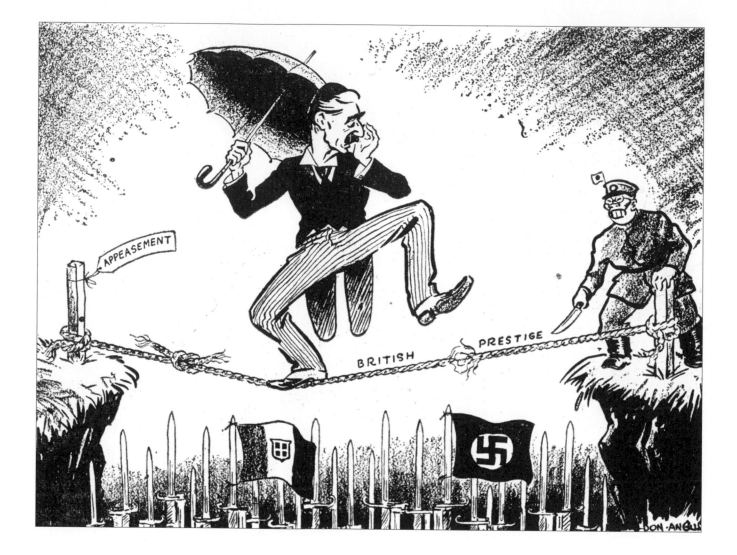

'Appeasement': a
tightrope-walking
Neville Chamberlain,
then Prime Minister,
complete with trademark
umbrella, is about to
come a cropper as British
prestige begins to unravel
– by New Zealand artist
Don Angus

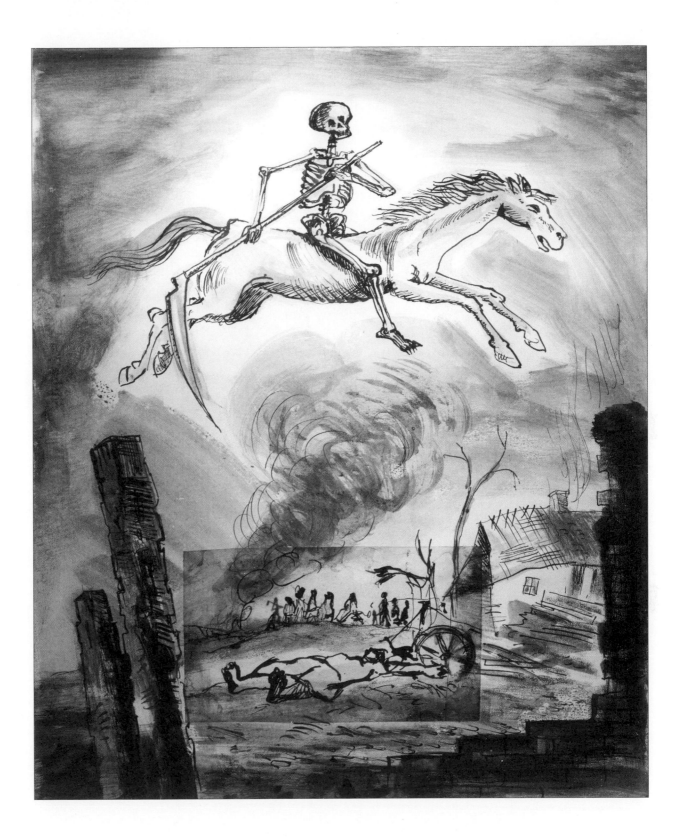

Pen and ink representation of the Nazis' invasion of Poland by
Jerzy Faczynski, who escaped to England in 1939 to fight for
the Polish free forces. In the Bible, the Fourth Horseman of the
Apocalypse was Death riding on a pale horse

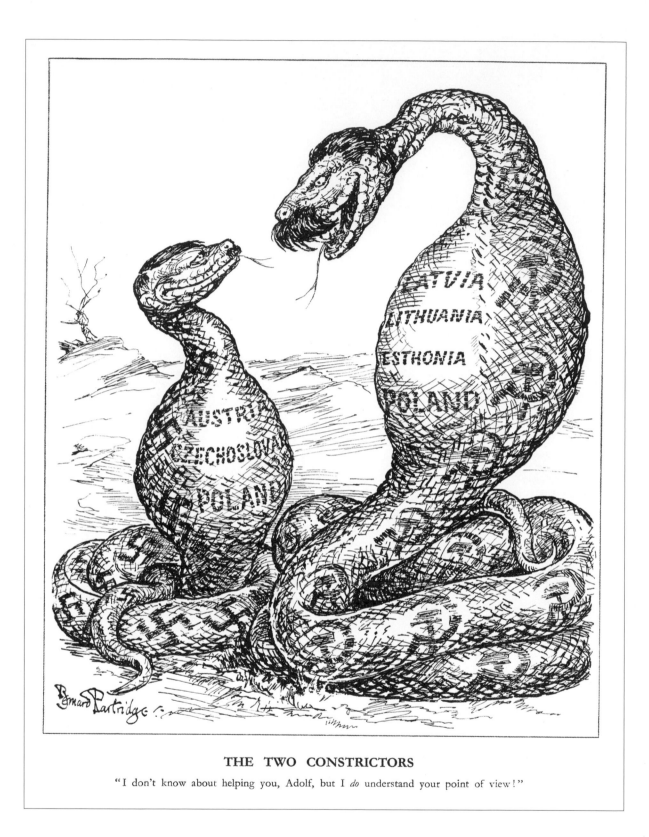

THE TWO CONSTRICTORS

"I don't know about helping you, Adolf, but I *do* understand your point of view!"

Who's the bigger snake? Bernard Partridge sees through the marriage of convenience between the Nazis and the Soviet Union

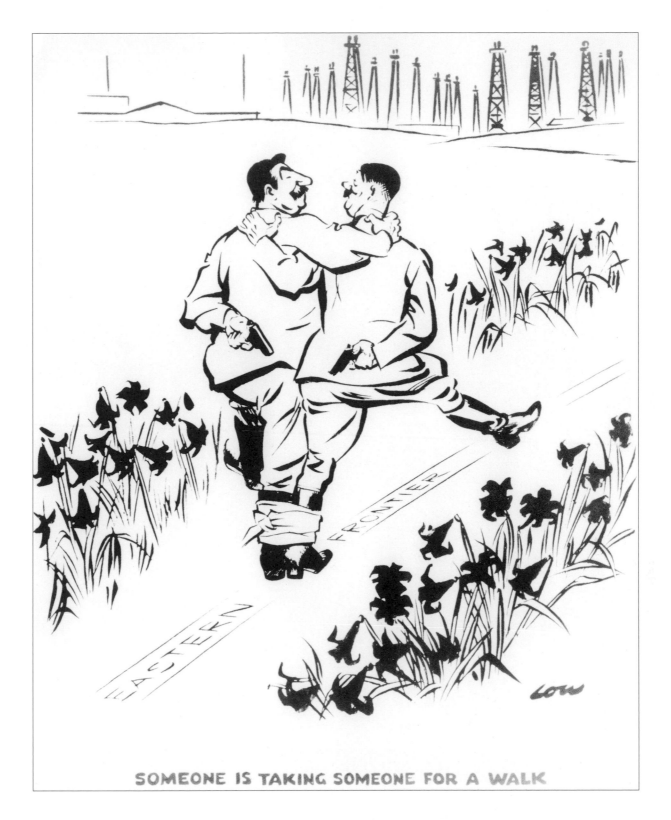

SOMEONE IS TAKING SOMEONE FOR A WALK

David Low also decides there isn't much to choose between Stalin and Hitler. As early as 1936, British diplomats began to receive complaints from Germany about New Zealand-born cartoonist Low's drawings of Hitler. They were really getting under the Führer's skin. During review sessions of the foreign press, Hitler would explode with rage when he saw the artist's latest work. Low was said to be high on the Nazi death list to be implemented once Britain was conquered

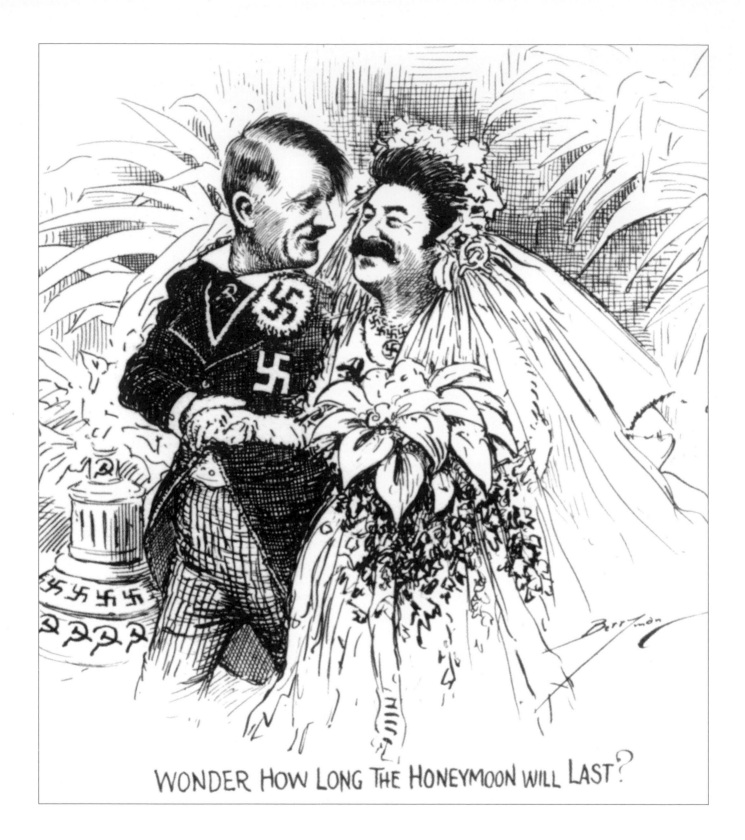

WONDER HOW LONG THE HONEYMOON WILL LAST?

Legendary US cartoonist Clifford
Berryman added his voice to the
widespread mockery of the Russo-
German non-aggression pact

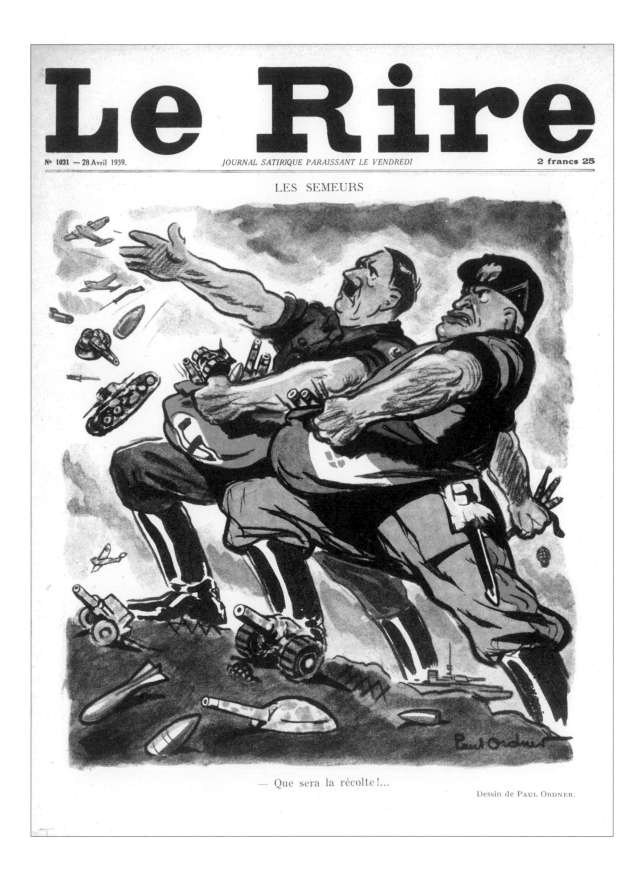

Hitler and Mussolini are sowing the fields of Europe with guns and tanks, but 'what will their harvest be?' – by Paul Ordner in French satirical weekly *Le Rire*

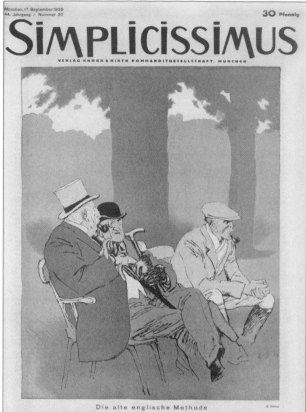

München, 17. September 1939
44. Jahrgang / Nummer 37

SIMPLICISSIMUS
VERLAG KNORR & HIRTH KOMMANDITGESELLSCHAFT, MÜNCHEN

30 Pfennig

Die alte englische Methode
„Das hat Old Churchill wieder mal gut gemacht: kaum ist der Krieg ausgebrochen, läßt er
die Athenia sinken und schon sind die Deutschen daran schuld. Gelernt ist eben gelernt."

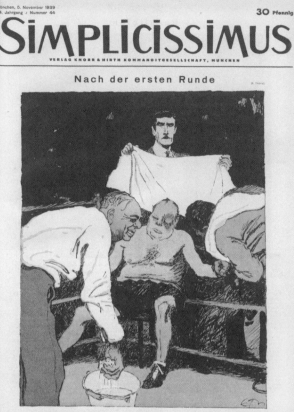

München, 5. November 1939
44. Jahrgang / Nummer 44

SIMPLICISSIMUS
VERLAG KNORR & HIRTH KOMMANDITGESELLSCHAFT, MÜNCHEN

30 Pfennig

Nach der ersten Runde

Churchill mußte mehrere schwere Treffer einstecken. Erste Runde einwandfrei für uns!

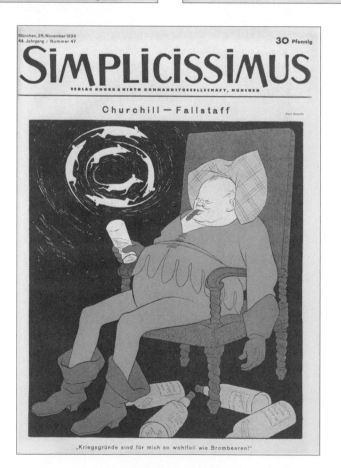

München, 26. November 1939
44. Jahrgang / Nummer 47

SIMPLICISSIMUS
VERLAG KNORR & HIRTH KOMMANDITGESELLSCHAFT, MÜNCHEN

30 Pfennig

Churchill — Fallstaff

„Kriegsgründe sind für mich so wohlfeil wie Brombeeren!"

Simplicissimus was Germany's top satirical magazine, which turned right-wing under the Nazis. Here are three covers from 1939 with (from the top) the view from the old fellows on a park bench, pointing out 'England's traditional habit of blaming the Germans for everything'; Churchill, then First Lord of the Admiralty, taking a pummelling in the first round of the naval war; a drunken Churchill as Falstaff

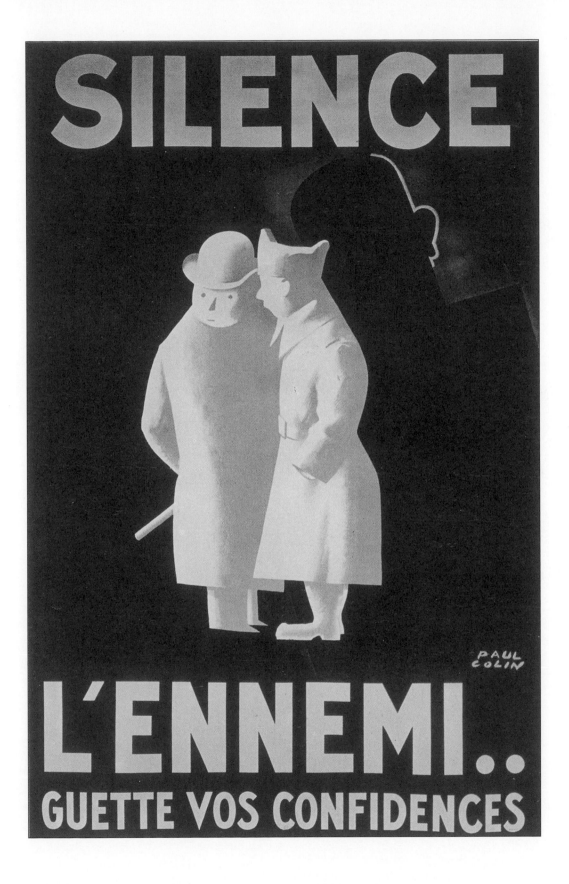

'The Enemy is on the Prowl for Your Secrets': Paul Colin was one of France's greatest poster artists. He helped launch the career of his lover Josephine Baker with his poster for *Revue Nègre* in 1925 and produced just shy of 2,000 posters during his lifetime

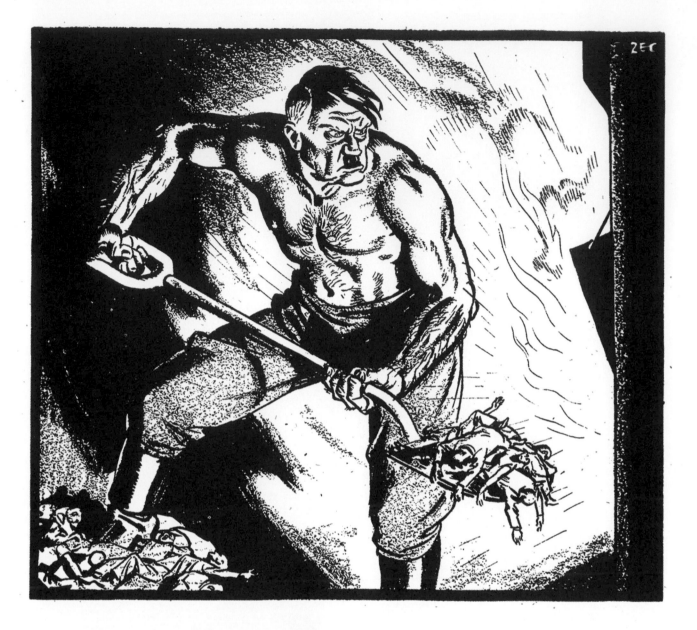

Above: 'The Stoker' – Hitler shovels more corpses into the furnace as the Germans burn their way across Europe – by Philip Zec in Britain's *Daily Mirror*; left: Marshall Petain brings Marianne of France to Vichy for a health cure, courtesy of *Der Stürmer*; opposite: 'The Campaign of Lies – the Democracies have called on their most loyal troops to encircle Germany.' Ducks are a German metaphor for lies, a *Zeitungsente* being a false story in a newspaper, and here they are seen emerging from Jewish lips. Vile anti-semitism was the default setting in Nazi newspapers and magazines

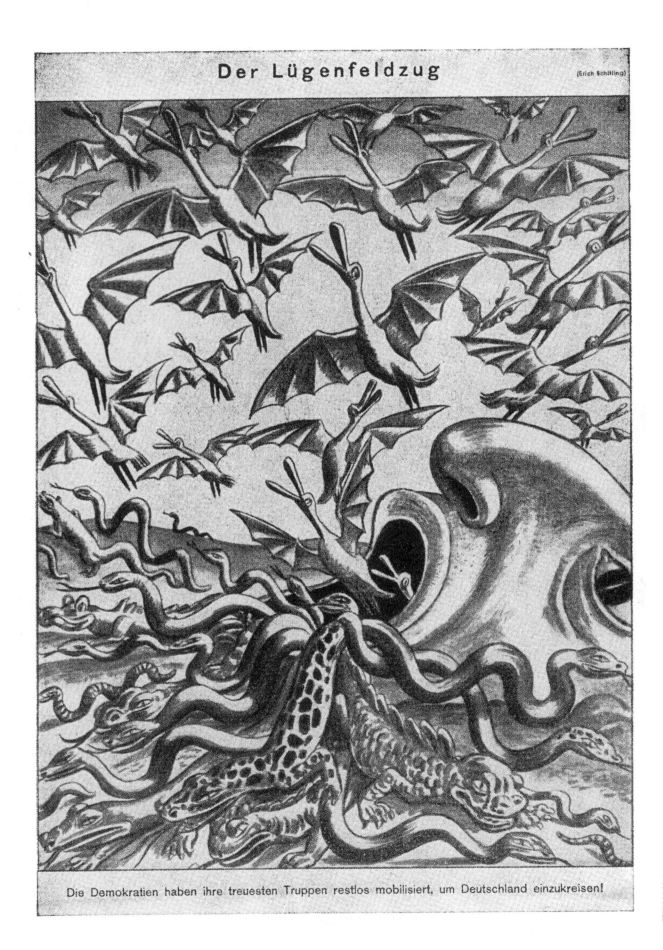

Die Demokratien haben ihre treuesten Truppen restlos mobilisiert, um Deutschland einzukreisen!

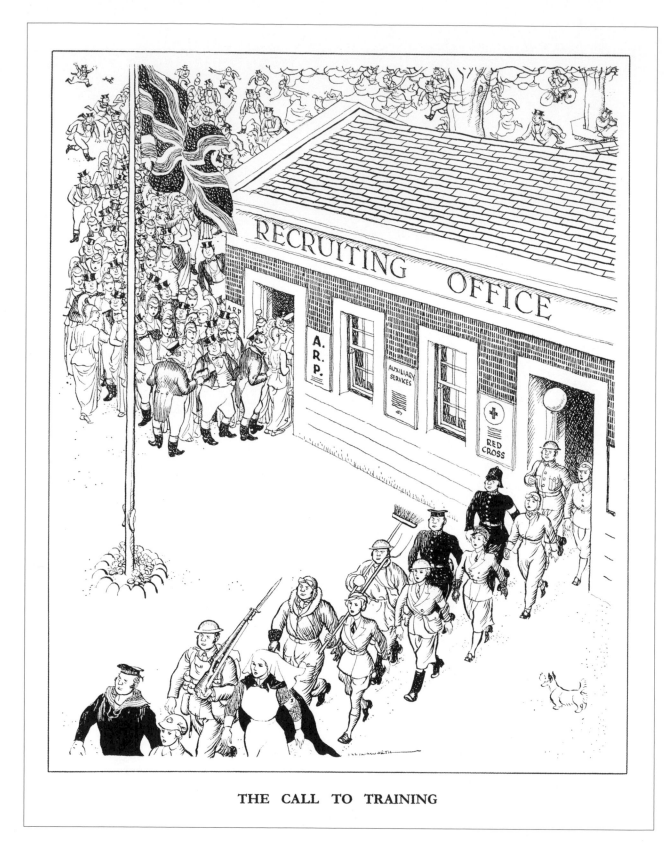

THE CALL TO TRAINING

A cheerful *Punch* cartoon in which a queue of John Bulls
and Britannias is transformed into a column of patriotic
volunteers for the auxiliary services – by Leslie Illingworth

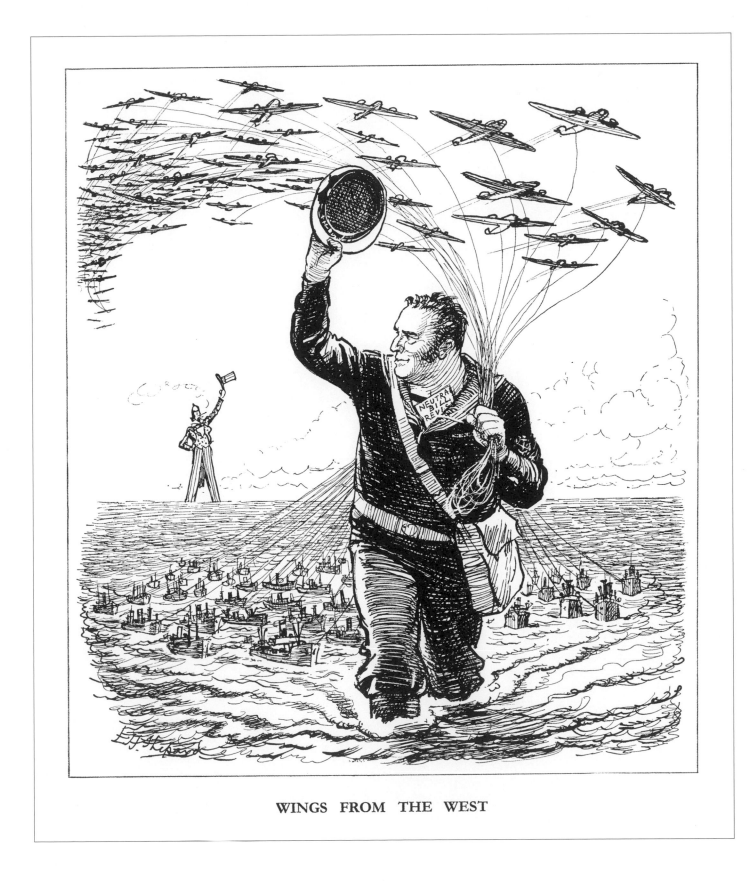

WINGS FROM THE WEST

Although the USA did not officially join the war until Pearl Harbor in 1941, it provided
aid and military assistance as soon as the arms embargo had been lifted – by E.H. Shepard

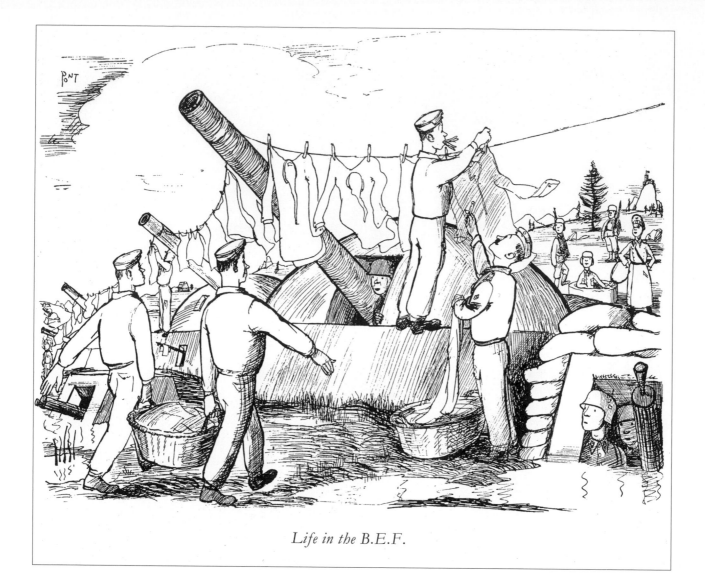

Life in the B.E.F.

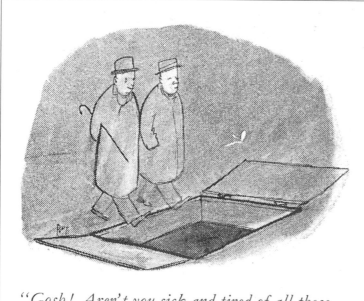

"Gosh! Aren't you sick and tired of all these silly jokes about the black-out?"

Pont always sought to downplay the gravity of any situation, gently sending up the character of the British at the same time. The cartoon (above) is a reference to a popular song of 1939, 'We're Going to Hang Out the Washing on the Siegfried Line', written by Captain James Kennedy, then serving in the British Expeditionary Force in the sector opposite the German defensive works known as the Siegfried Line

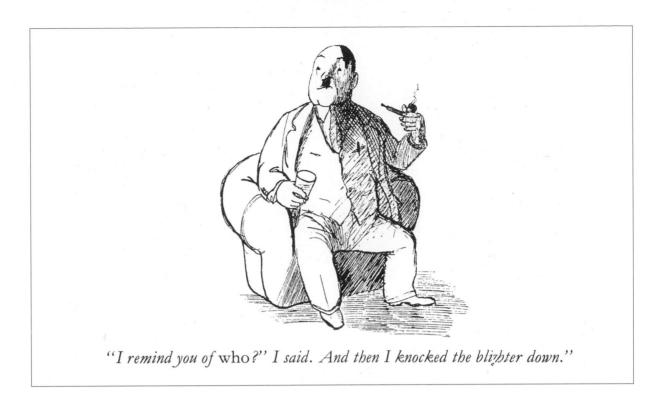

"I remind you of who?" I said. And then I knocked the blighter down."

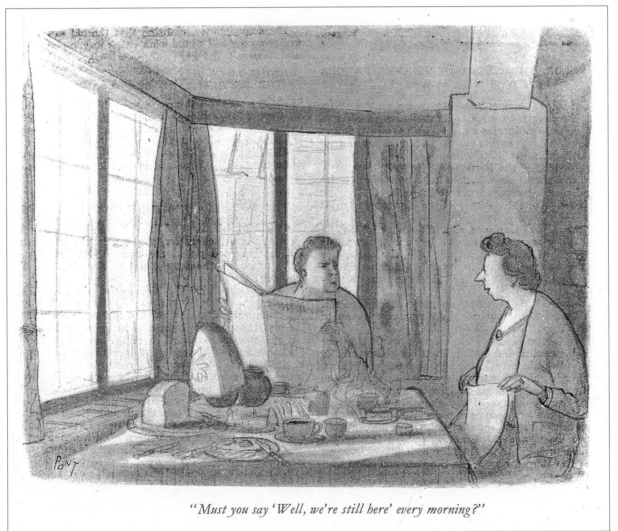

"Must you say 'Well, we're still here' every morning?"

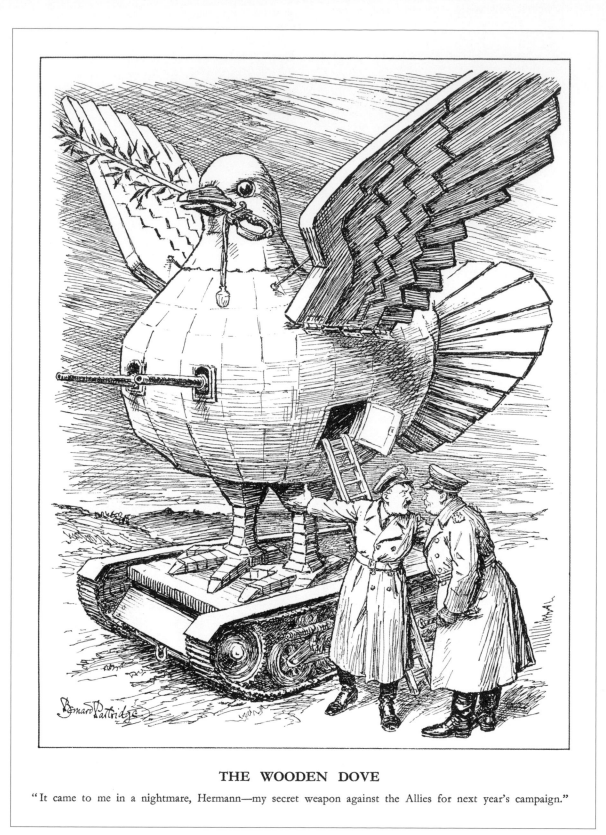

THE WOODEN DOVE

"It came to me in a nightmare, Hermann—my secret weapon against the Allies for next year's campaign."

Hitler explains his brilliant new plan to
Hermann Goering. This drawing by Bernard
Partridge appeared in *Punch*

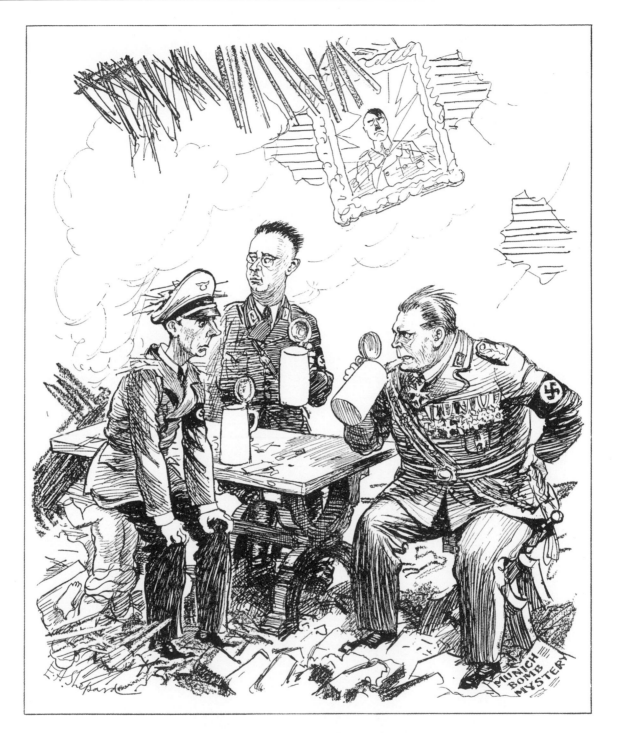

THE HAND OF PROVIDENCE

"If that doesn't make him more popular, his next escape must be narrower still."

This cartoon by E.H. Shepard commemorates Johann Georg Elser's attempt to assassinate Adolf Hitler in a Munich beer cellar – Hitler left 13 minutes before the bomb went off. Elser was also planning to kill Hitler's jealous comrades Goering and Goebbels

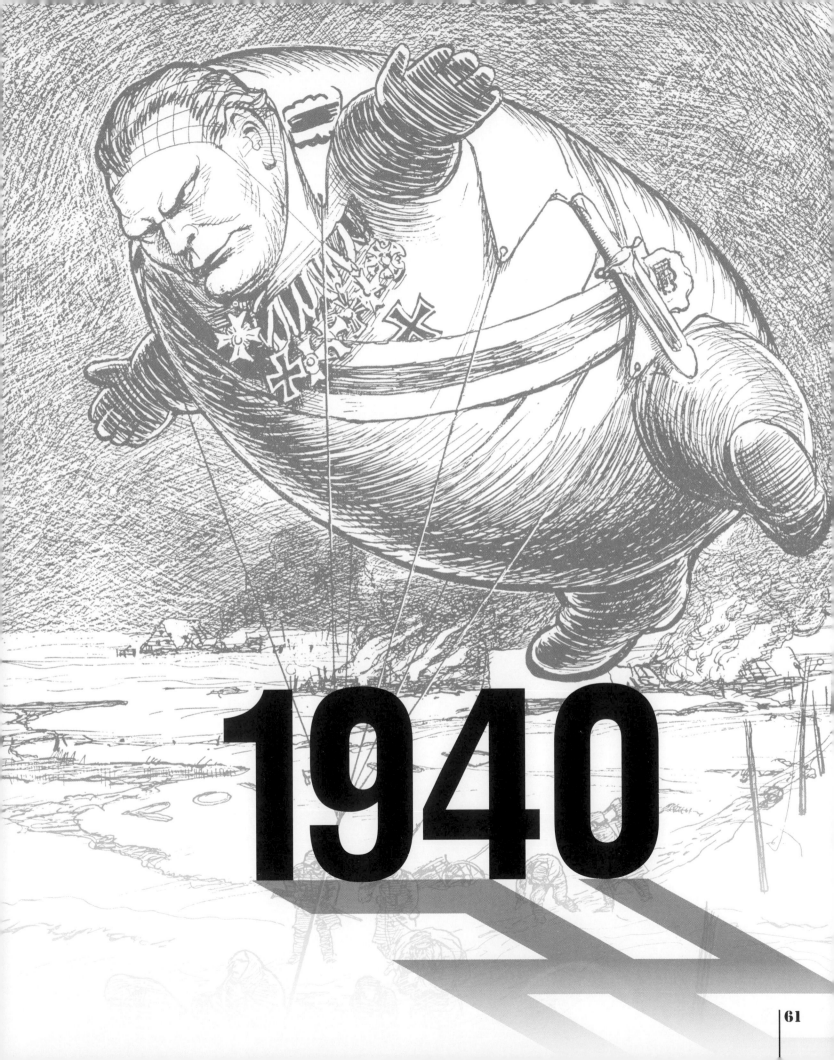

1940

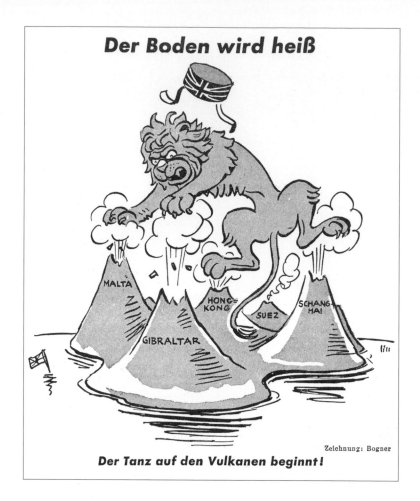

Der Boden wird heiß

Der Tanz auf den Vulkanen beginnt!

Zeichnung: Bogner

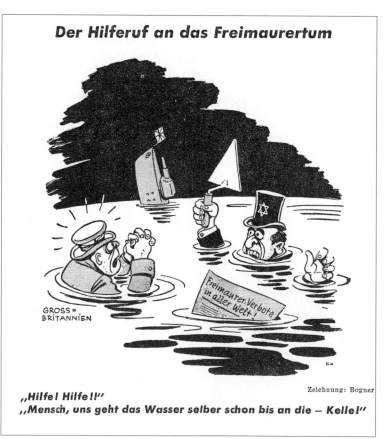

Der Hilferuf an das Freimaurertum

GROSS-
BRITANNIEN

Freimaurer-Verbote in aller Welt!

Zeichnung: Bogner

„Hilfe! Hilfe!!"
„Mensch, uns geht das Wasser selber schon bis an die – Kelle!"

Above: 'The Floor gets hot: the dance on the volcanoes begins!': anti-British cartoon by Bogner in *Das Schwarze Korps*, the magazine of the SS; left: 'The Cry for help to Freemasonry': John Bull: 'Help. Help.' Freemason: 'Man, the water is right up to my… trowel', also by Bogner in *Das Schwarze Korps*; right: 'peacemaker' Neville Chamberlain and 'warmonger' Churchill lament the disaster at Dunkirk in this piece of German propaganda. Across the water, British propagandists put their minds to the task of turning defeat at Dunkirk into victory of a kind for domestic consumption

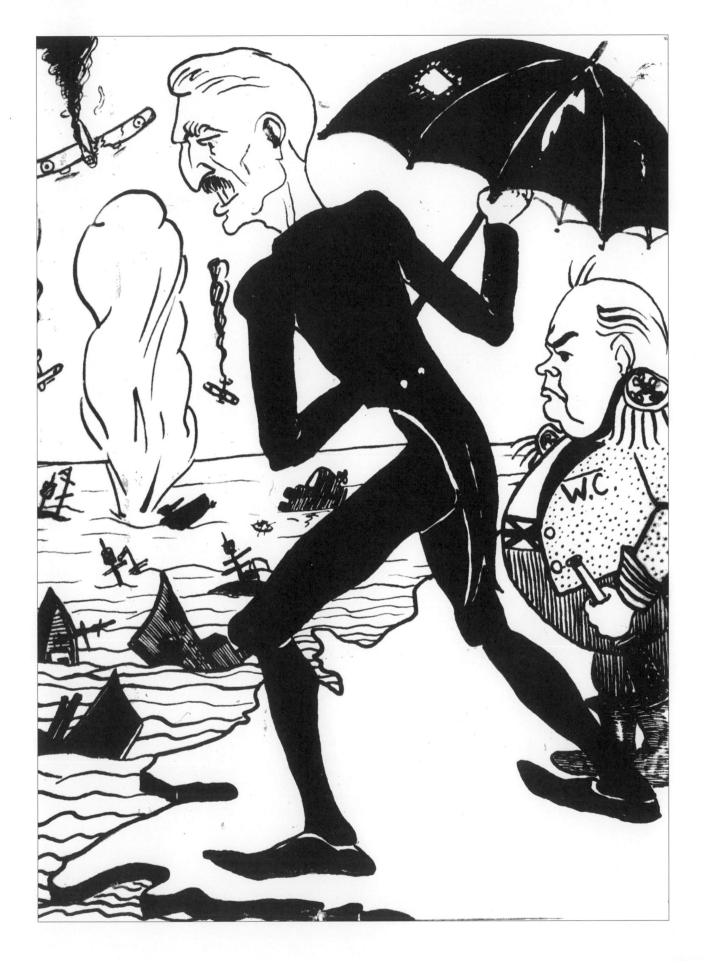

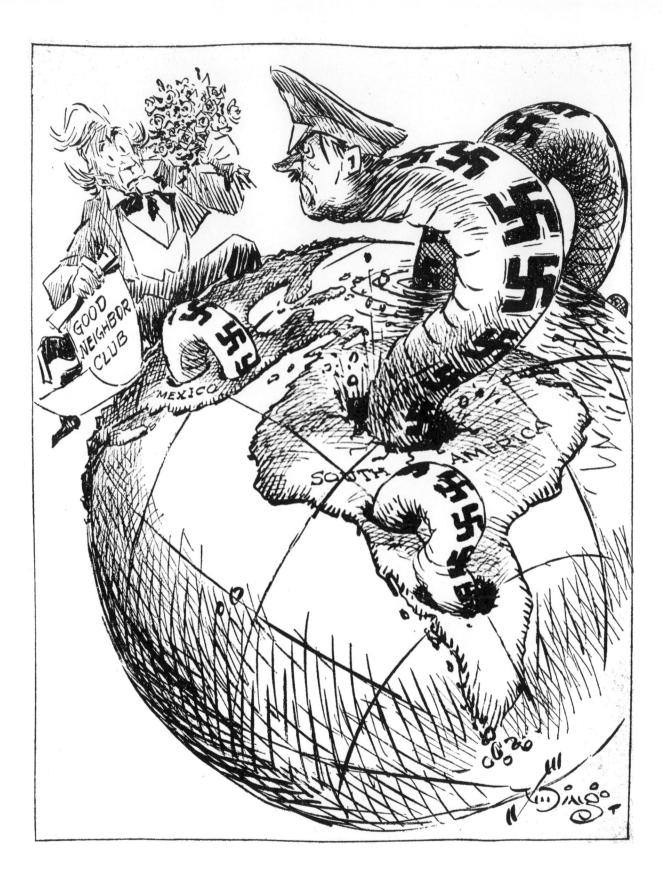

'Peaceful Penetration': a warning to US isolationists that
the Nazis were capable of threatening interests in America's
backyard – by Pulitzer Prize winner J.N. ('Ding') Darling

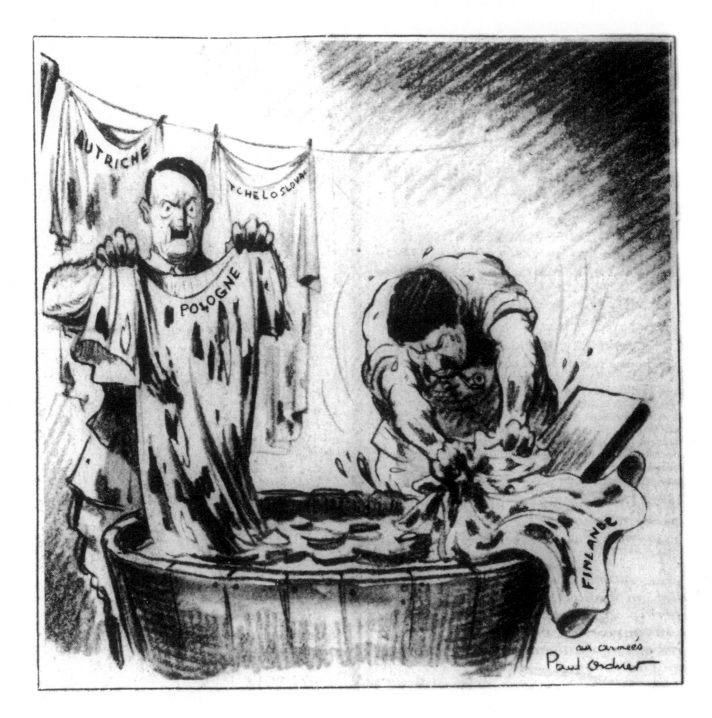

Hitler and Stalin wash their dirty linen
in public but, try as they might, they
can't remove the bloodstains from
Austria, Czechoslovakia, Poland and
Finland. Drawing by Paul Ordner first
published in *Marianne* magazine

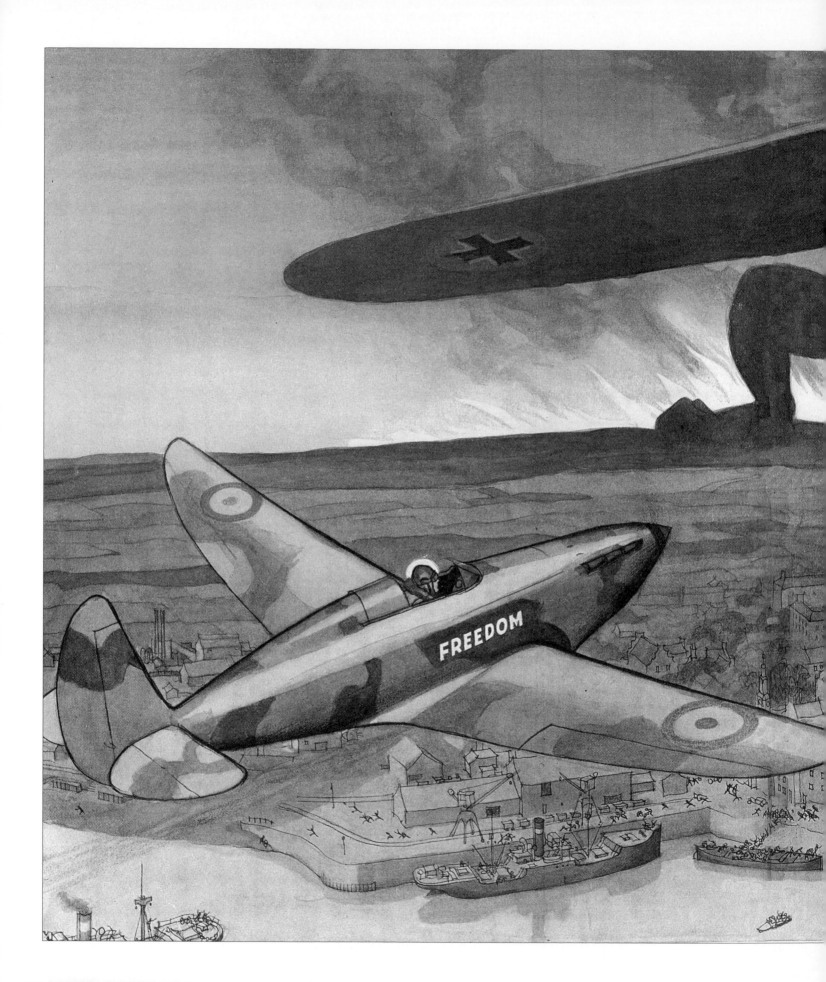

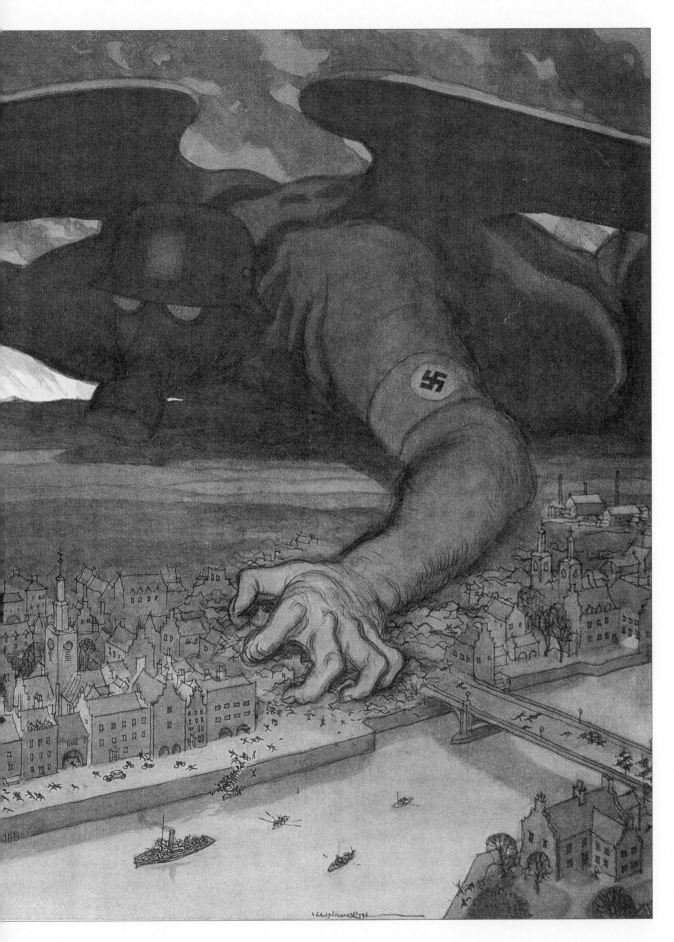

A single Spitfire stands between the British and disaster as it takes on the German juggernaut in this memorable drawing by Leslie Illingworth for *Punch*

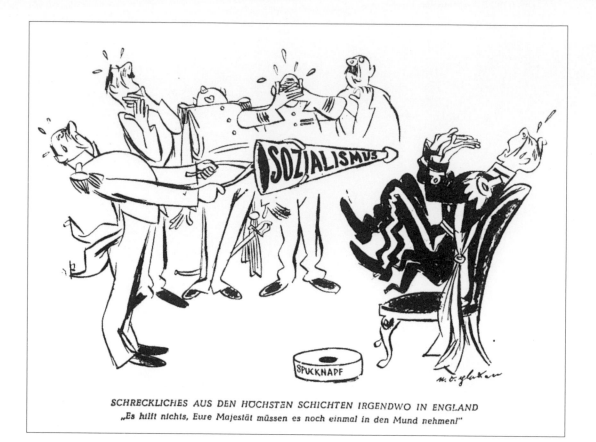

SCHRECKLICHES AUS DEN HÖCHSTEN SCHICHTEN IRGENDWO IN ENGLAND

„Es hilft nichts, Eure Majestät müssen es noch einmal in den Mund nehmen!"

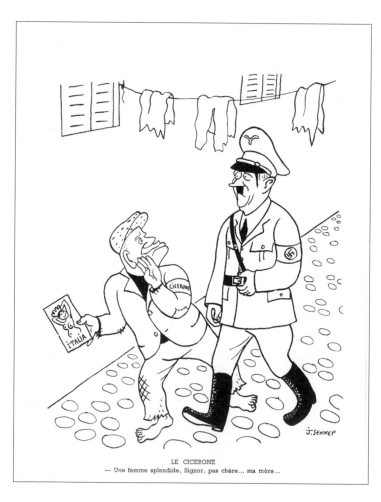

LE CICERONE

— Une femme splendide, Signor, pas chère... ma mère...

Above: 'The Terrible problems of the Upper Classes Somewhere in England – Your Majesty, there is no other choice, you just have to swallow it [socialism]' from *Das Reich*. Josef Goebbels wrote the editorials for this 'upmarket' weekly; left: French artist Sennep has Mussolini attempting to sell his mother's sexual favours to Hitler

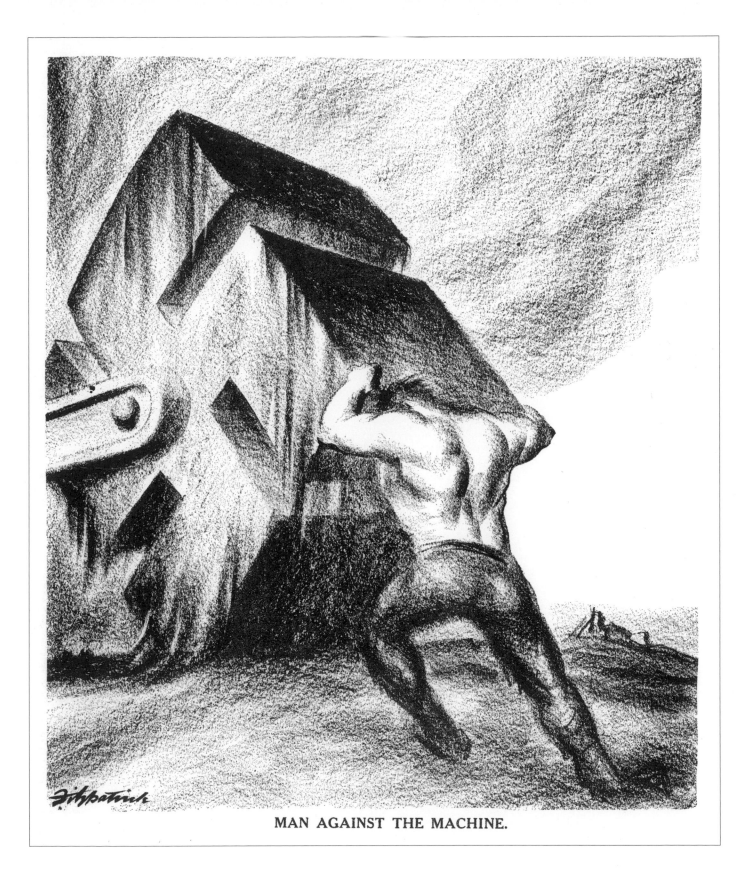

MAN AGAINST THE MACHINE.

'Man Against the Machine' by Pulitzer Prize winner
Daniel Fitzpatrick in the *St. Louis Post-Dispatch*

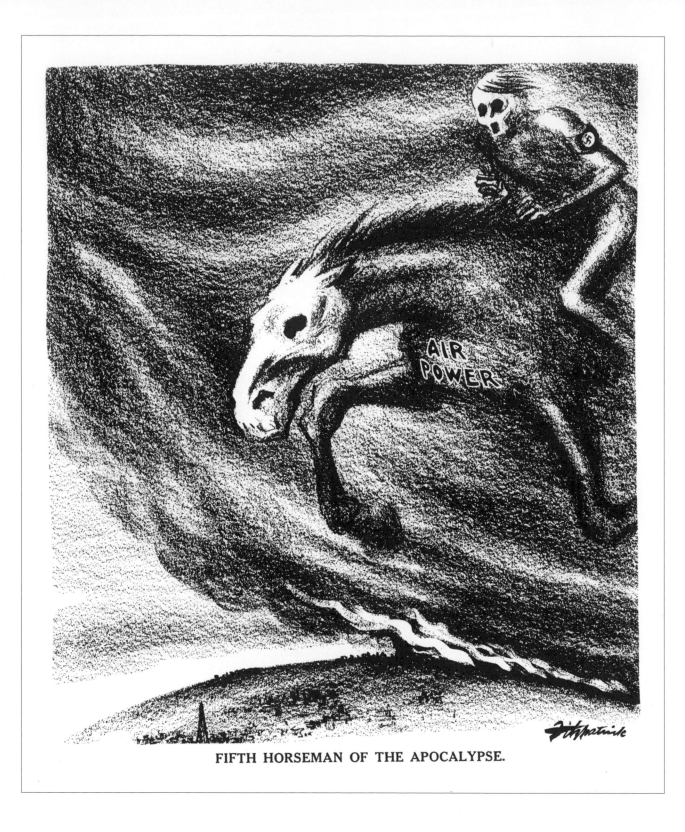

FIFTH HORSEMAN OF THE APOCALYPSE.

'The Fifth Horseman of the Apocalypse' by Daniel Fitzpatrick, whose powerful body of work played an important part in making the US rethink its isolationist stance towards Europe; right: in *De Robot* by L.J. Jordaan, the German automaton marches unstoppably across Holland. This was first published in an underground newspaper called *De Groene Amsterdammer*

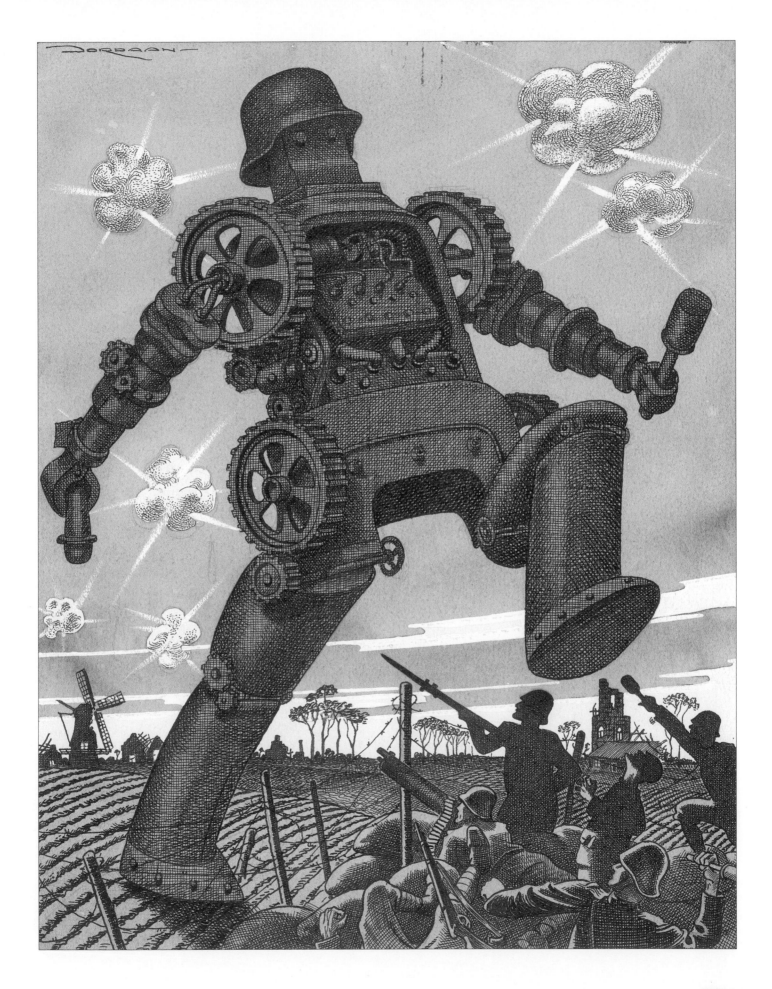

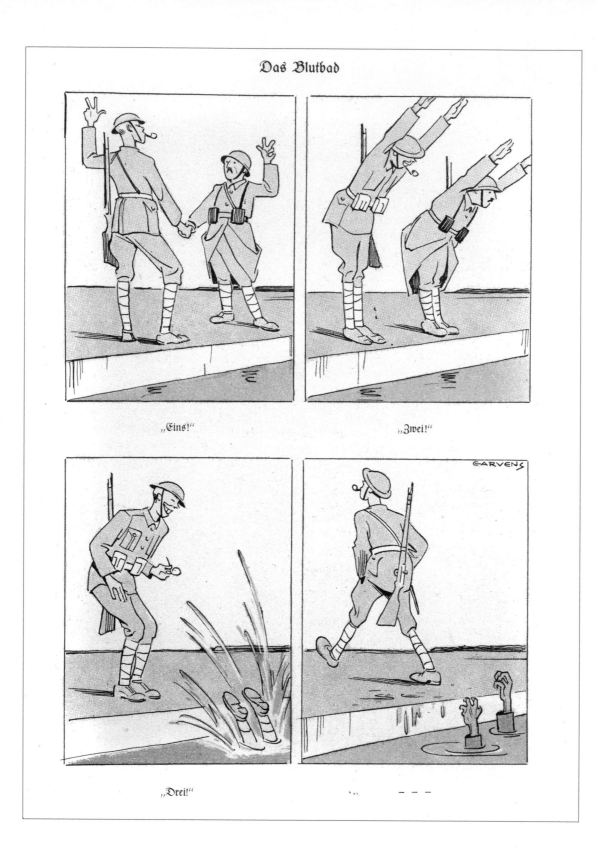

'The Bloodbath' shows the British betraying their French allies as a typical Tommy takes his French counterpart to the brink, then laughingly takes a step backwards as monsieur dives into the bloodbath alone. This is a German propaganda strip by Oskar Garvens, who produced a very similar work about the Russian betrayal of the Germans, also called 'The Bloodbath'

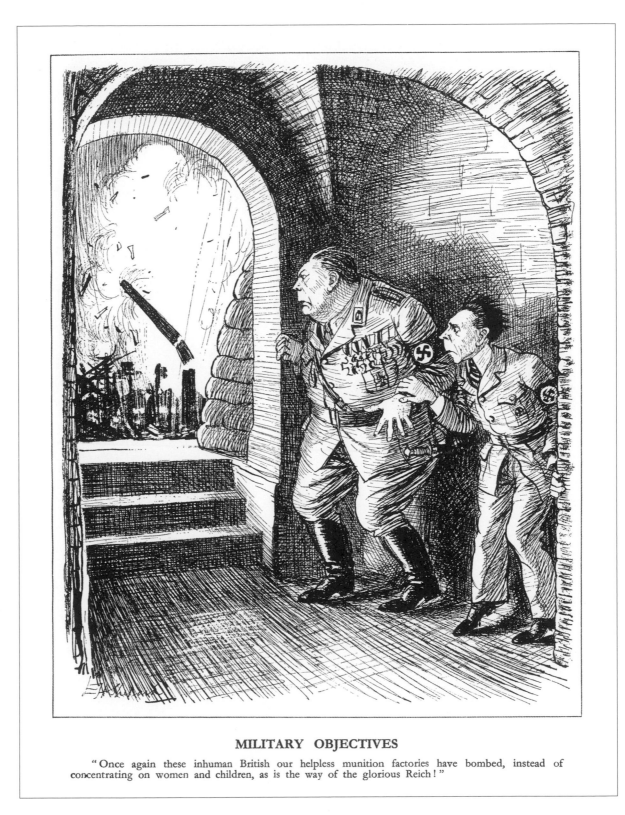

MILITARY OBJECTIVES

"Once again these inhuman British our helpless munition factories have bombed, instead of concentrating on women and children, as is the way of the glorious Reich!"

E.H. Shepard's drawing of a cowardly Goebbels and Goering serves two purposes, reminding us of the cruelty and viciousness of the Nazis as well as portraying British bombing as being increasingly effective

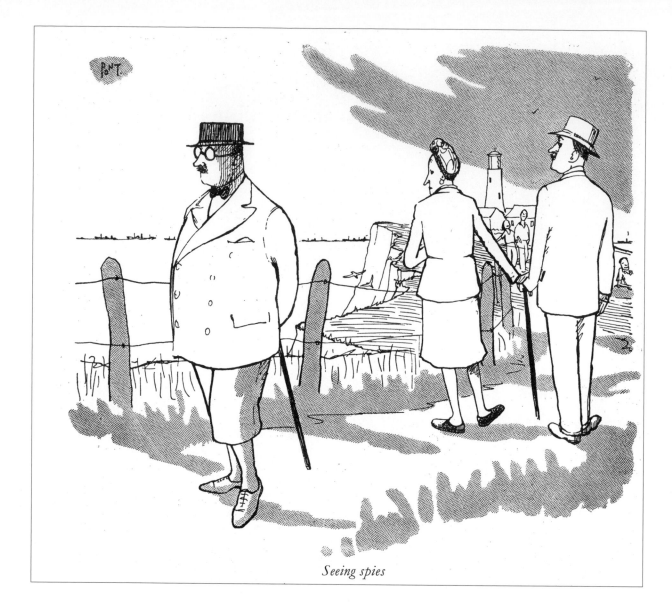

Seeing spies

Pont (Graham Laidler)

One of the great chroniclers of the British way of life, Graham Laidler was born in 1908 in Jesmond, Newcastle upon Tyne. His family moved to the south of England after the premature death of his father and Laidler began training at the London School of Architecture, but was never able to take up this profession after he was diagnosed with tuberculosis in 1932. He was, however, able to put his draughtsmanship to good use.

Under the pseudonym of Pont (short for *Pontifex Maximus*, the high priest in Ancient Rome), he became a cartoonist for *Punch* magazine where his keen eye was put to use in observing the foibles of his fellow countrymen. His best work was as gentle as it was subtle.

Pont was a master of understatement. In 'Seeing spies', above, he seems to suggest that, when you come to think about it, anyone could be a spy. Or, opposite above, he shows a family gathering on top of their Anderson shelter in order to get a better view of a bombing raid. Perhaps the most famous Pont drawing is the pub, opposite below, where life carries on regardless, despite the imminent possibility of invasion by the Nazis.

Pont died of poliomyelitis at the age of 32 in 1940 when Britain was undergoing nightly bombardment at the hands of the Luftwaffe and the Nazi High Command were training their sights across the Channel. Pont is commemorated by the Pont Award for cartoonists who reflect 'the British Character'.

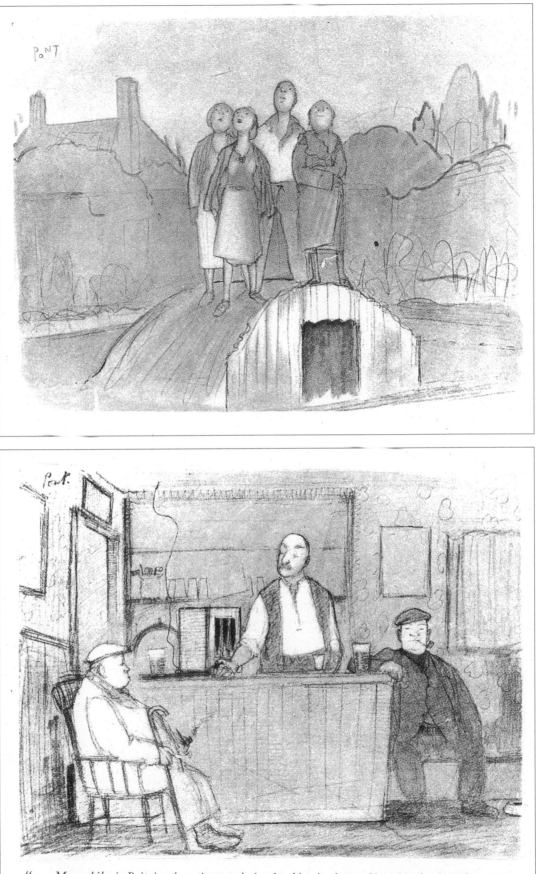

" . . . Meanwhile, in Britain, the entire population faced by the threat of invasion, has been flung into a state of complete panic . . . etc., etc., etc."

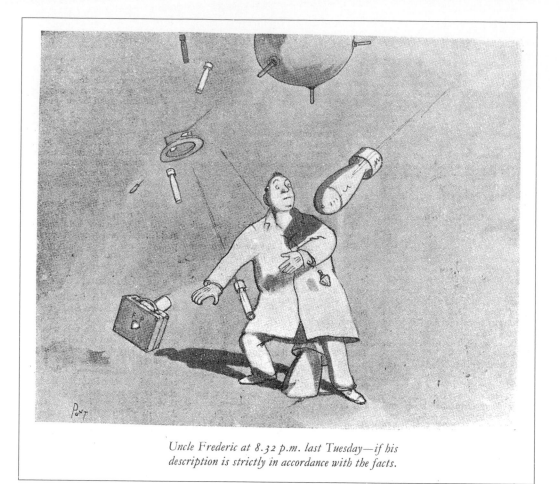

Uncle Frederic at 8.32 p.m. last Tuesday—if his description is strictly in accordance with the facts.

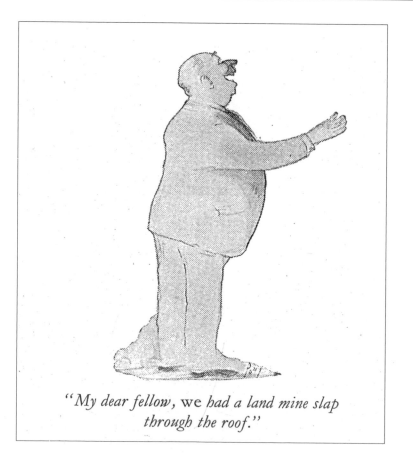

"My dear fellow, we had a land mine slap through the roof."

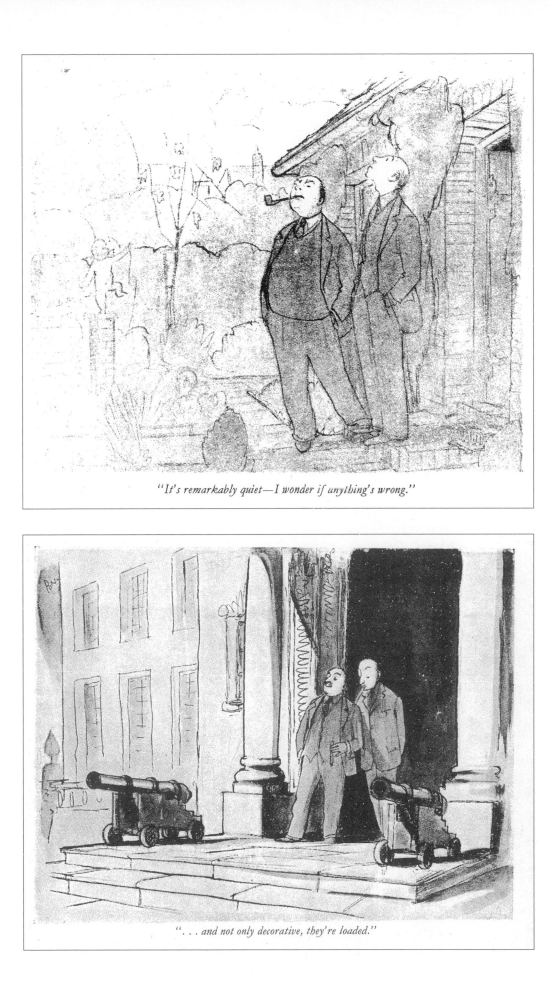

"It's remarkably quiet—I wonder if anything's wrong."

"...and not only decorative, they're loaded."

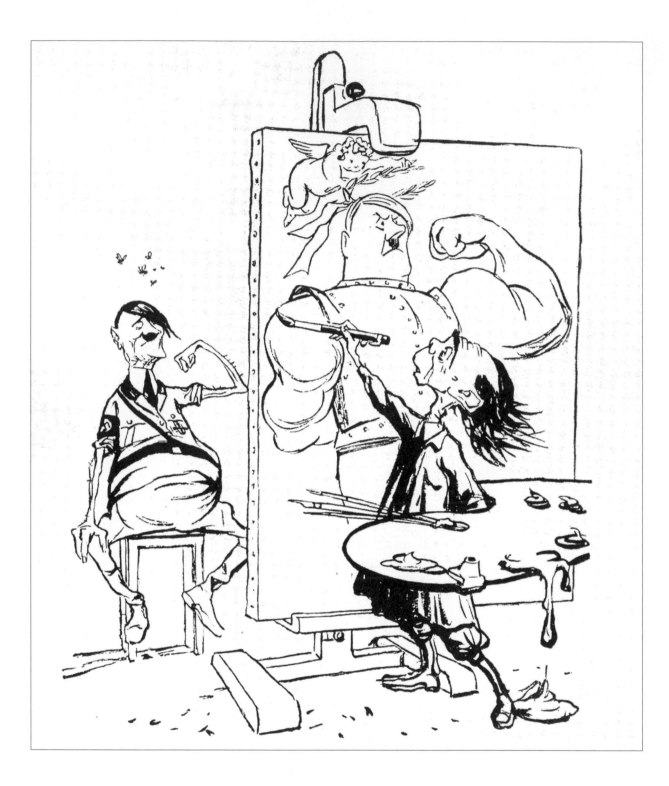

'Teutonic Warrior Knight'
perfectly captures the genius of
Josef Goebbels in the dark arts
of propaganda – as well as similar
attributes in artist David Low

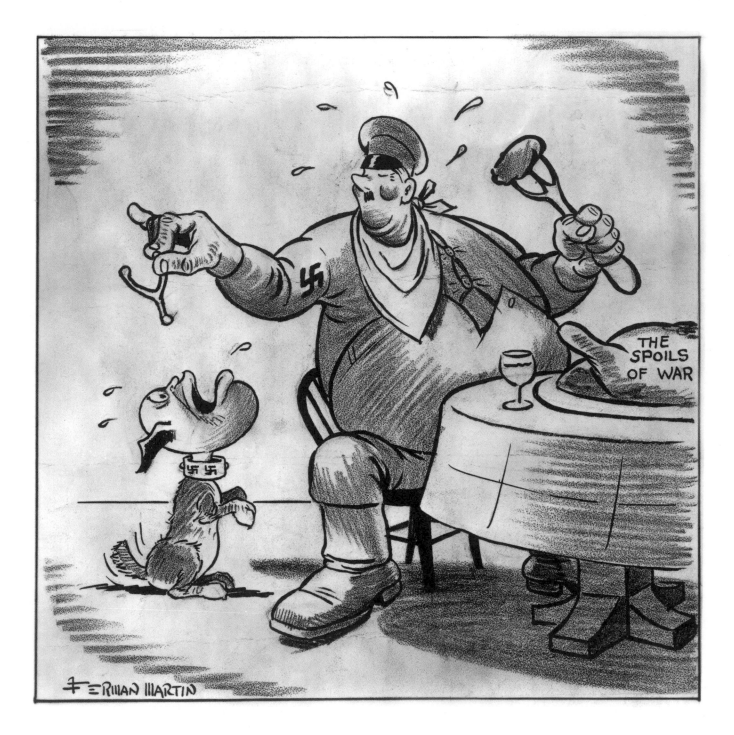

'Dinner for Two': Mussolini begs for scraps
at Hitler's table and is given the wishbone
as consolation – by Ferman Martin of
the *Houston Chronicle*. When France
surrendered to Germany and Italy in June
1940, Hitler took two entire provinces from
France for Germany, but gave Italy only a
few pockets of land in the Alps

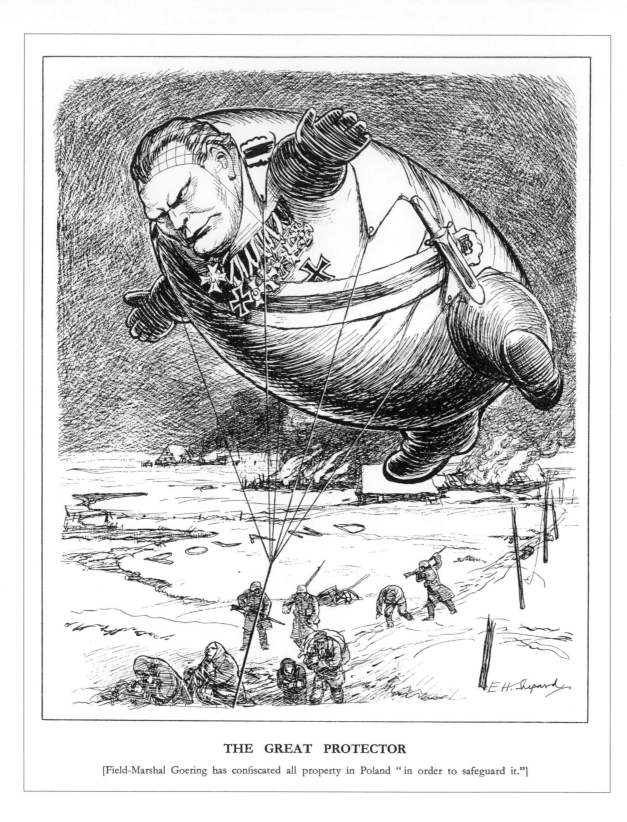

THE GREAT PROTECTOR

[Field-Marshal Goering has confiscated all property in Poland "in order to safeguard it."]

E.H. Shepard pictured Goering
as a barrage balloon, bloated with
what he had consumed, hovering
menacingly above the war-torn
landscape of Poland

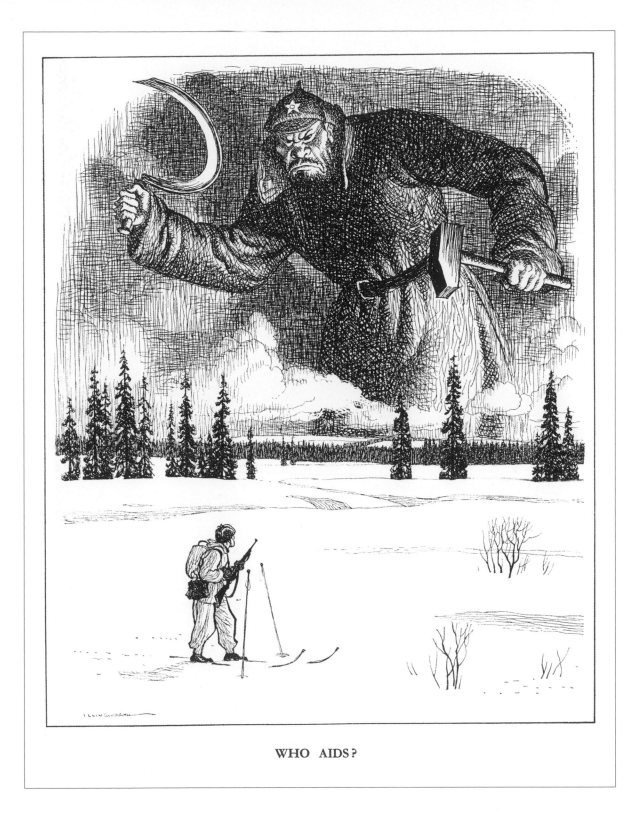

WHO AIDS?

Little Finland prepares to protect itself as the
spectre of the Soviet Union, armed with hammer
and sickle, looms over its border

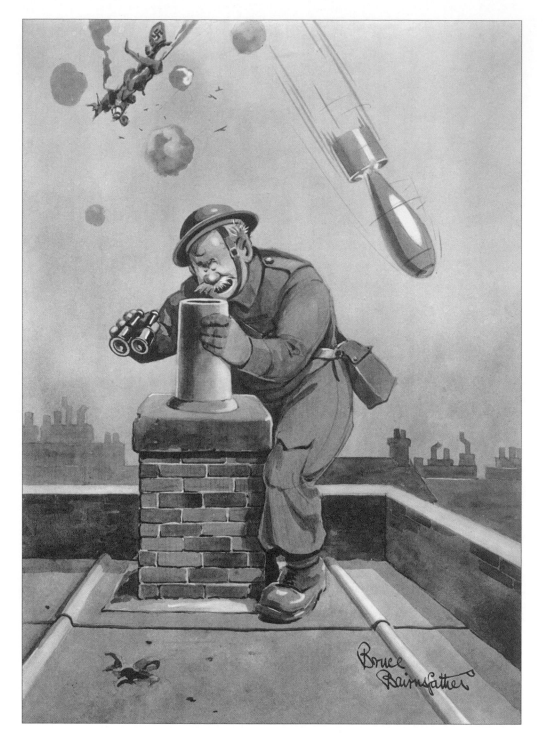

'Old Bill and Co': at the height of
a German air-raid, the British ARP warden
is shouting down the chimney, 'I said,
I reckon it's time you went to the shelter.'
British artist Bruce Bairnsfather was
hospitalized with shell shock after the
Battle of Ypres in World War I and served
as official cartoonist to the US Army in
Europe during World War II

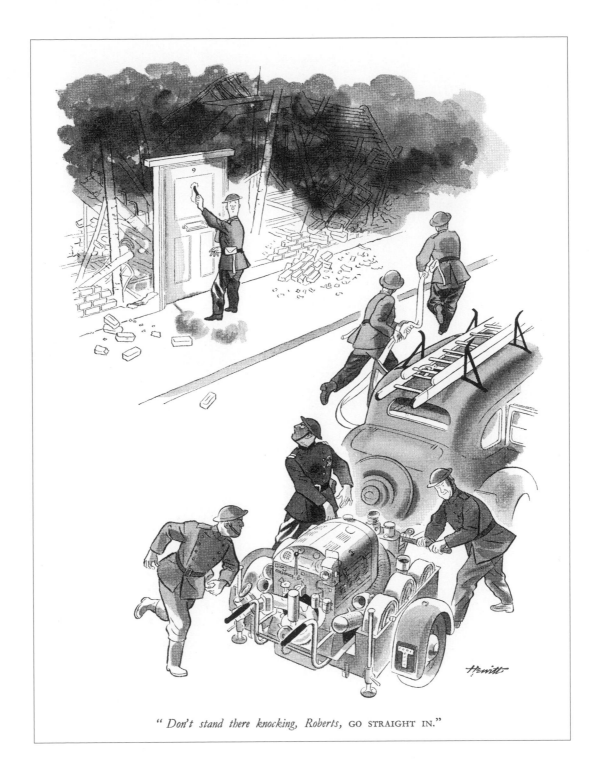

" Don't stand there knocking, Roberts, GO STRAIGHT IN."

In 1940, Britain was taking
a battering from the Luftwaffe;
this cartoon by Hewitt shows
a forgetful British fire warden
observing the usual proprieties in a
situation where they are no longer
remotely useful

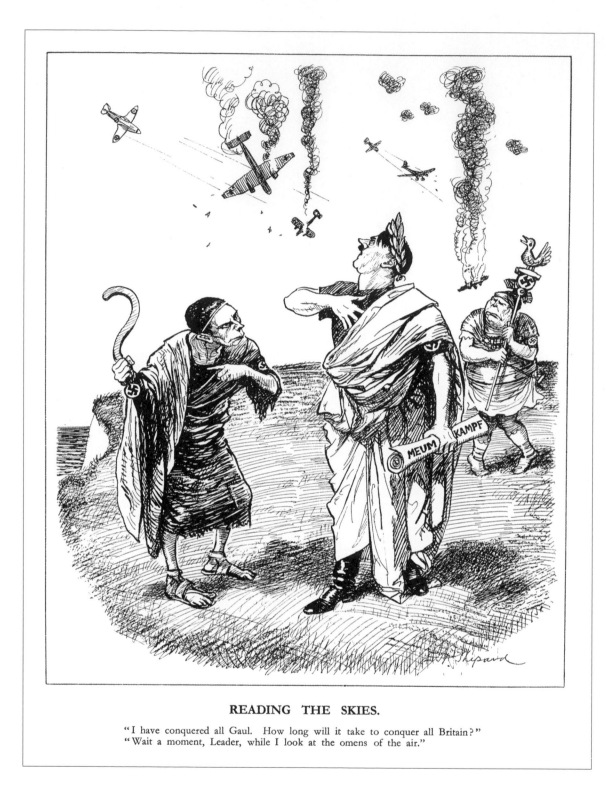

READING THE SKIES.

"I have conquered all Gaul. How long will it take to conquer all Britain?"
"Wait a moment, Leader, while I look at the omens of the air."

E.H. Shepard cast Hitler as a
Roman emperor to Goebbels'
fawning seer as the Battle
of Britain raged overhead,
complete with a schoolboy
joke in bad Latin

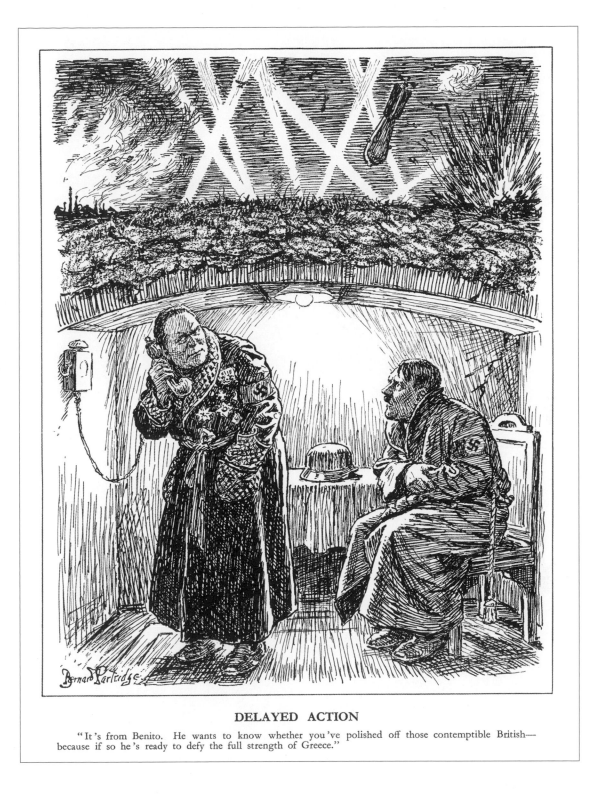

DELAYED ACTION

"It's from Benito. He wants to know whether you've polished off those contemptible British—because if so he's ready to defy the full strength of Greece."

Divide and rule: Bernard Partridge sought to tickle up discord within the ranks of the Axis powers by pointing out the feeble contribution of the Italian armed forces

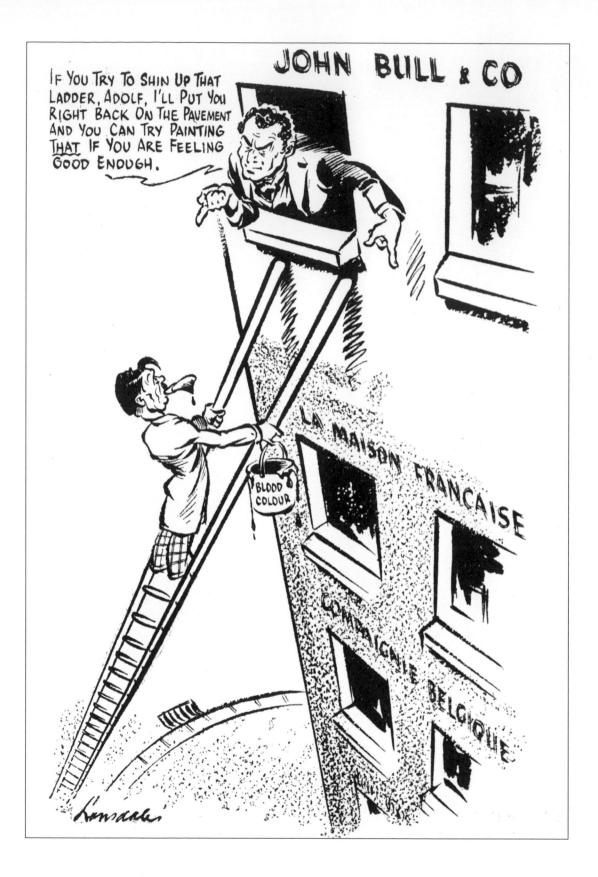

Hitler was supposed to have worked as a house painter in Munich
and this idea provided inspiration for a number of wartime
cartoonists, including Neil Lonsdale in the *New Zealand Observer*

I first heard old Mrs. Todd at the post office telling somebody—

then Mr. Brewis told me himself;

Miss Greer came out with the same story—

and I thought little Miss Hopstead was going to take a fit when she told me.

Doctor Gregory had a completely different version of the same thing—

and as for Admiral Stoker . . .

Col. Chargem and his friend could talk of nothing else—

Young Whatshisname was full of it—

so were the people in the bank.

The Vicar was booming about it all over the place—

and Mrs. Trent had, as usual, got the whole thing mixed up.

Vera Prestwood said her father had gone to bed immediately when he heard it—

But old Clogwheels said he had expected worse.

Frank ran right across the road to tell me—

and even the people at the Wilsons' wanted to know what I thought.

But I am not going to tell YOU what it was, because I never repeat rumours.

The Saturday morning rumour.

Rumours spread like wildfire during wartime. Pont liked the idea of showing how a rumour spread, but preferred to tease the reader as to what that rumour might have been

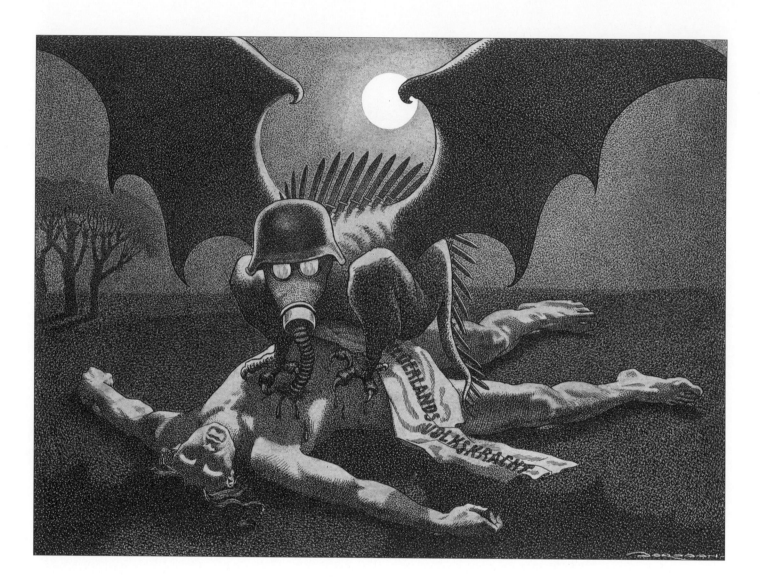

A German vampire
feasts on the blood
of the Dutch in
this stunning
image by Leendert
Jurriaan Jordaan

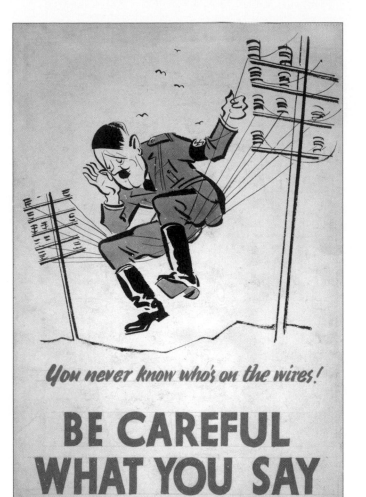

British poster warning people to watch what they said 'on the blower' as the telephone was then known

'With the Greatest of Ease?' by Vaughn Shoemaker in the *Chicago Daily News* – taking the words from a popular song of the time, Shoemaker noted Hitler's unhindered progress through northern Europe, implying that the Balkans were next and that the world had better do something about it

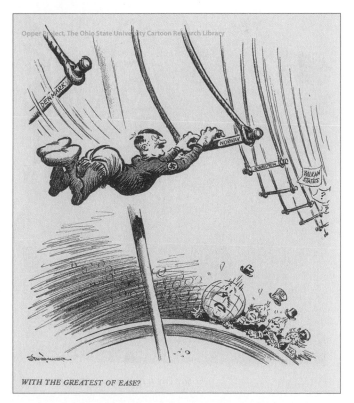

WITH THE GREATEST OF EASE?

1941

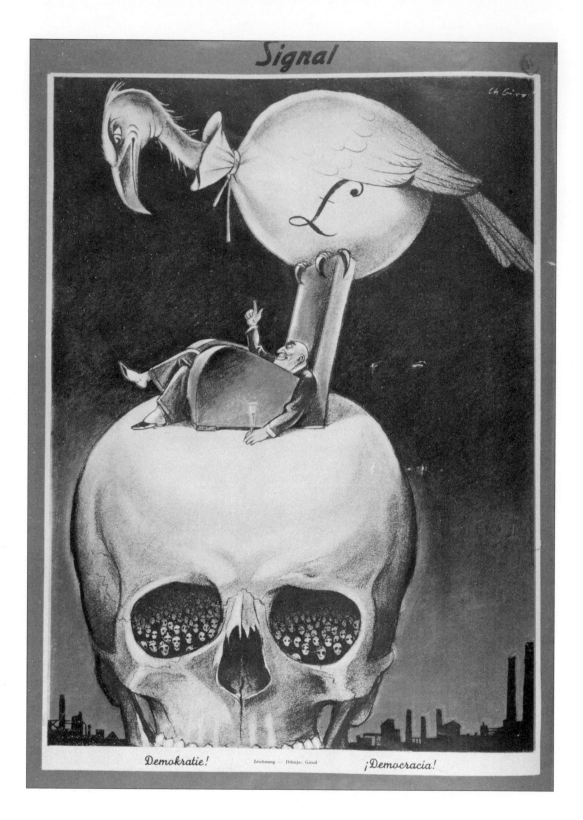

Signal was a glossy propaganda magazine produced by the Wehrmacht for distribution throughout occupied Europe. At its height, the circulation was a heady 2.5 million in around 30 languages. This image is entitled 'Democracy!'

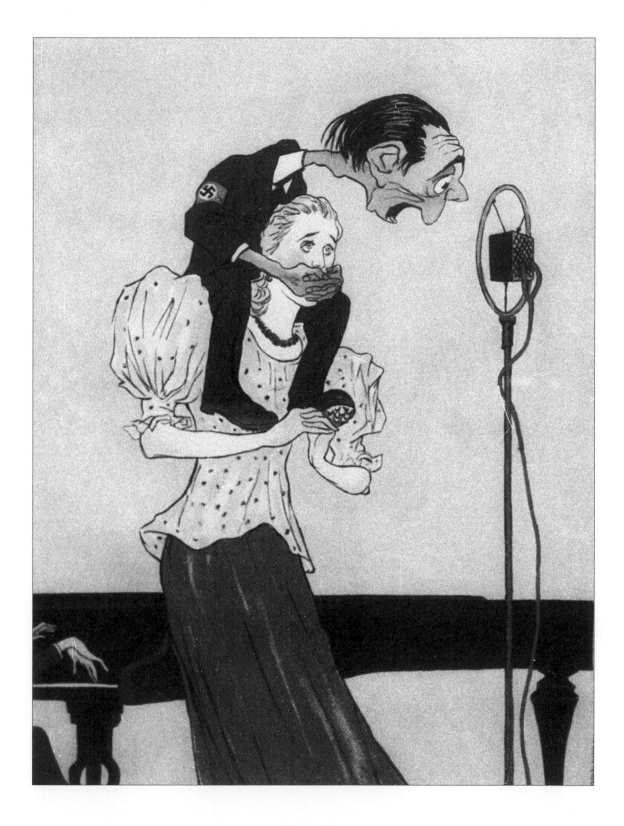

'Instead of Soprano': Josef Goebbels was rumoured to have had an affair with soprano Elisabeth Schwarzkopf and there's no doubt he was intent on turning culture into a propaganda tool of the Nazi state. None of this escaped the vigilance of the Kukryniksy group of cartoonists in Russia

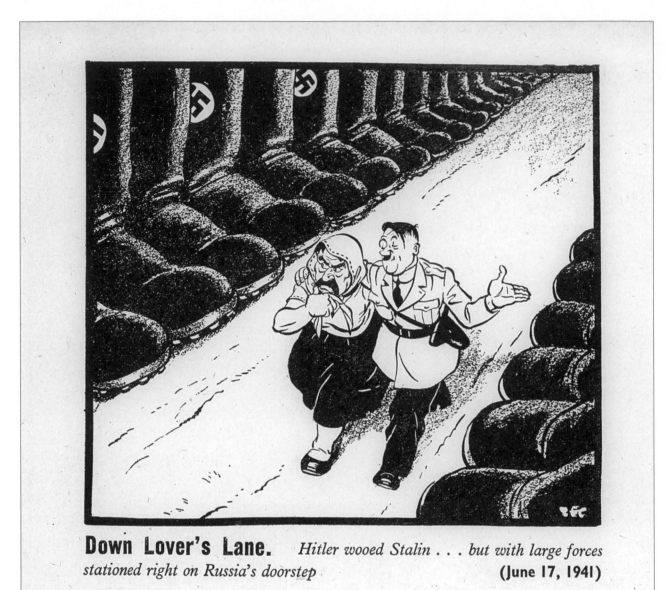

Down Lover's Lane. *Hitler wooed Stalin . . . but with large forces stationed right on Russia's doorstep* **(June 17, 1941)**

On 22 June 1941, under the codename 'Operation Barbarossa', Germany invaded Russia – Hitler had always regarded the pact between Germany and Russia as short term and just about everyone could see the break-up coming from a mile off, including Philip Zec in the *Daily Mirror*

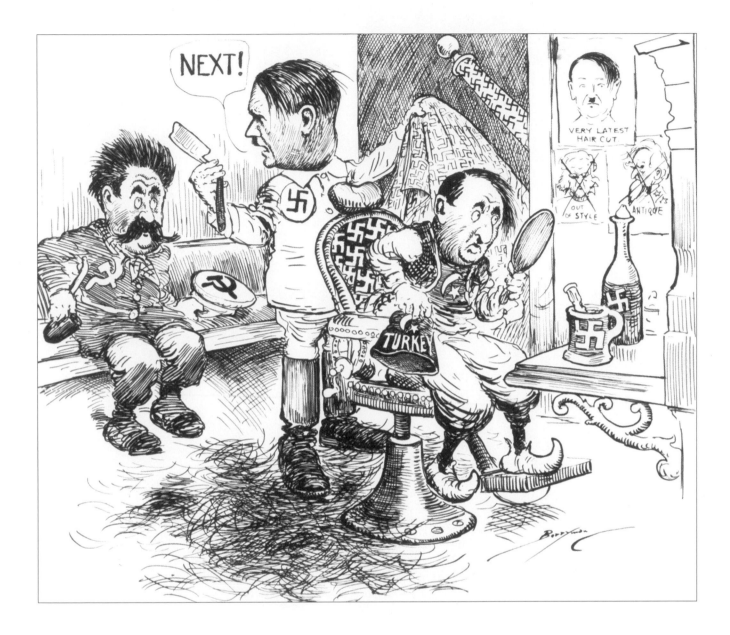

'Hitler's Barbershop': the Führer only cuts hair one way – by legendary US cartoonist Clifford Berryman

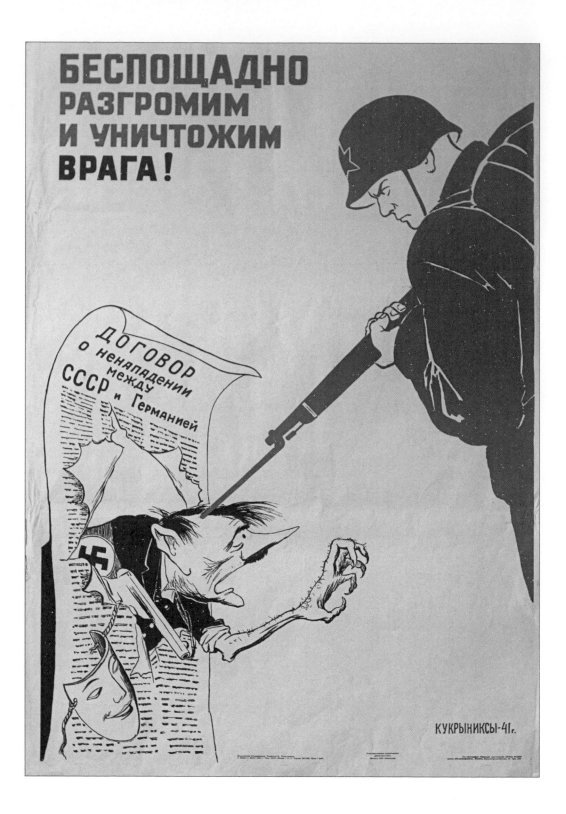

'Let's Destroy the Enemy Mercilessly!': Kukryniksy liked to
go straight for the jugular in the 74 posters they produced for
Moscow's TASS studio during the 'Great Patriotic War'. This
was perhaps one of their more restrained efforts

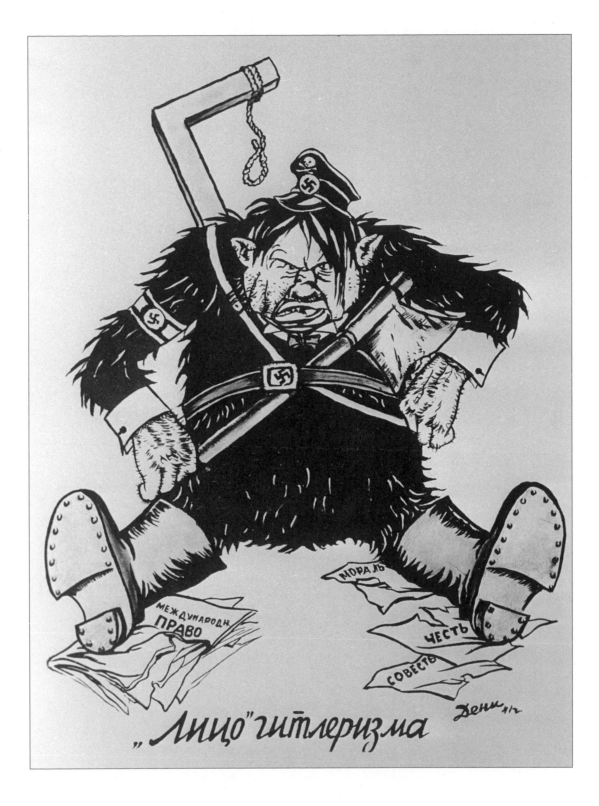

'The Face of Hitlerism' by Viktor Deni. Deni worked
for *Pravda*, the Communist Party daily, but returned
to making posters during World War II, a task he had
previously performed during the Bolshevik revolution

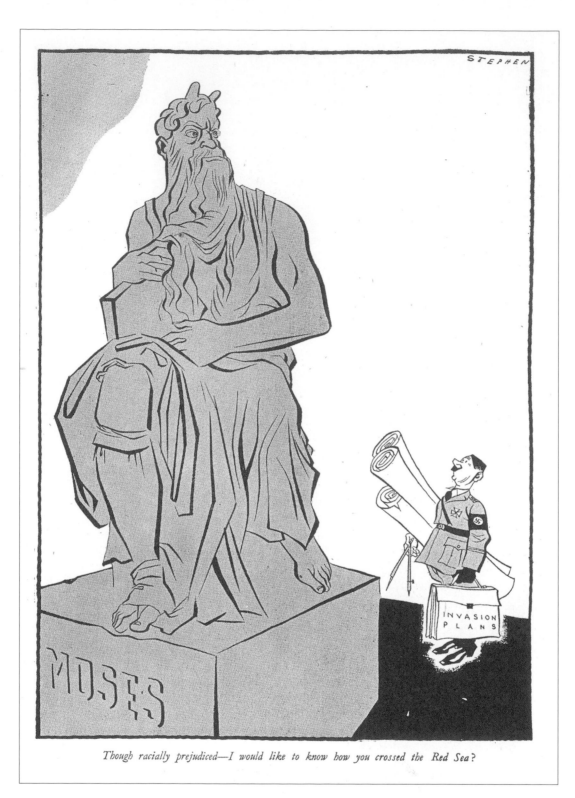

Though racially prejudiced—I would like to know how you crossed the Red Sea?

A subtle effort from Czechoslovak cartoonist
Stephen (Stephen Roth) as Britain faced invasion,
part of a book called *Jesters in Earnest* published in
wartime Britain with a preface by David Low. This
is a dig at Hitler's inability to cross the English
Channel to invade Britain

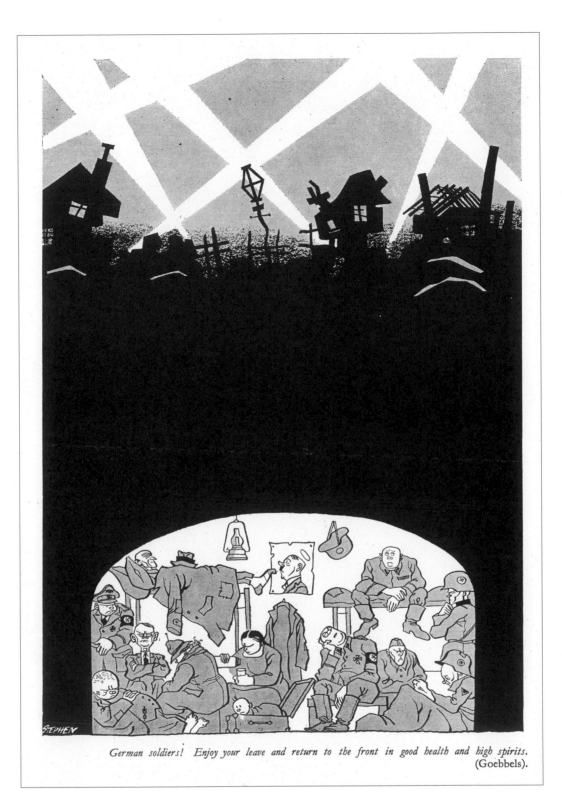

German soldiers! Enjoy your leave and return to the front in good health and high spirits.
(Goebbels).

This was Stephen's take on the realities facing
Germany despite the encouraging words to
the troops from Josef Goebbels. The image
contains some rewarding details

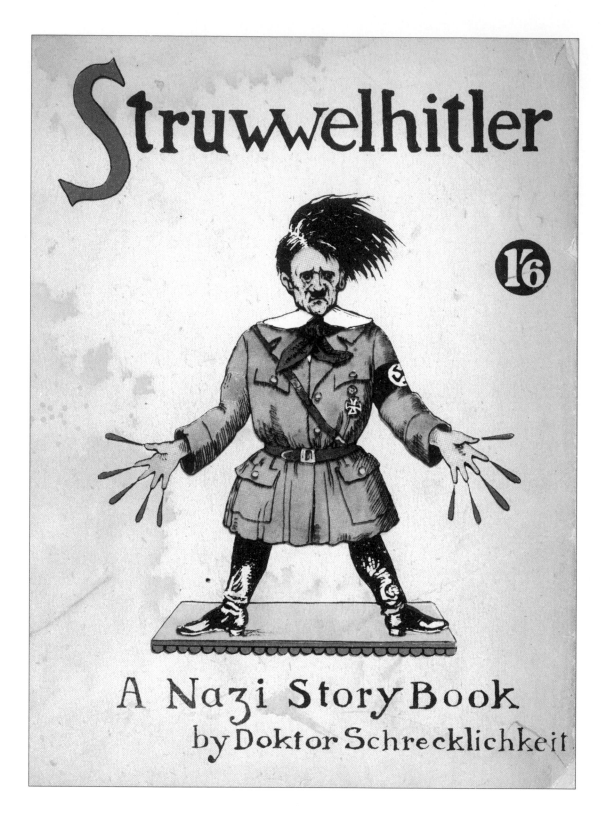

'Struwwelhitler': the front cover of a book written in parody
of *Struwwelpeter*, a collection of cautionary stories for children
compiled with a cruel Germanic edge. Here, the inside pages
featured Mussolini, Goebbels and other favourites

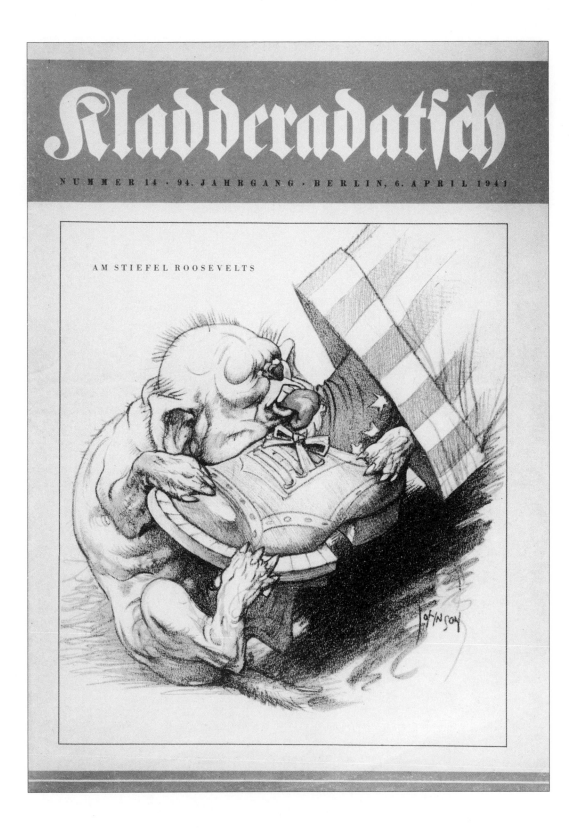

Kladderdatsch was a satirical magazine founded in 1848. When it was taken over by industrialist Hugo Stinnes in 1923 it shifted increasingly to the right. This cover by Arthur Johnson shows Churchill licking Roosevelt's boots just after the USA had entered the war – the artist's father was American but he was brought up in Germany by his mother

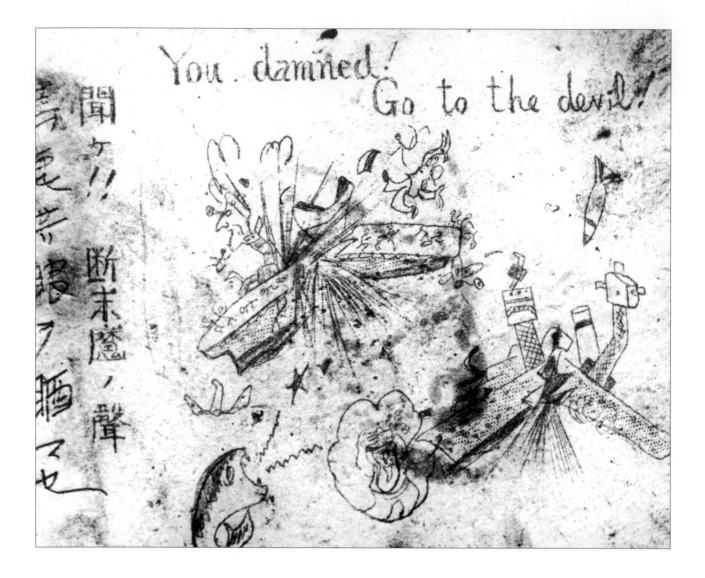

This was a leaflet dropped
by Japanese pilots over
Pearl Harbor. Crudely
phrased, it was reproduced
on duplicating machines
using rough foolscap. The
Japanese lettering says,
'Listen to the voice of
doom. Open your eyes,
blind fools'

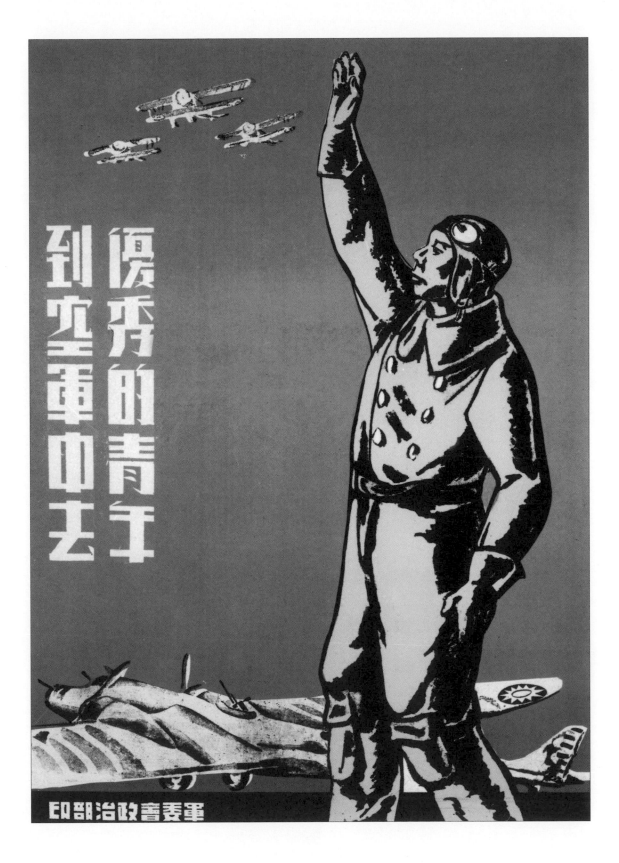

Poster inviting 'talented young men' to join the Chinese air force – part of a propaganda campaign by the occupying Japanese

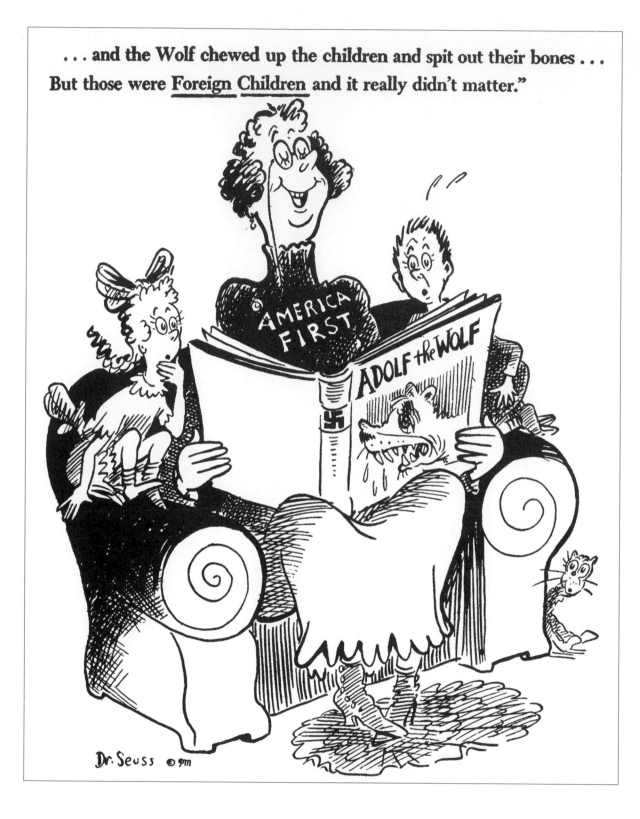

"... and the Wolf chewed up the children and spit out their bones ... But those were <u>Foreign Children</u> and it really didn't matter."

'Adolf the Wolf': Dr Seuss (Theodor Seuss Geisel) was a prolific political cartoonist during World War II; he was highly critical of American isolationism

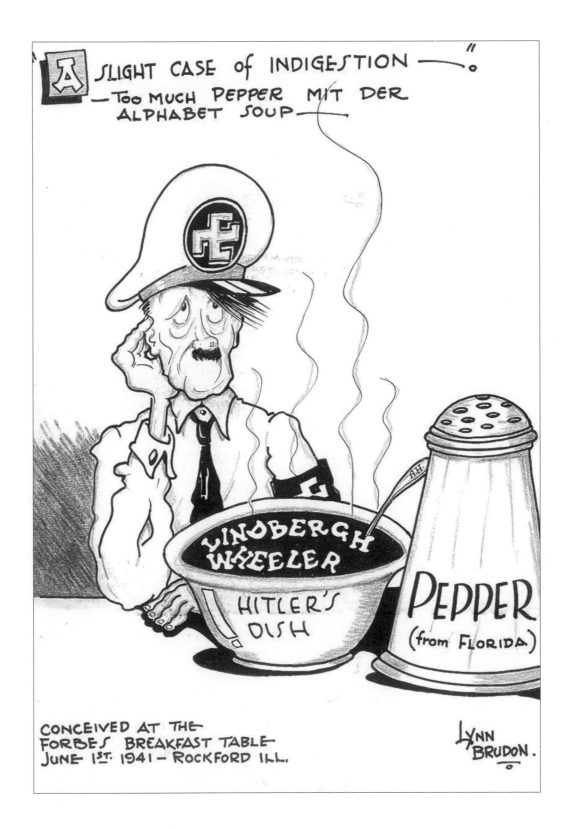

'Pepper Soup': Hitler finds his alphabet soup, with the names of Nazi sympathizers spelt out in it, has been spoiled after the speech of Florida senator Pepper in support of joining the Allied cause – by Lynn Brudon

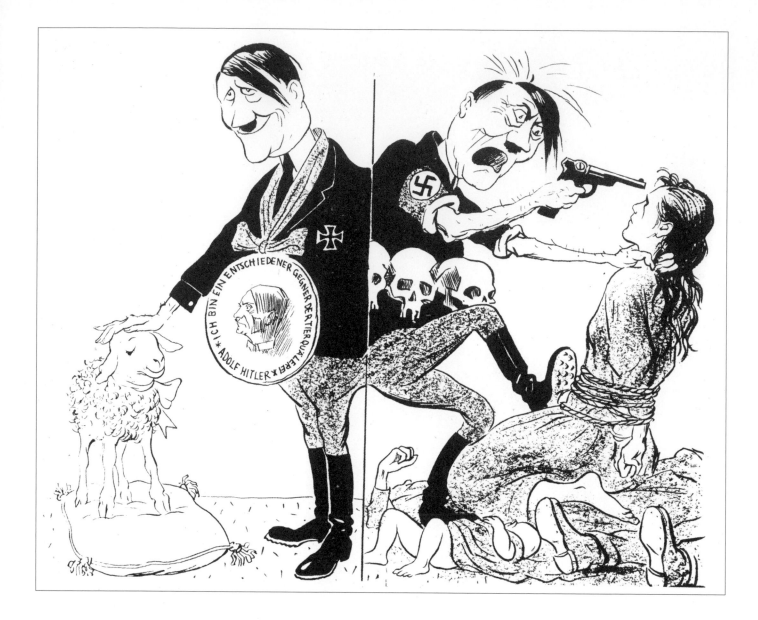

Kukryniksy

Kukryniksy was the name adopted by three Russian caricaturists, Mikhail Kuprilianov, Porfirii Krylov and Nokolai Sokolov, who met at the newly established VKHUTEMAS art school, Moscow, in the 1920s. Inspired by the atmosphere of revolutionary fervour, they adopted their collective name in 1924 and ditched the parochialism that had previously characterized their work. There was a job to be done for the USSR.

Kukryniksy learned how to apply their keen sense of the grotesque to political subjects and they became rising stars of Soviet publications such as *Krokodil* and *Pravda*. Maxim Gorky stepped forward to encourage them and their acidic portraits of Hitler, Mussolini, Franco and other fascists became increasingly merciless…

During World War II, they produced over 70 posters for the TASS studio in Moscow and, after the war, they were sent to document the Nuremberg trials by *Pravda*. Kukryniksy produced vital propaganda used to spur on the Soviet war effort and won the Stalin Prize five times, along with the Lenin Prize (1965) and the State Prize of the USSR (1975).

Above: 'Cannibal Vegetarian': another vicious skit on Hitler, contrasting his treatment of animals and human beings; opposite: the image top left is by Boris Yefimov, the others are all by Kukryniksy

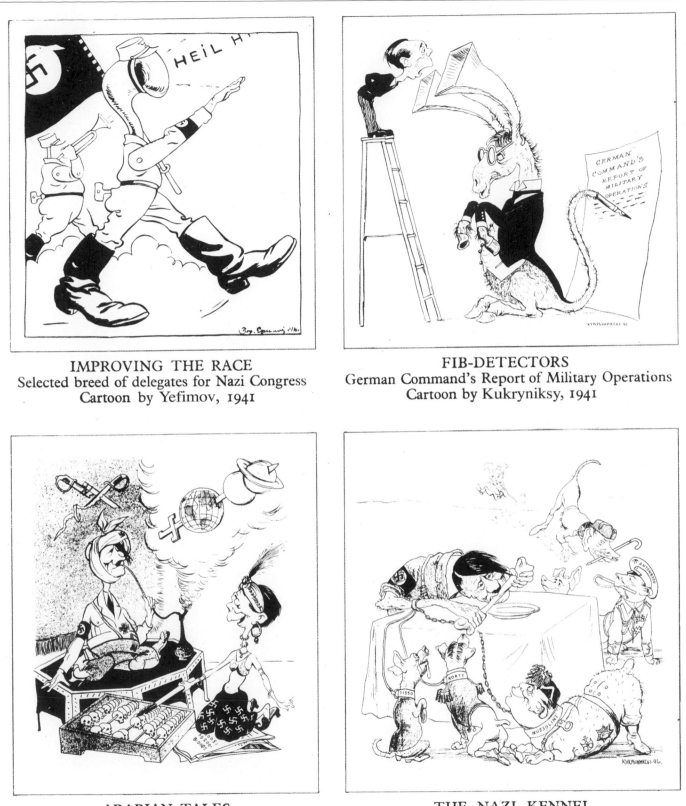

IMPROVING THE RACE
Selected breed of delegates for Nazi Congress
Cartoon by Yefimov, 1941

FIB-DETECTORS
German Command's Report of Military Operations
Cartoon by Kukryniksy, 1941

ARABIAN TALES
Cartoon by Kukryniksy, 1941

THE NAZI KENNEL
Cartoon by Kukryniksy, 1941

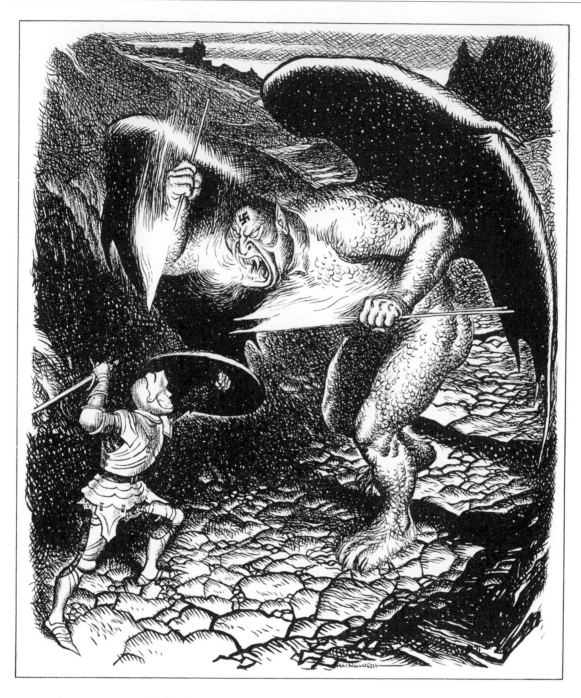

"Therefore, he resolved to venture and hold his ground."

Leslie Illingworth quoted John Bunyan's *The Pilgrim's Progress* and
neatly captured the mood in Britain, where resolve was practically
all that was available to vanquish a monstrous foe

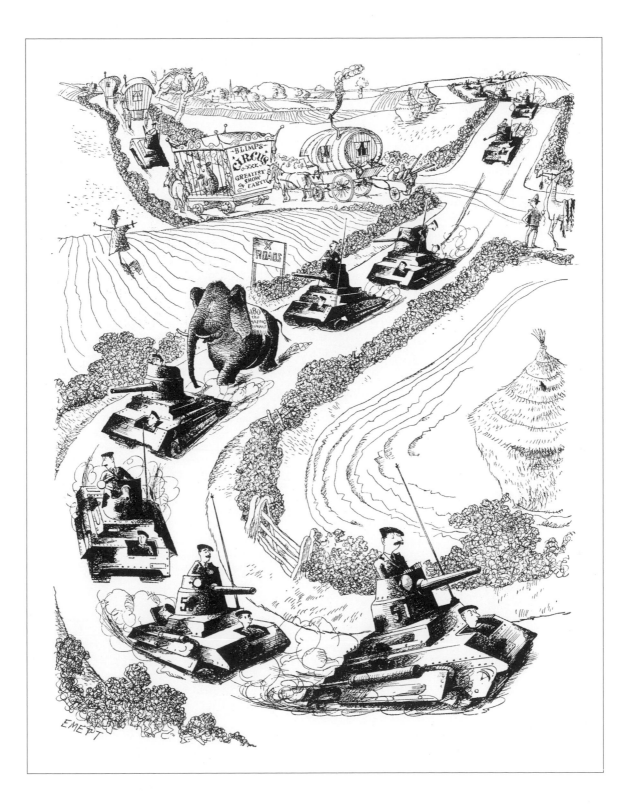

The work of artist Rowland Emett proved that, even in the direst
circumstances, the British still had time for gentle gags, as a circus
elephant gets mixed up with a convoy of tanks in the English countryside

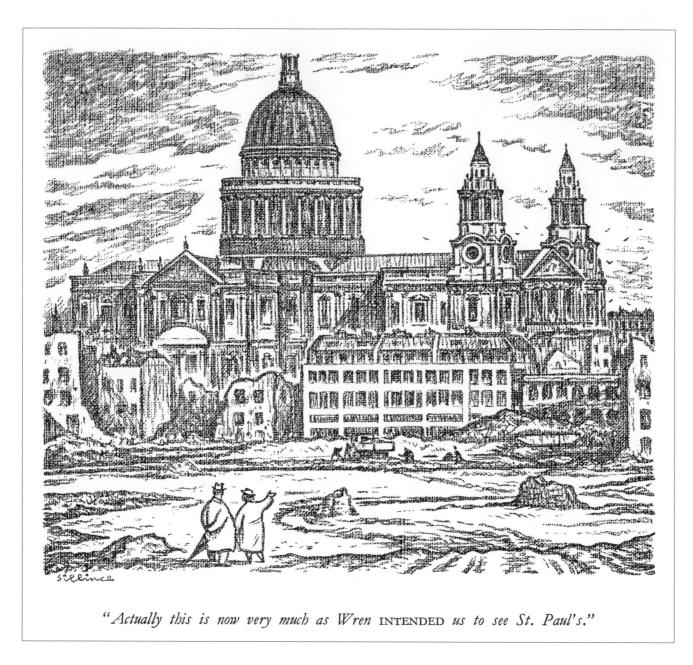

"*Actually this is now very much as Wren* INTENDED *us to see St. Paul's.*"

This cartoon by W.A. Sillince in *Punch* captured the spirit of the Blitz: forget the damage caused by German bombing, St Paul's now symbolized that the British would survive whatever was thrown at them

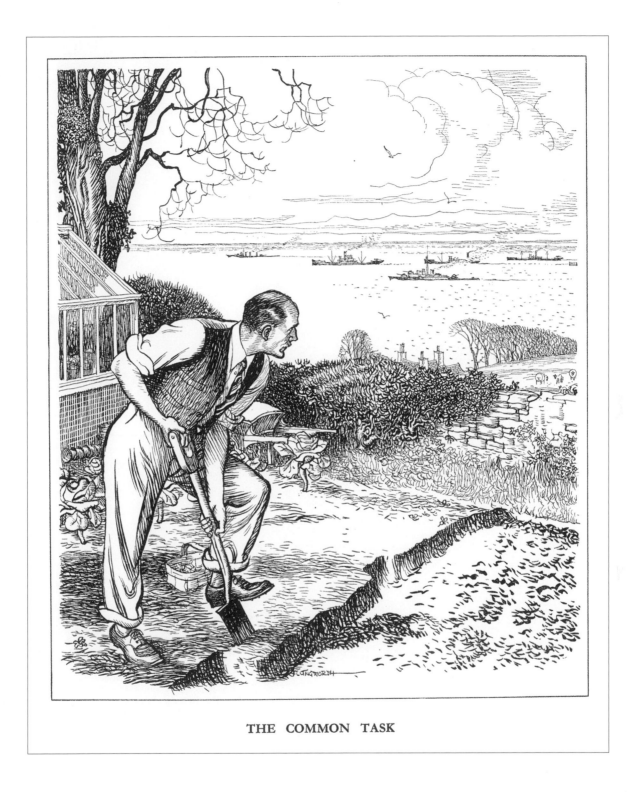

THE COMMON TASK

Also in *Punch*, Leslie Illingworth pictured an older man quietly but determinedly digging for victory as British warships steam past

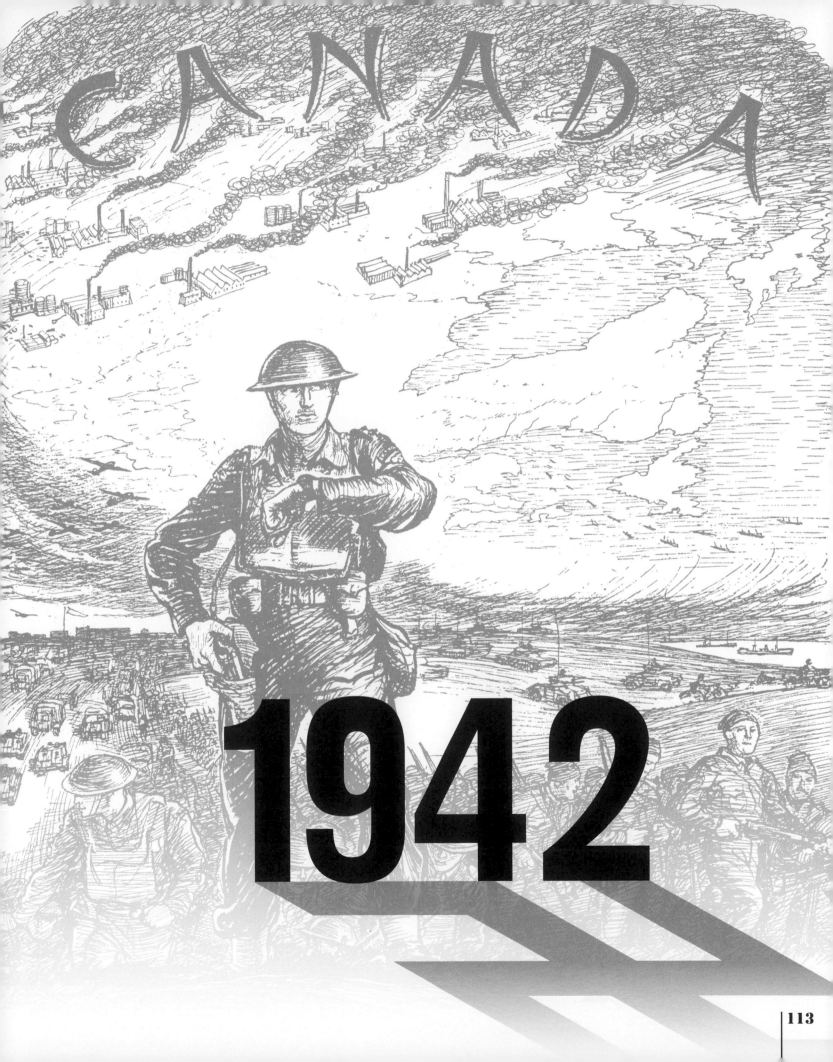

CANADA

1942

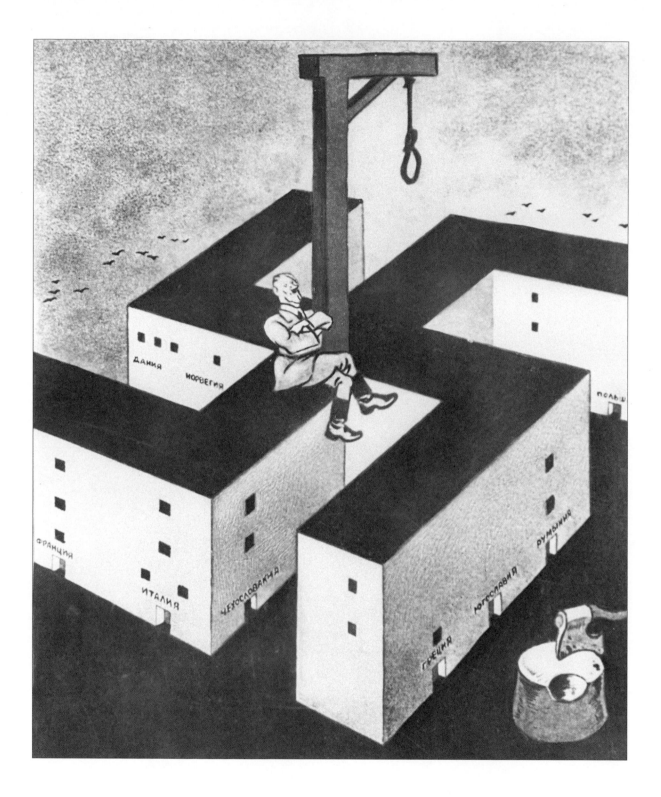

'New Order': the Nazis wished to impose a 'new order' on Europe and
this cartoon by Boris Yefimov highlights the trail of death in countries
that had been incorporated into the Third Reich: Denmark, Norway,
France, Italy, Czechoslovakia, Greece, Yugoslavia, Romania and Poland

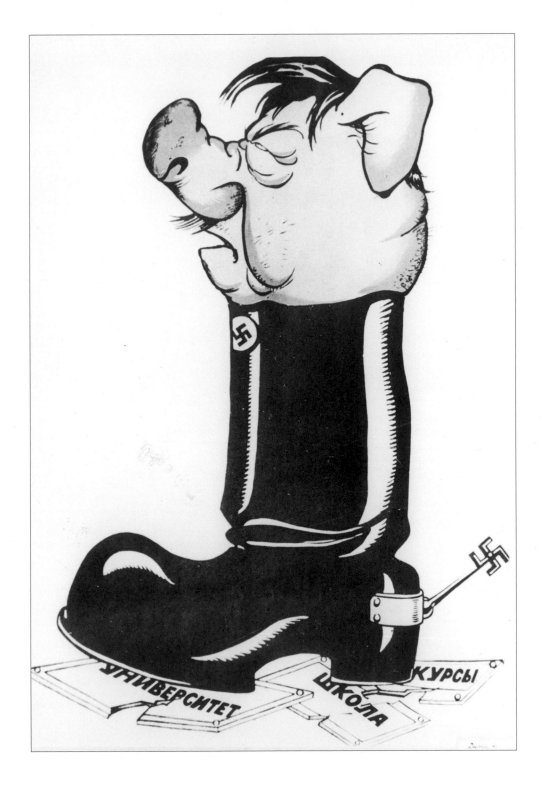

Russian poster specialist Viktor Deni derided Hitler as an ignorant pig stuffed into a jackboot: 'University, School, Courses… What use has a pig for culture and science? Its horizon is extremely narrow. *Mein Kampf* is its highest achievement…'

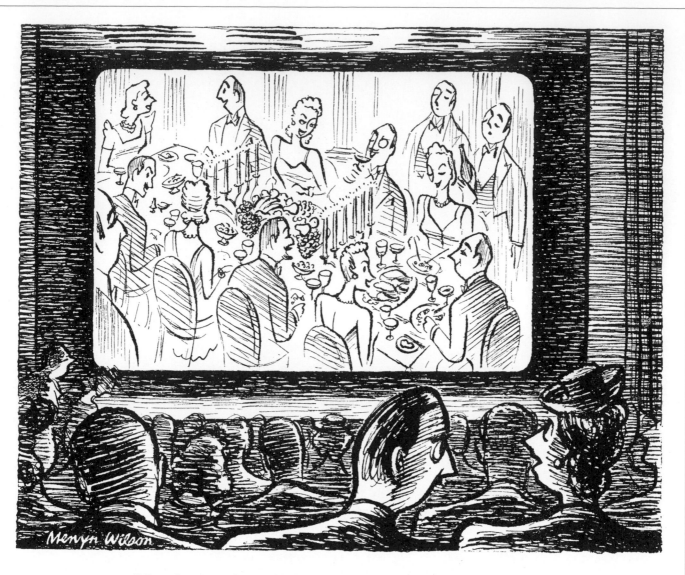

"By the way, I managed to get some corned beef for dinner."

Above: Mervyn Wilson's comment on wartime shortages from *Punch*; opposite above, 'Flagday for the Eastern Front' by Stephen, a satirical view of how the war was going on the home front in Germany; below: 'We're fighting for culture, Jimmy', a racist Nazi leaflet mocking black US troops. (The response – 'But what is culture?' – is missing on this version of the cartoon, as is the title, 'Liberators')

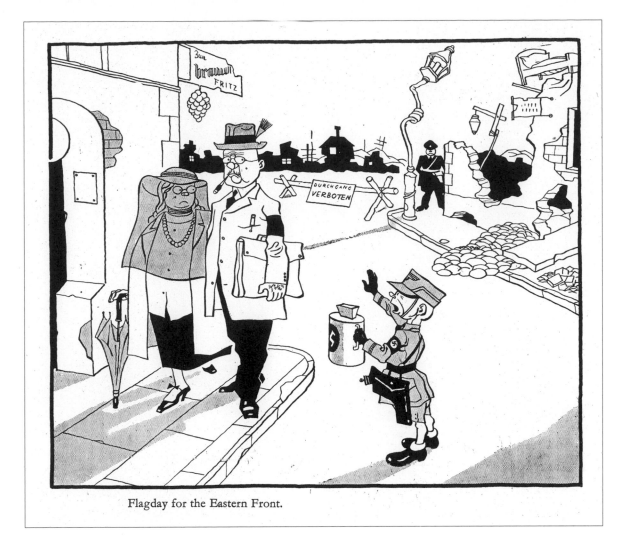

Flagday for the Eastern Front.

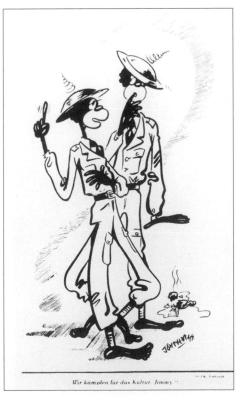

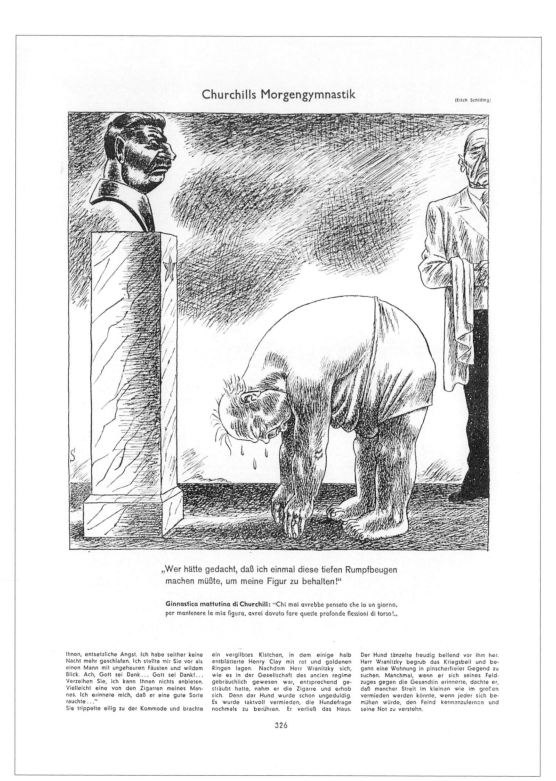

'Churchill's Morning Exercises – Who'd have thought that I'd have to keep bending over like this to keep my figure!' – drawn by Erich Schilling for *Simplicissimus*

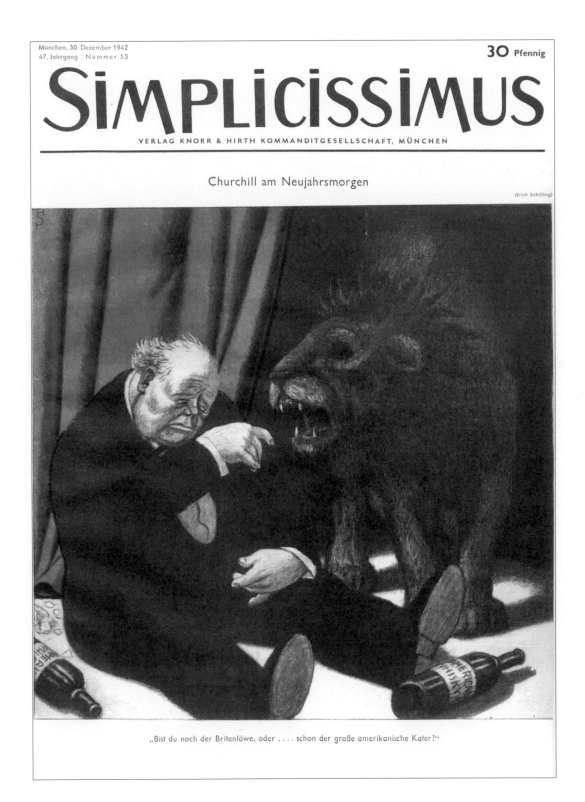

München, 30. Dezember 1942
47. Jahrgang / Nummer 53

30 Pfennig

SIMPLICISSIMUS

VERLAG KNORR & HIRTH KOMMANDITGESELLSCHAFT, MÜNCHEN

Churchill am Neujahrsmorgen

(Erich Schilling)

„Bist du noch der Britenlöwe, oder schon der große amerikanische Kater?"

'Churchill on New Year's Day – Are you the British lion… or the big American tom-cat?' (*Kater* also means a hangover in German.) Schilling loved his New Year's messages to Churchill, but by winning the war Churchill had the last word. The artist killed himself in 1945

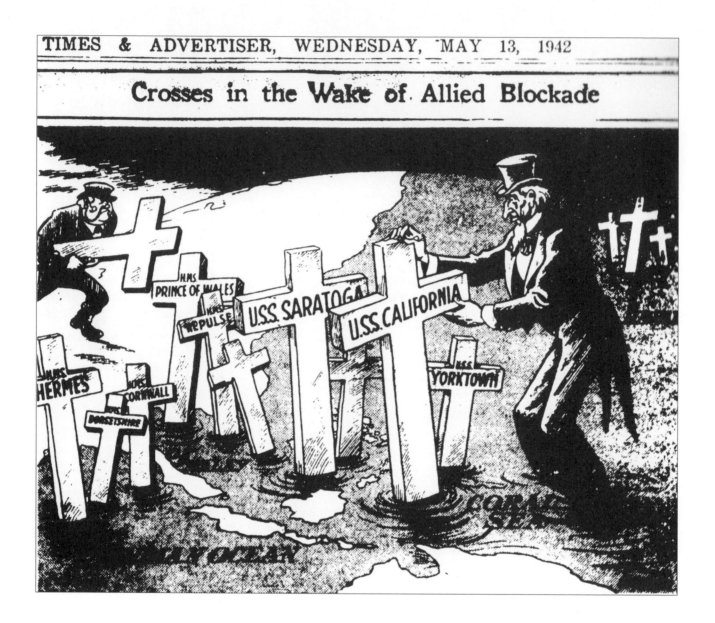

TIMES & ADVERTISER, WEDNESDAY, MAY 13, 1942

Crosses in the Wake of Allied Blockade

Propaganda image from the Japanese English-language newspaper *Japan Times & Advertiser*, which shows Uncle Sam and Winston Churchill busy erecting gravestones to ships which the Japanese claimed, often erroneously, their forces had sunk

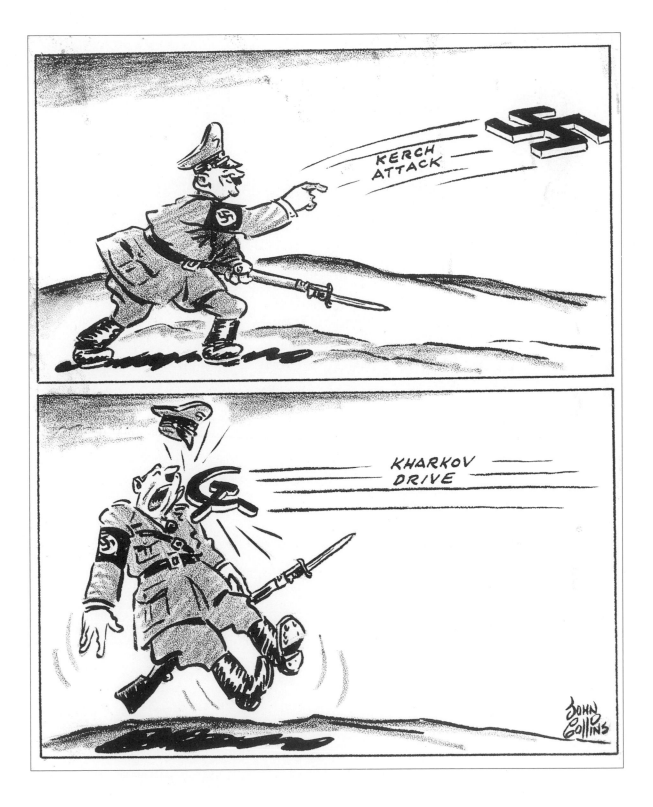

'The Boomerang': Hitler discovers his attack on Kerch has not
quite worked out the way he anticipated – by Canadian cartoonist
John Collins

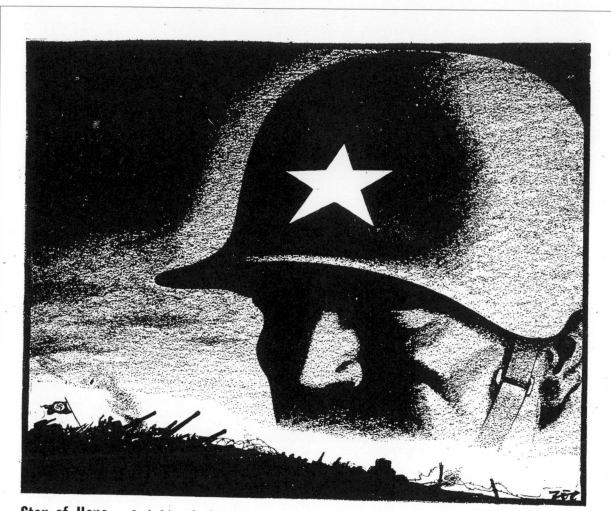

Star of Hope. *Locked in a death-grapple round Kharkov and the Crimea, the Red Army was still the hope of the free world, now arming itself with all speed.*

(May 19, 1942)

It might be hard to imagine now, but the Red Army briefly became a beacon of hope for the West, as shown in Philip Zec's *Daily Mirror* offering

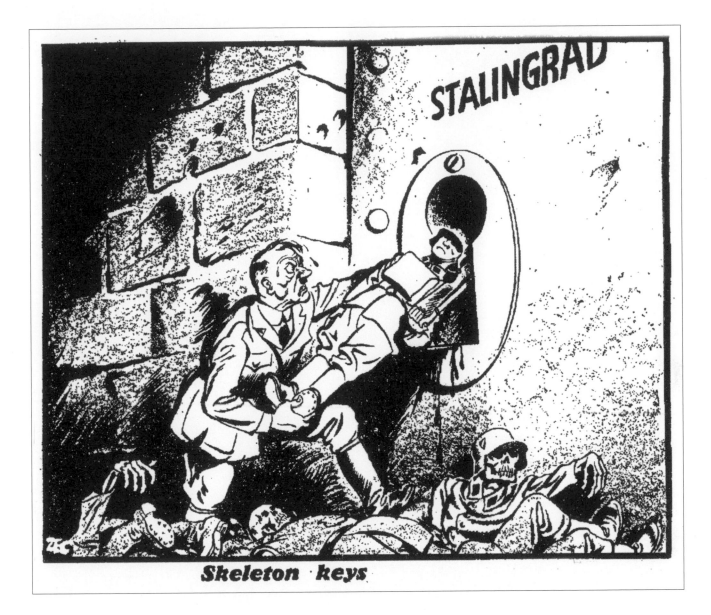

Skeleton keys

Despite the sacrifice of hundreds of thousands of troops, Hitler still couldn't find the key to taking Stalingrad. This is how Zec saw the turning point in the war

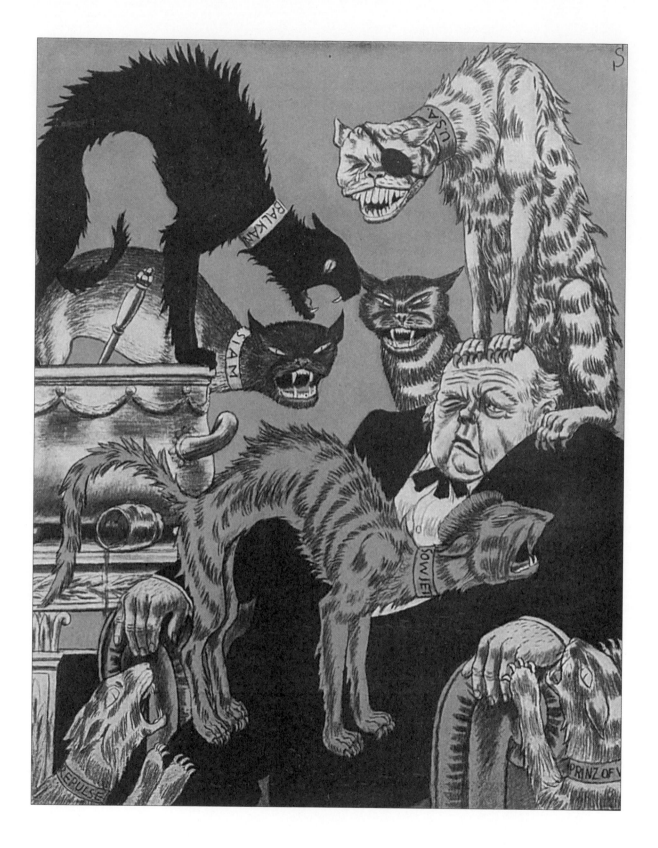

'Churchill's New Year's Day Hangover' (*Katzenjammer* means 'the wailing of cats' and 'hangover' in German): rancid drunken alleycats crawl all over Winston Churchill who is in a terrible state after consuming his home-made punch made from lies and illusions (passing reference is also made on cats' collars to the recent loss of HMS *Repulse* and the *Prince of Wales*, sunk by Japanese aircraft in the Far East)

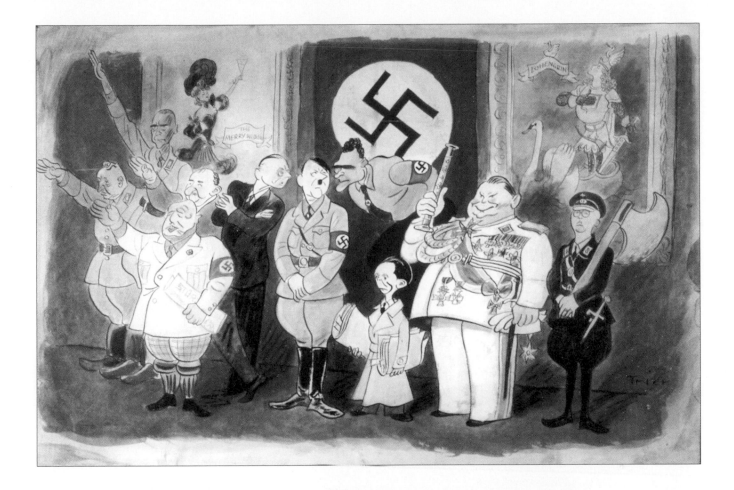

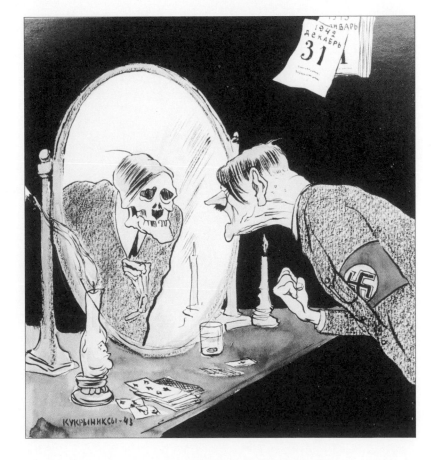

Above: group portrait of the leaders of the Axis powers drawn by the talented Walter Trier, a German-speaking Jew from Prague who produced leaflets for the Ministry of Information after fleeing Germany in 1936. Later, he emigrated to Canada; right: 'Hitler at Stalingrad' – Kukryniksy imagine Hitler's face in the mirror after defeat in the 'city of steel'

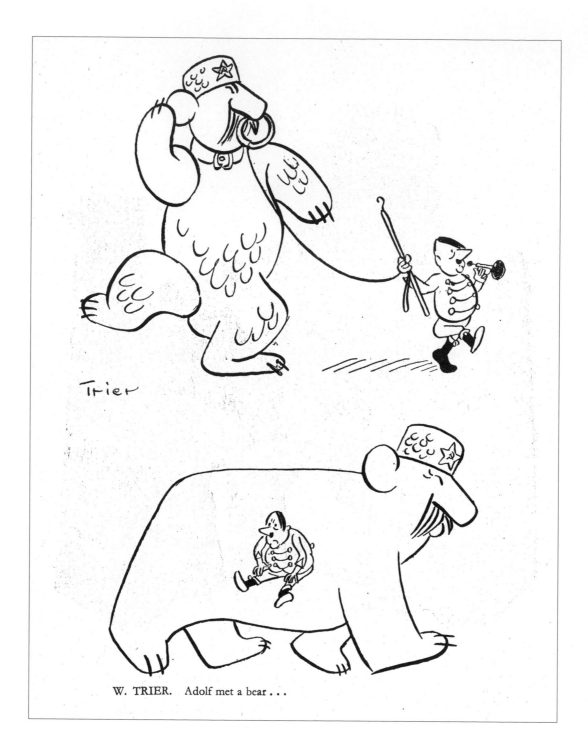

W. TRIER. Adolf met a bear . . .

Walter Trier neatly
encapsulated the story of
what happened when Adolf
met Josef

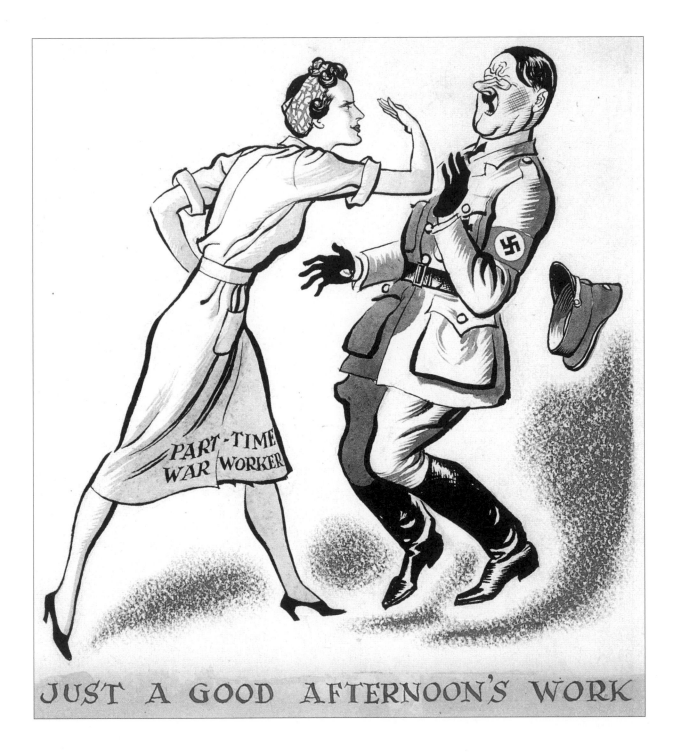

JUST A GOOD AFTERNOON'S WORK

Suddenly, it seemed, everybody was lining up to take
a swing at Hitler. This British poster for part-time war
workers drew on the new mood of optimism

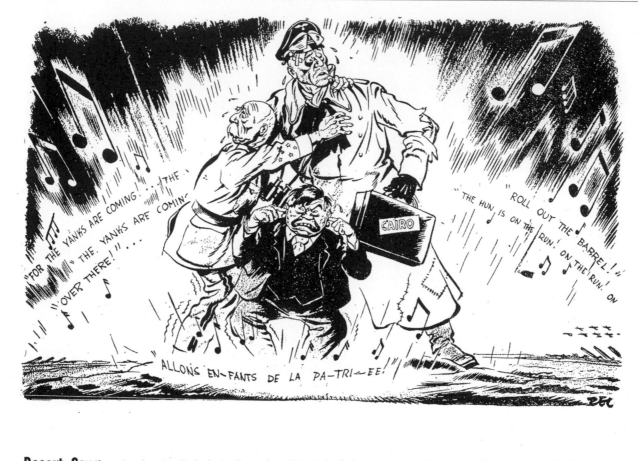

Desert Song. *It was the End of the Beginning. British and American troops landed in Algeria, and, with Montgomery's Eighth Army, began to squeeze the Axis out of the Mediterranean.*
(November 9, 1942)

After the Torch Landings in November 1942 which saw American troops disembarking on the Vichy French shores of North Africa, Axis hopes in the region were clearly doomed. Here Philip Zec portrays the despair of German Field Marshal Erwin Rommel, and French politicians Philippe Petain (with moustache) and Pierrre Laval (in dark suit)

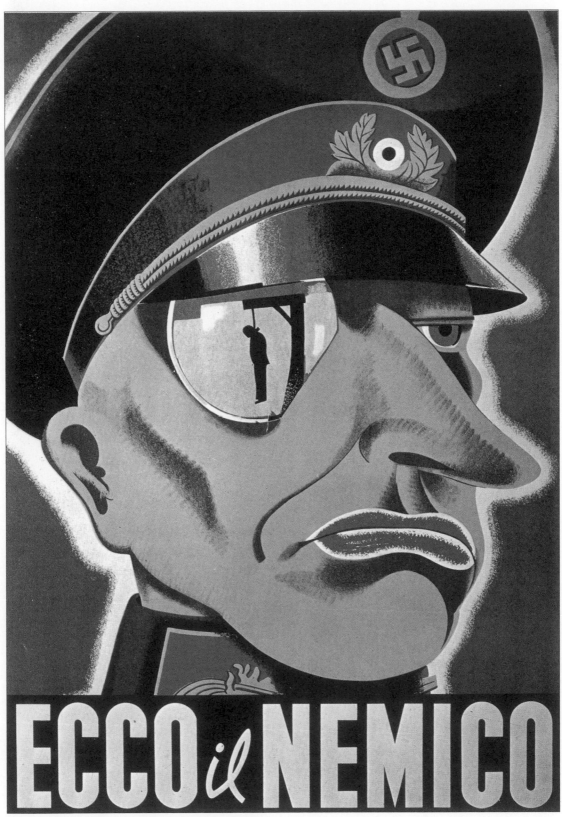

'This is the Enemy': a classic US poster that
was translated into many languages, including
Italian (as seen here) – it was painted by Karl
Koehler and Victor Ancona

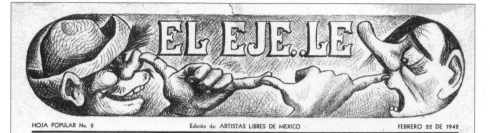

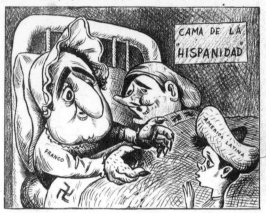

Above: an anti-fascist broadside from the Mexican magazine, *El Eje. .Le*, with a cover which cocks a snook at Hitler, then shows Franco in bed with Hitler and, below that, the couple are canoodling over a copy of *Mein Kampf*

Right: US poster by Sherman Cooke

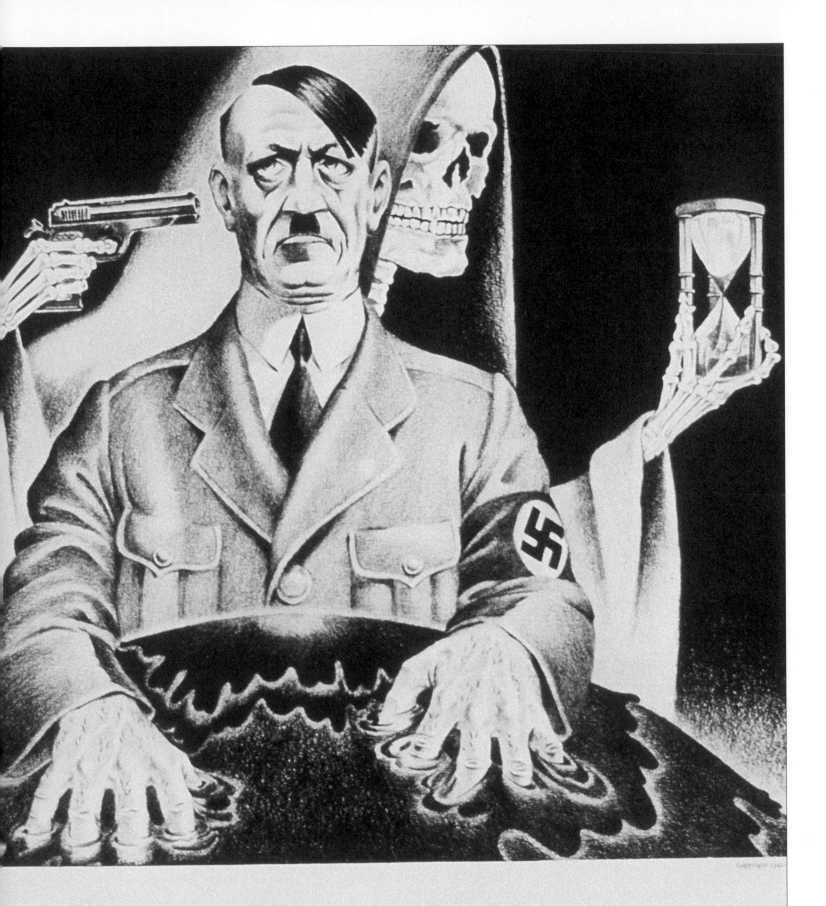

Time is Short, Adolph!

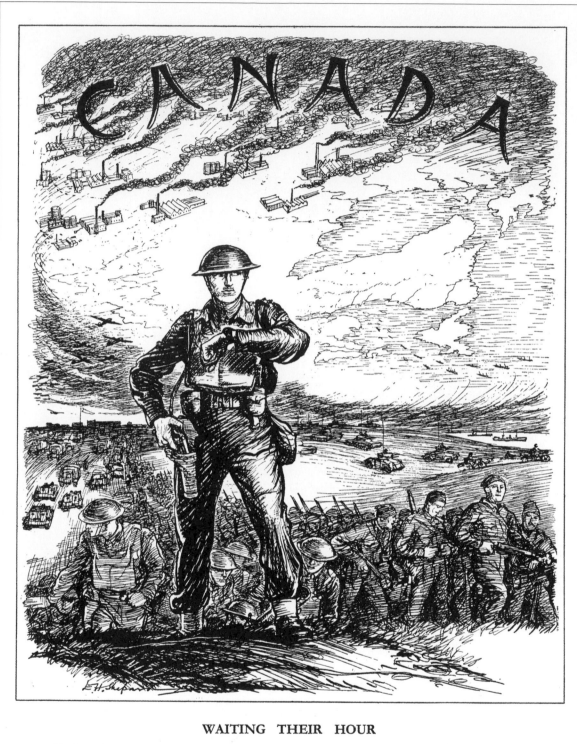

WAITING THEIR HOUR

[On December 17th, 1939, the first contingent of the Canadian Army, now in Britain, landed on our shores.]

E.H. Shepard's celebration of Canada's contribution
to the Allied war effort – without friends like this,
events might have gone quite differently for Britain
and the rest of the free world

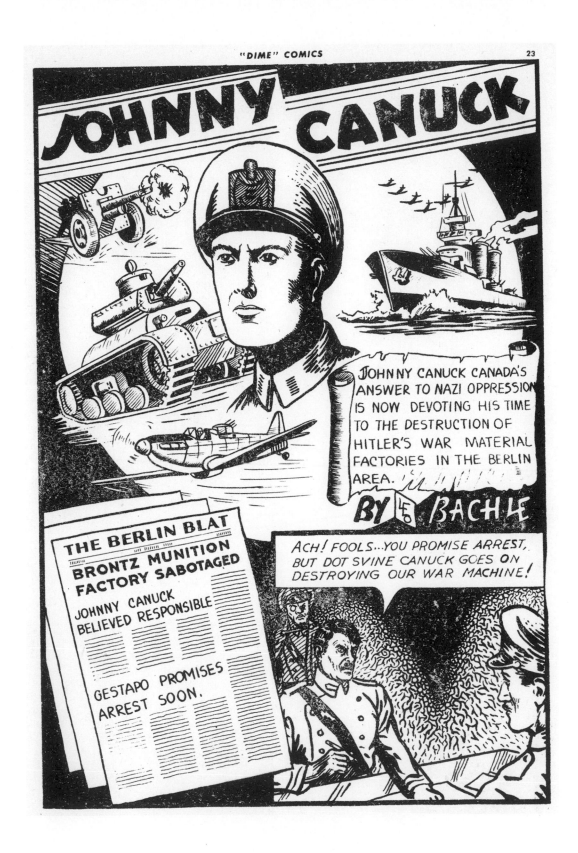

Johnny Canuck was a lumberjack when he first turned up as the embodiment of Canada in 1869. He was reinvented as an action hero by cartoonist Leo Bachle for Bell's *"Dime" Comics* in February 1941, and went on to win the war virtually single-handed after a brief encounter wtih Adolf Hitler

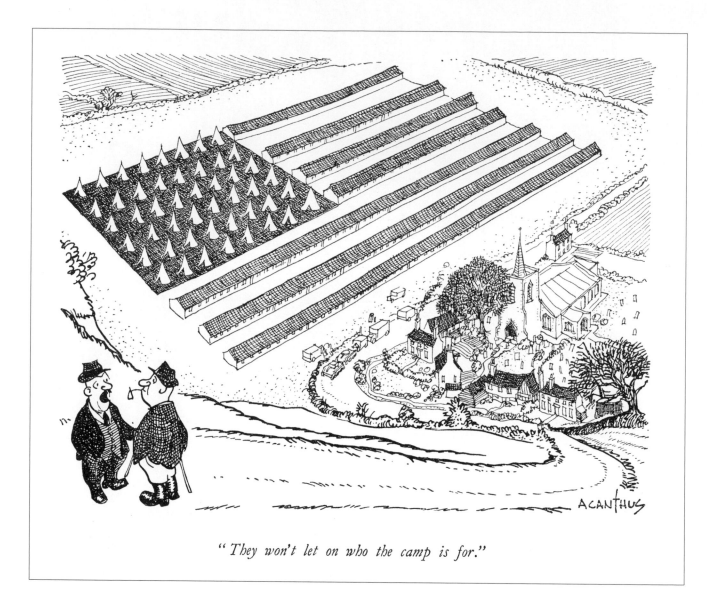

"They won't let on who the camp is for."

Frank Hoar was a British architect who designed the original terminal for Gatwick airport. He also worked under the name 'Acanthus' for such magazines as *Punch* and *The New Yorker*

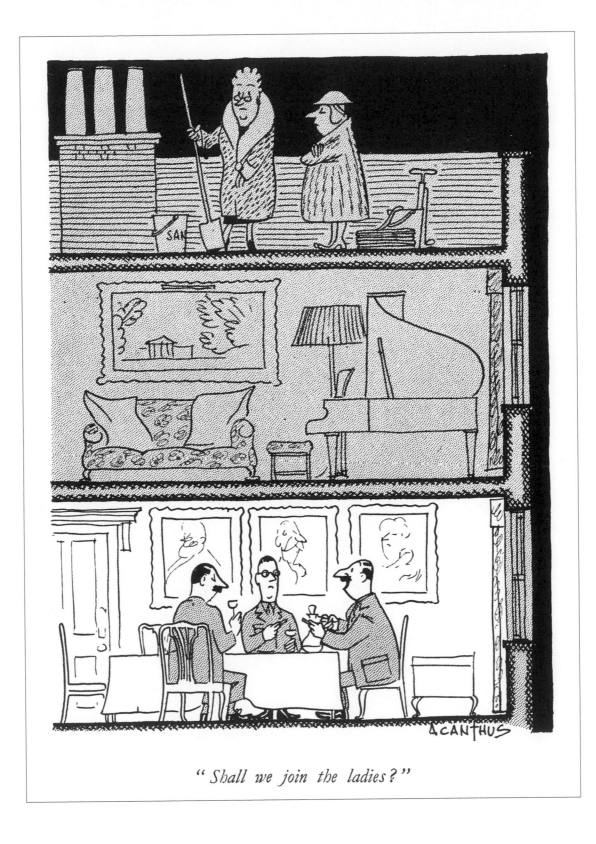

"*Shall we join the ladies?*"

Acanthus produced many cartoons about the 'Home Front'
during the war and this one is a classic of its type

1943

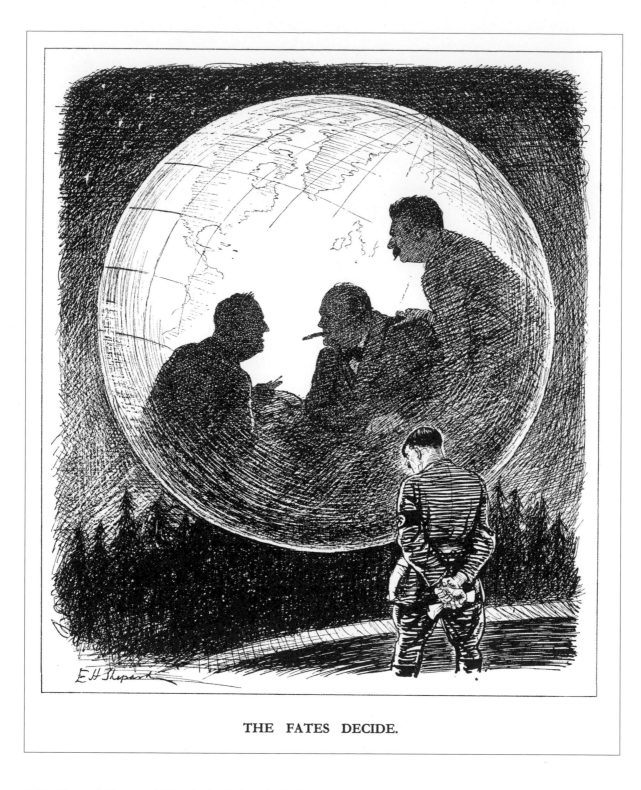

THE FATES DECIDE.

E.H. Shepard illustrated *Winnie the Pooh* and *The Wind in the Willows*, and also drew the Big Cuts (full-page political cartoons) for *Punch* magazine. In 1945 he succeeded Bernard Partridge as *Punch*'s senior cartoonist, but he felt he wasn't particulary well suited to the role since he had no particular interest in politics. He also used to agonize over whether he had achieved a good likeness of the characters he was drawing. Shepard served in World War I and won the Military Cross at Ypres in 1917. 'The Fates Decide' is one of his masterpieces

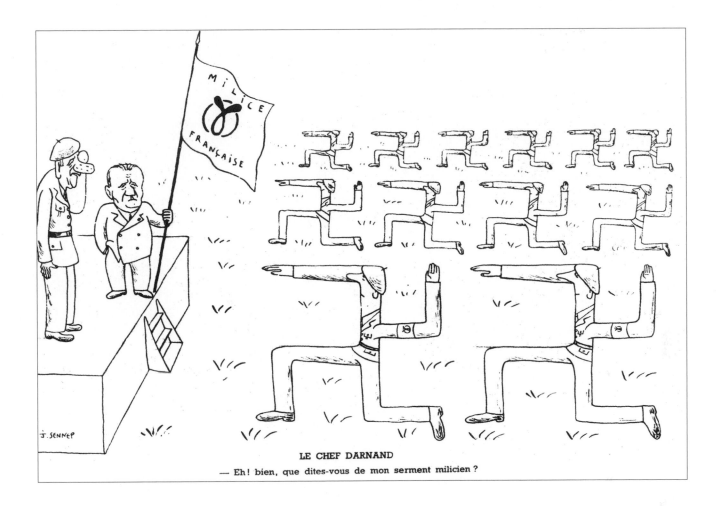

LE CHEF DARNAND
— Eh! bien, que dites-vous de mon serment milicien ?

Joseph Darnand, leader
of the Vichy French
collaborators, is saying,
'What do you think
of the *milice*'s oath of
loyalty?' [*milice* means
militia] – by Sennep

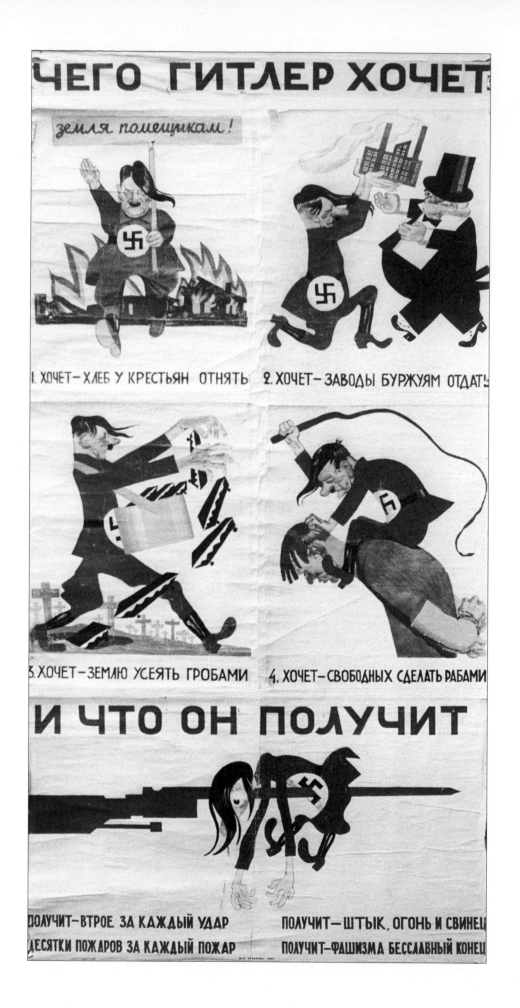

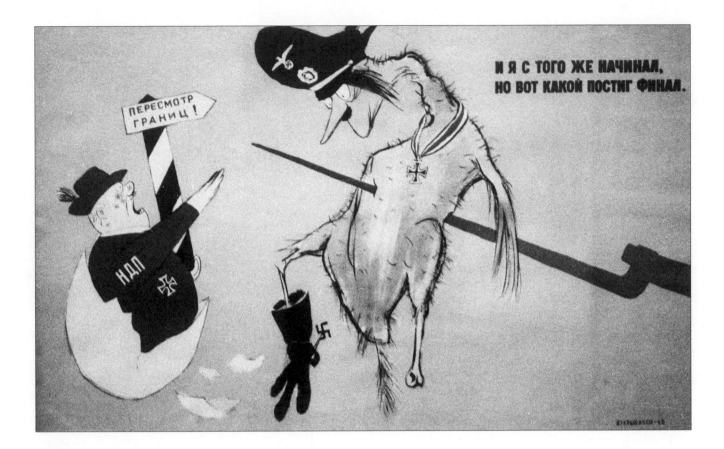

И Я С ТОГО ЖЕ НАЧИНАЛ,
НО ВОТ КАКОЙ ПОСТИГ ФИНАЛ.

Left: 'What Hitler wants and what he'll get' by Mikhail Cheremnykh, co-founder of satirical magazine *Krokodil* – this poster is from 1941, but by 1943 its prediction had proved uncannily accurate; above: 'I started up like this but ended up this way' – Kukryniksy allowed themselves a little schadenfreude following Hitler's defeat in Russia

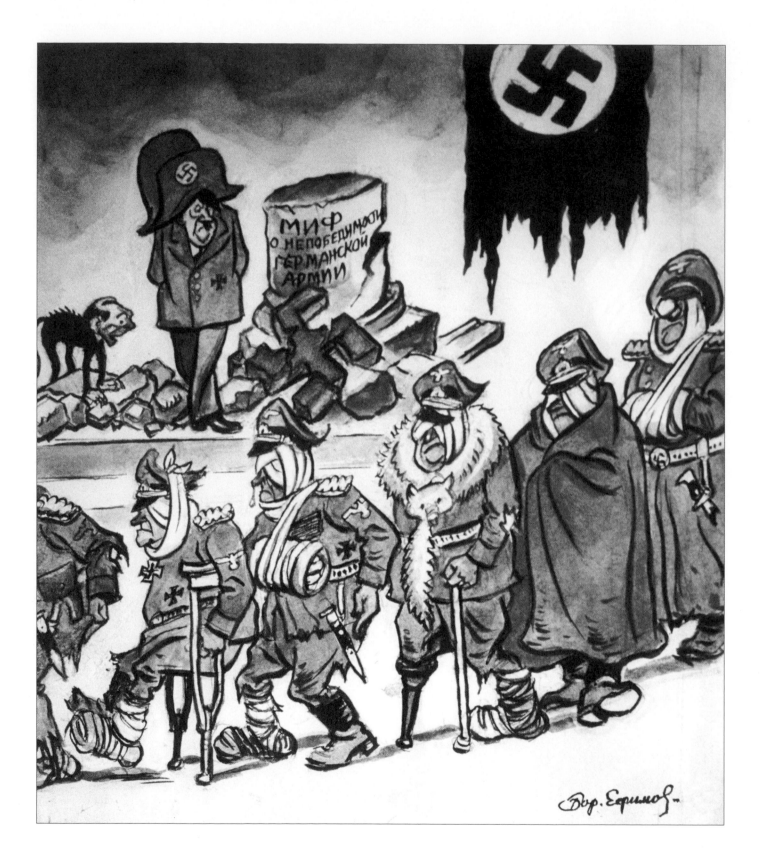

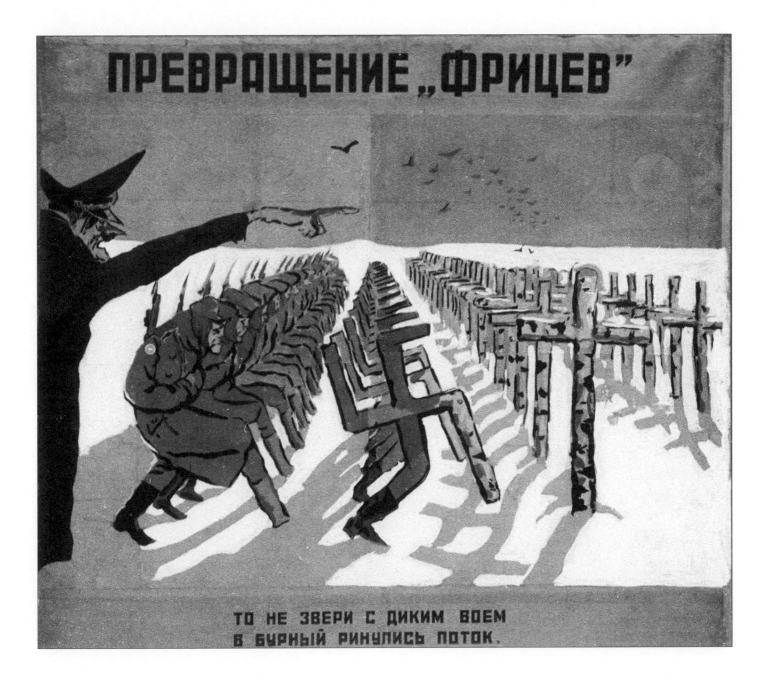

Left: 'Jerry in Winter':
Hitler and Goebbels sadly
survey their battered army in
retreat – by Boris Yefimov;
above: 'Transformation of
the Krauts' by Kukryniksy
tells its own story about
the high cost of invading
Mother Russia

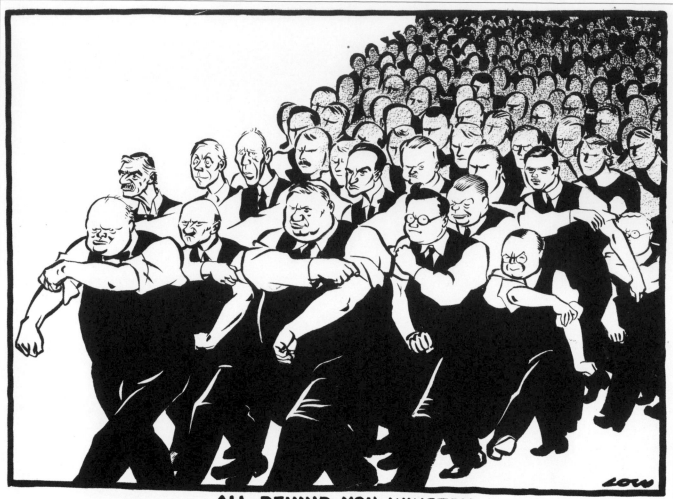

ALL BEHIND YOU, WINSTON

LOW

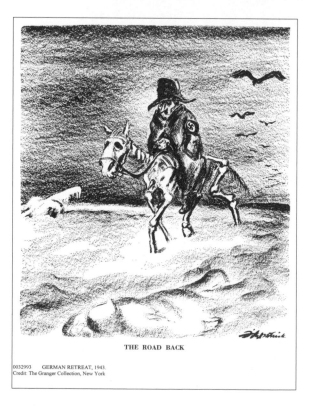

THE ROAD BACK

Above: Churchill heads a phalanx of British men who mean business – by David Low; left: mounted on a skeletal horse, Hitler takes the lonely road home like Napoleon before him – by Daniel Fitzpatrick; right: 'I Have Lost the Ring': a bedraggled, moany Hitler laments the loss of his ring at Stalingrad (and the 22 divisions within it) – by Kukryniksy

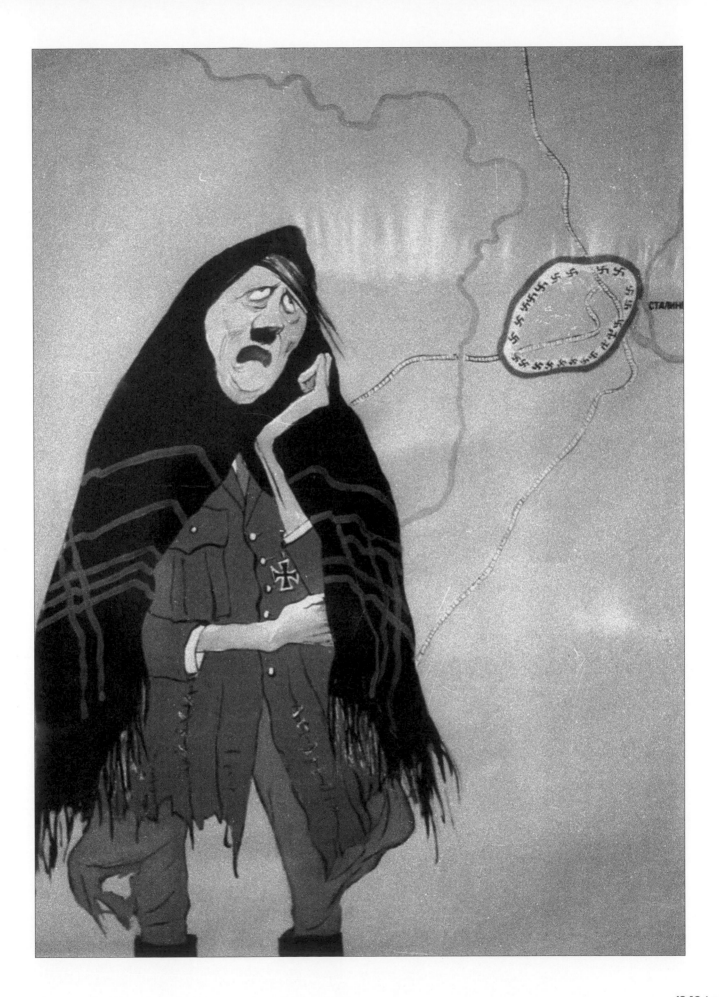

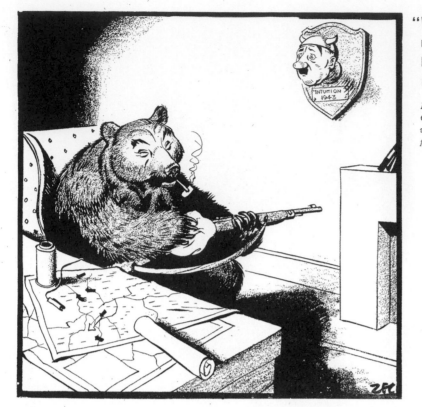

"We have taken up new positions on the Eastern Wall."
Nazi Radio.

Hurled back from Stalingrad, German troops could only wait as the Red Army prepared for its final drive.

(January 27, 1943)

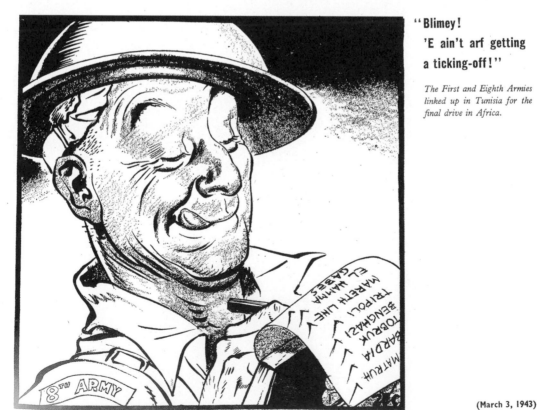

**"Blimey!
'E ain't arf getting a ticking-off!"**

The First and Eighth Armies linked up in Tunisia for the final drive in Africa.

(March 3, 1943)

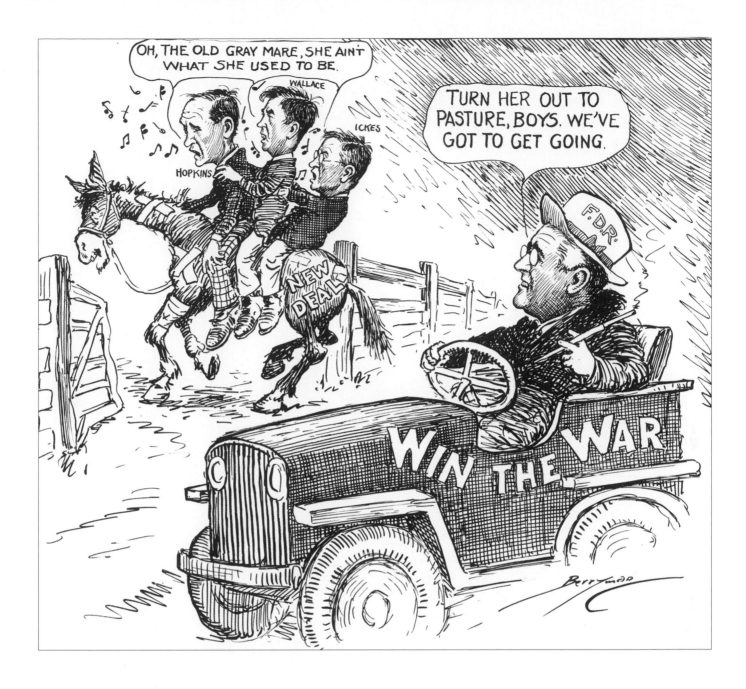

Above left: Philip Zec drew a Russian
bear that looked uncannily like Stalin
with Hitler's head mounted on the wall
behind; left: the tide had turned and
Zec now viewed defeating the Germans
in North Africa as a mopping-up
operation; above: Roosevelt puts the
New Deal out to pasture, while he gets
on with winning the war – by Pulitzer
Prize winning artist Clifford Berryman

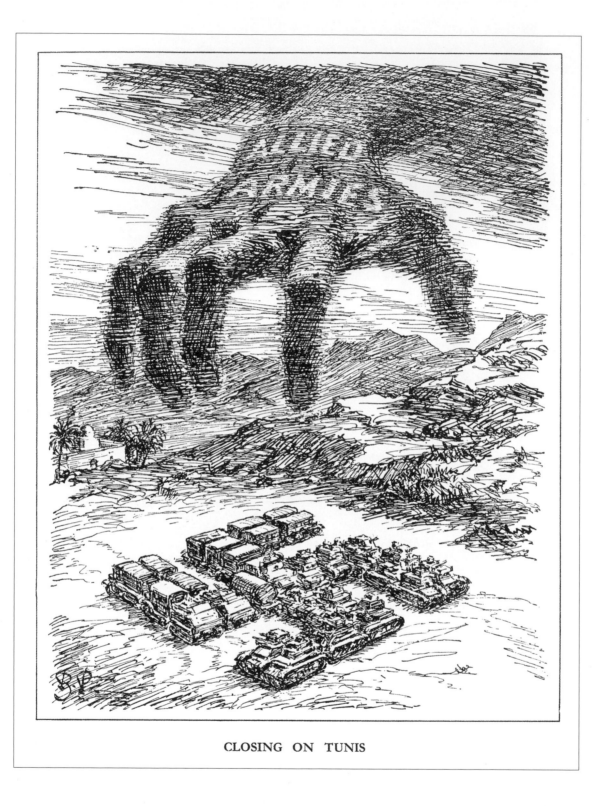

CLOSING ON TUNIS

Now it was the swastika that looked vulnerable, as illustrated by Bernard
Partridge in *Punch* magazine. *Punch* had its paper ration increased because
the British government viewed it as a vital contributor to the war effort

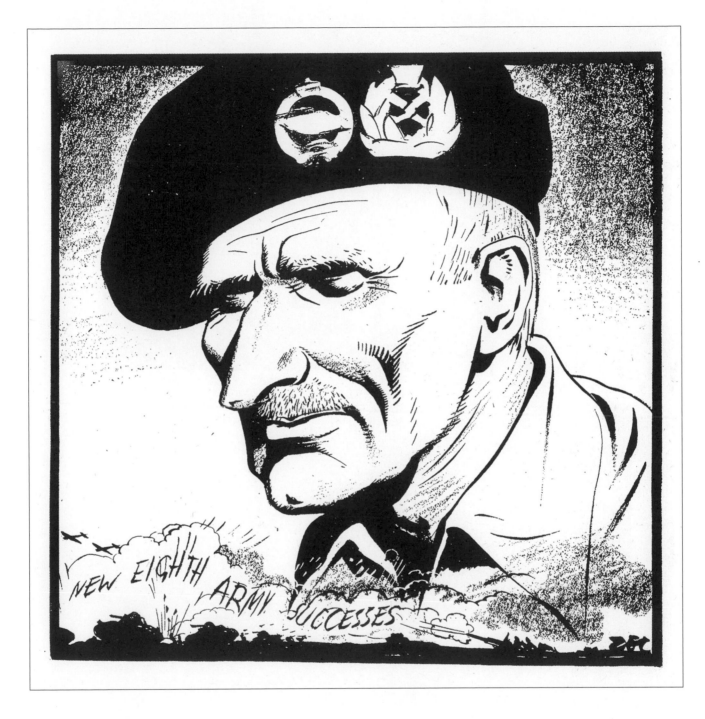

Field Marshal Montgomery, *aka*
Monty, became the hero of the hour
as the Eighth Army swept all before it
– by Philip Zec in the *Daily Mirror*

"We can't make friends, but we can influence people!"

As the Axis began to crack, the Gestapo stepped-up its drive to keep enslaved Europe in chains.

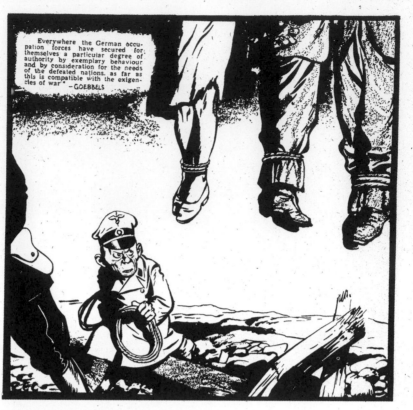

(March 16, 1943)

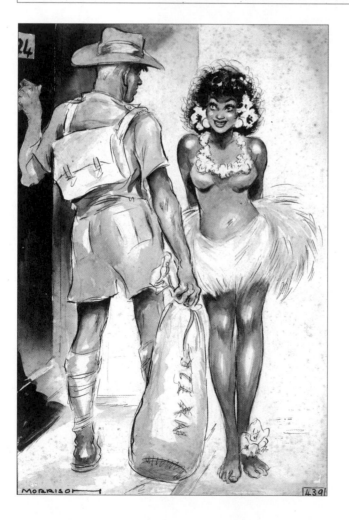

Above: Goebbels' words rang hollow as more and more German atrocities came to light – by Philip Zec in the *Daily Mirror*; left: 'DIGGER Home on Leave: "Now don't forget you're only a mascot."' An Australian soldier provides some last-minute instructions to his lady friend as he waits for his wife to answer the door – by Joan Morrison; opposite: a warning to Germans to observe the black-out – 'The Enemy Can See Your Light'!

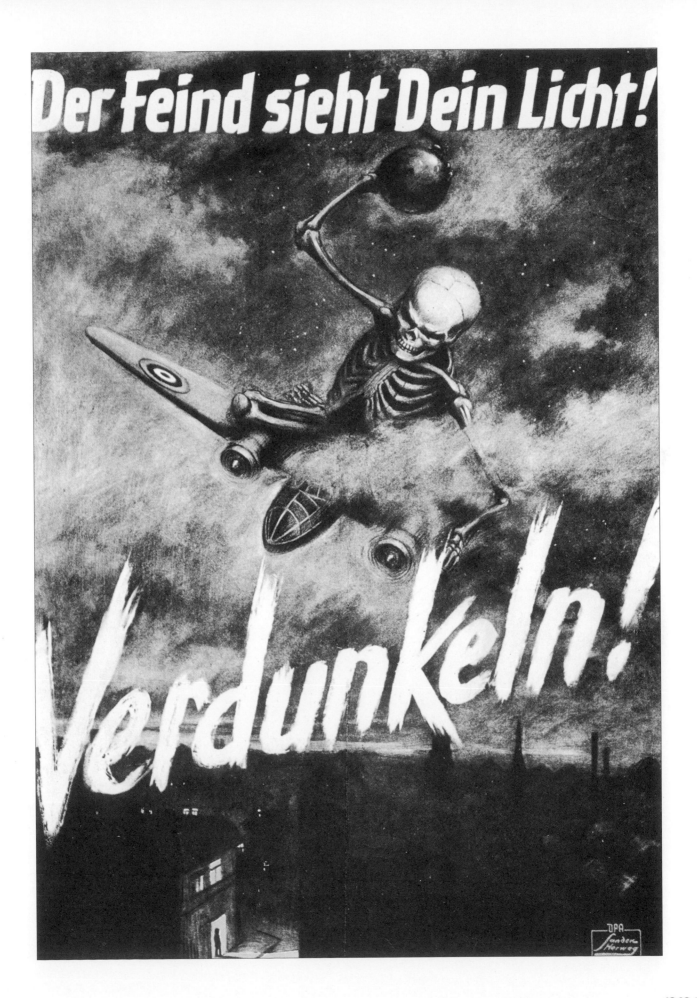

Marry in haste . . .
repent at leisure.

With the Allies in Sicily, and his country weary of a lost war, the Duce, for want of a better home, resigned and fled to the uneasy bosom of his Fuehrer.

(July 23, 1943)

Above: the SS attempted to rescue Mussolini when he was imprisoned by the Italian government, as seen at the time by Philip Zec; right: a Russian soldier's drawing of 'Fritz in the Cold'

The insect crawls out of the stone.

The Beginning of the End came, and Himmler, uneasy about German morale, now turned his whip on his own people.

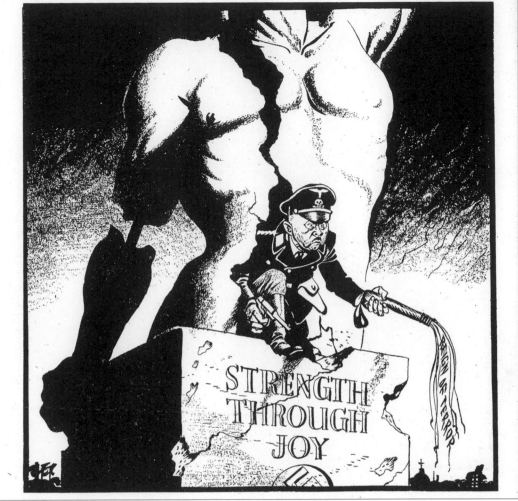

(August 24, 1943)

Above: in the *Daily Mirror* Philip Zec satirised Himmler's attempts to lift German morale. Strength Through Joy was the official German tourist agency that had encouraged German workers to become fit by promoting active holiday activities such as skiing and hiking

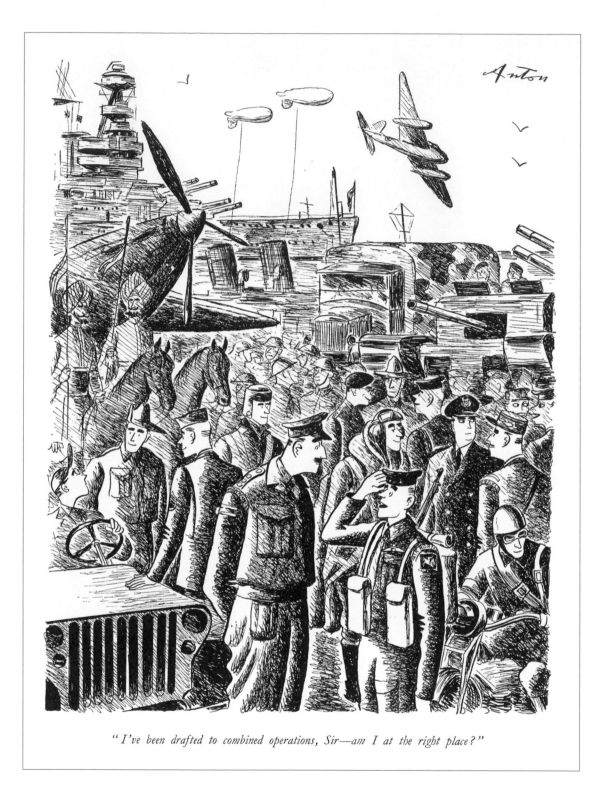

" I've been drafted to combined operations, Sir—am I at the right place?"

Suddenly everyone was pooling resources to send the
Germans back where they came from – this amusing
image was by Anton. ('Anton' was the brother and sister
combination of Harold and Beryl Yeoman)

The man who re-planned Berlin.

The Architect of War saw his plans go up in flame as the Allied Air Forces came to Germany.

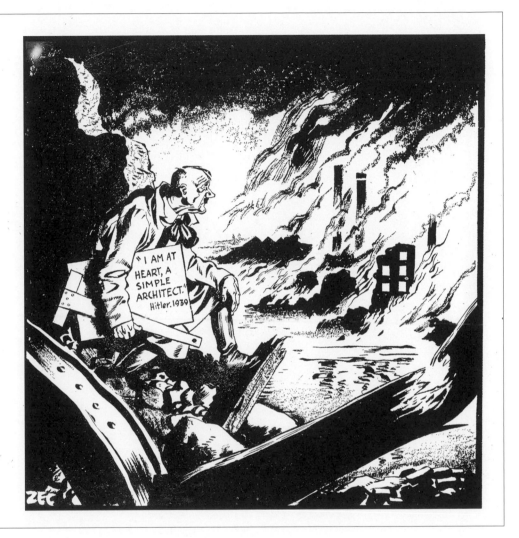

(November 26. 1943)

This cartoon by Philip Zec was inspired by the famous Hitler quote of 1939: 'I am at heart a simple architect.' In 1908 Hitler had hoped to study architecture at the Vienna Academy, but his family was too poor to afford the tuition fees so he never achieved his teenage ambition

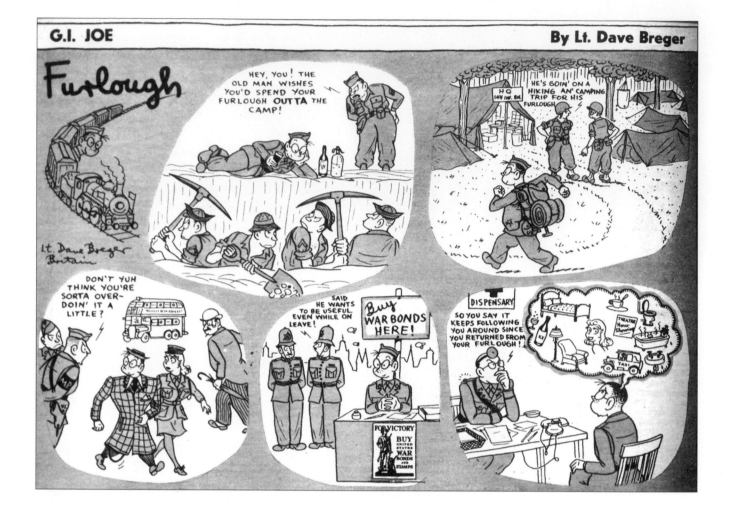

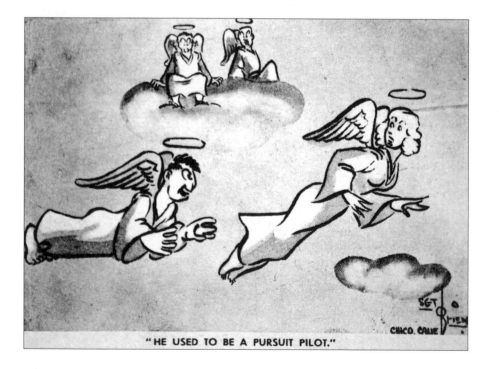

"HE USED TO BE A PURSUIT PILOT."

Above: *G.I. Joe* was the creation of serving soldier Sgt. Dave Breger and his strip led to the widespread usage of the term in wartime; opposite above: *The Sad Sack*, a term which might translate as 'loser' today, was invented by Sgt. George Baker and syndicated after 1945; left and right: these individual cartoons were drawn by US servicemen during the war

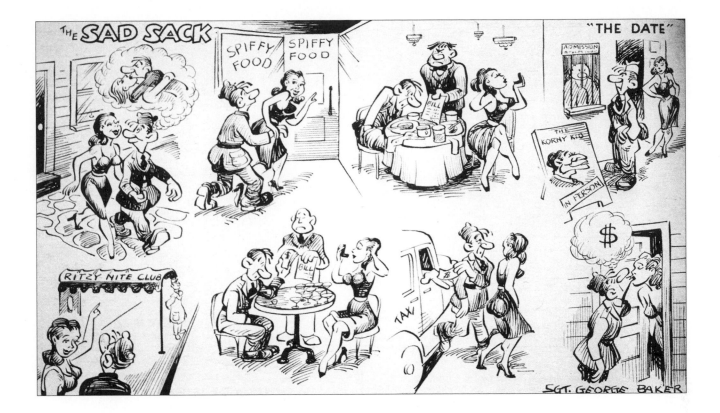

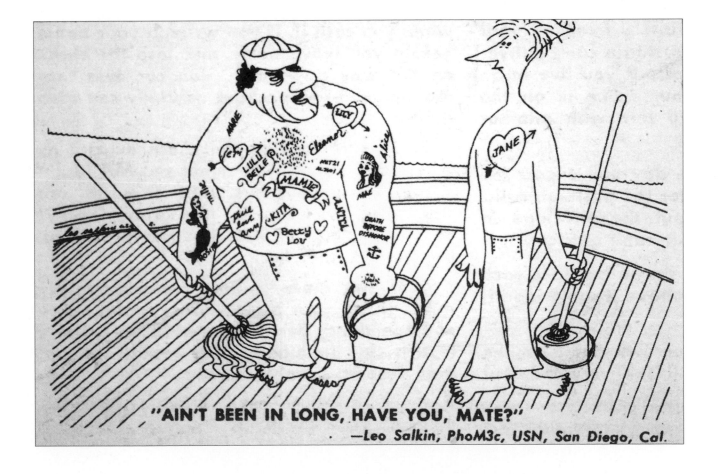

"AIN'T BEEN IN LONG, HAVE YOU, MATE?"

—Leo Salkin, PhoM3c, USN, San Diego, Cal.

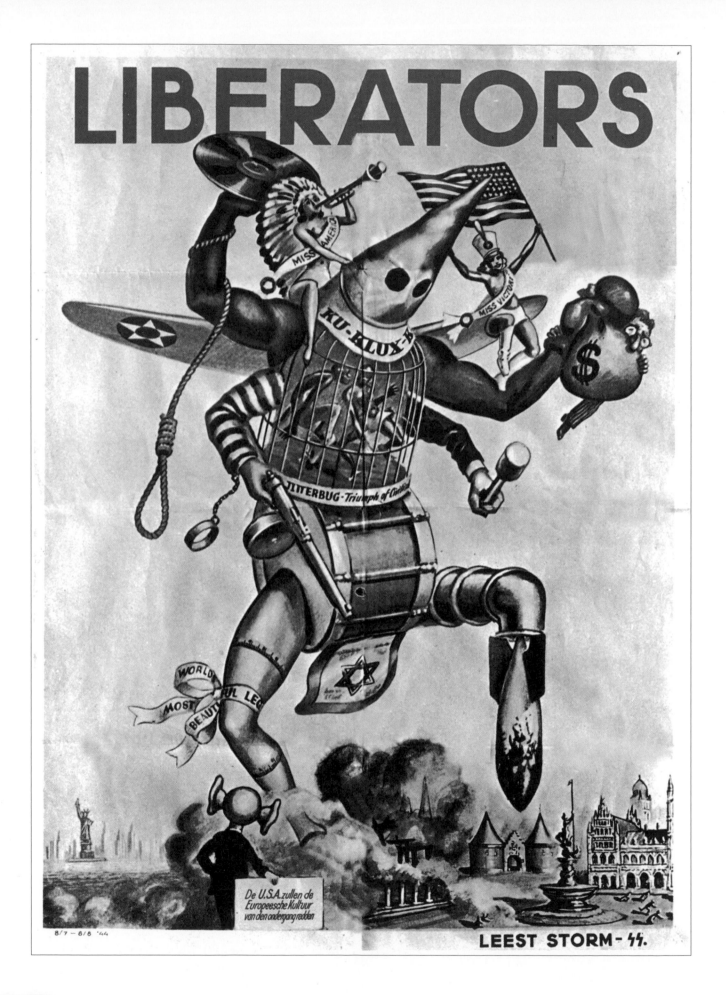

Labour organisation in the Škoda armament factories.

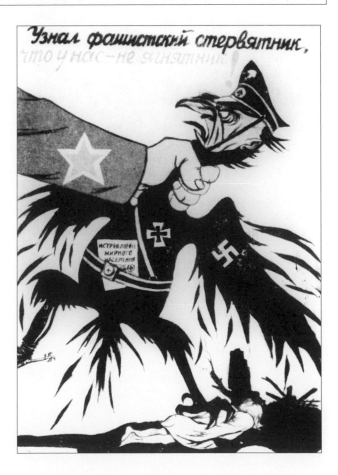

Узнал фашистский стервятник,
что у нас — не ягнятник.

Left: this SS poster by Leest Storm shows the USA as a monster destroying European culture underfoot and rampaging through the Netherlands in the guise of liberator; above: a cartoon by Stephen shows the situation in the armaments factories in Czechoslovakia, several of which produced top secret weapons for the occupying Germans; right: 'Fascist Crow, we don't have any lambs here [*in Russia*]' by Soviet artist Viktor Deni

Philip Zec cartoon with Winston Churchill
performing his 'On your marks' routine by
the White Cliffs of Dover

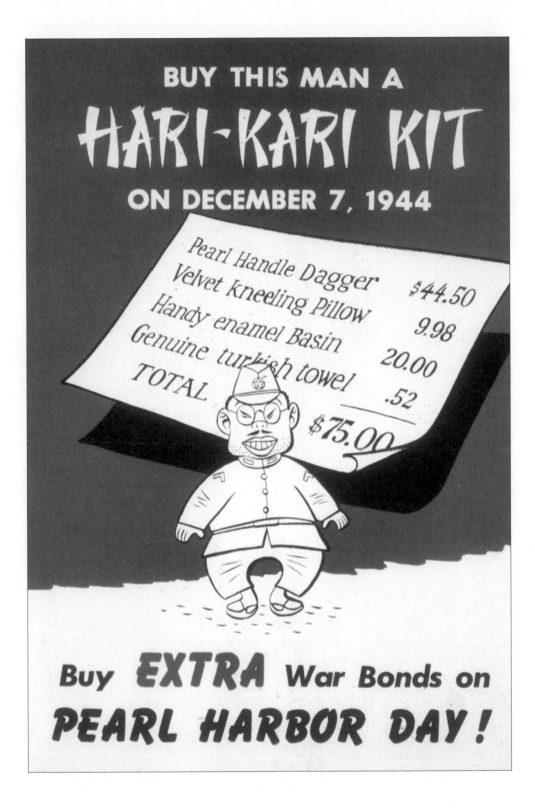

US poster exhorting the public to buy more war bonds on the pretext of helping Japanese Emperor Hirohito to fund his own suicide kit

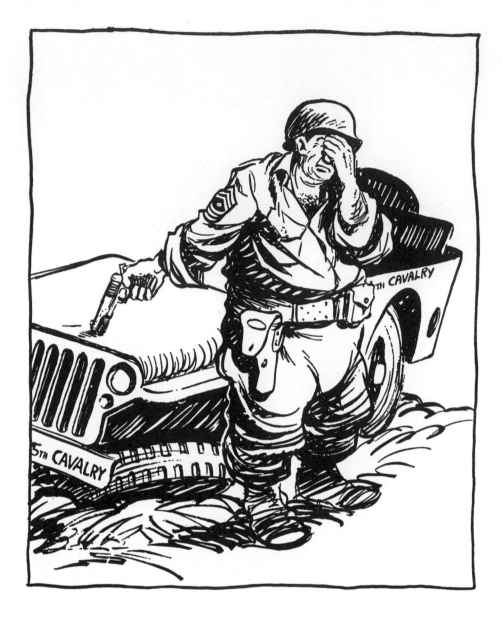

Bill Mauldin

Bill Mauldin was born in New Mexico in 1921 and enlisted in the US army in 1940 after serving in the Arizona Guard.

As a sergeant with the 45th Division, Mauldin landed in Sicily and worked as a cartoonist for *Stars & Stripes* as well as the company magazine. He was given his own personal jeep to drive around in and produced around six cartoons a week, providing a warts-and-all version of what life was like for regular US soldiers, known as 'dogfaces', on the front line in Europe and elsewhere. His work was distributed throughout the US army at home and abroad and it was phenomenally popular among serving men.

Mauldin's most famous creations were Willie and Joe, two dirty, unshaven GIs (opposite) who constantly cast doubts over the leadership qualities of their officers and whose laconic utterances left the reader in no doubt that war was a very hard slog indeed – so terrible you had to laugh.

Mauldin's attitude earned him a lengthy lecture from General George Patton who 'threatened to throw his ass in jail for spreading dissent', but Dwight Eisenhower defended the cartoonist on the grounds that his work provided a safety valve for the frustrations of GIs.

Mauldin was wounded by a mortar shell near Monte Cassino in 1943. He decided to have Willie and Joe killed off on the very last day of combat, but the staff at *Stars & Stripes* dissuaded him from doing the deed. He won the Pulitzer Prize in 1945.

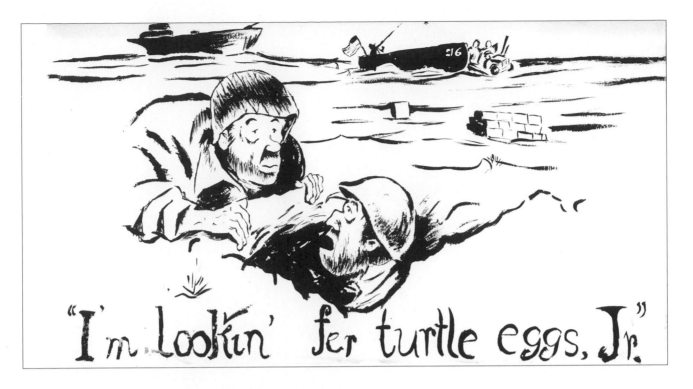

"I'm lookin' fer turtle eggs, Jr."

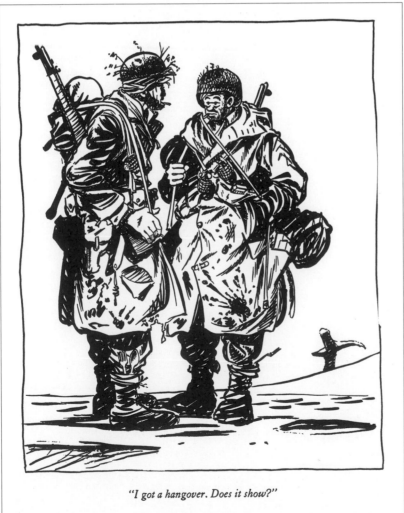

"I got a hangover. Does it show?"

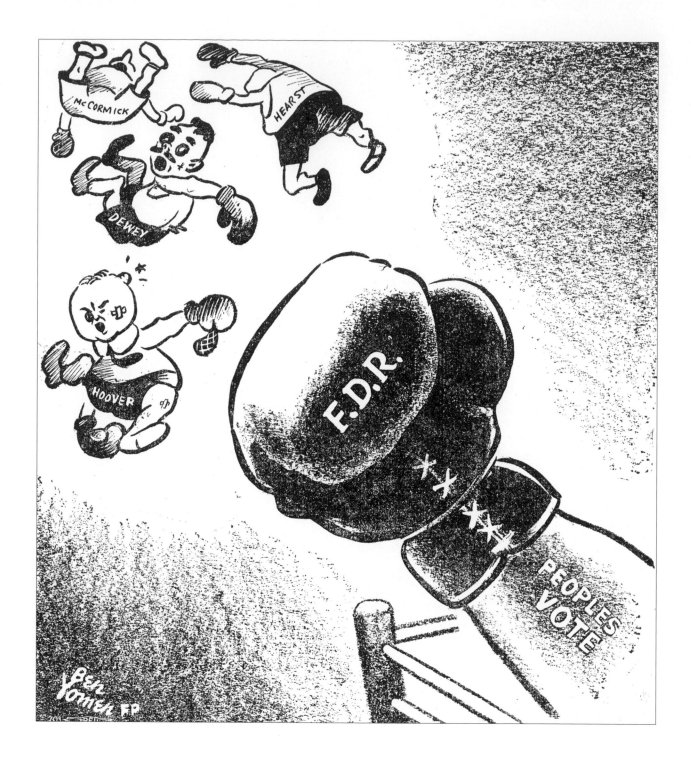

F.D. Roosevelt won the 1944 US election, routing
opponents such as Yellow Press baron William
Randolph Hearst, Tom Dewey and J. Edgar Hoover
– by radical US cartoonist Ben Yomen, this image was
syndicated worldwide

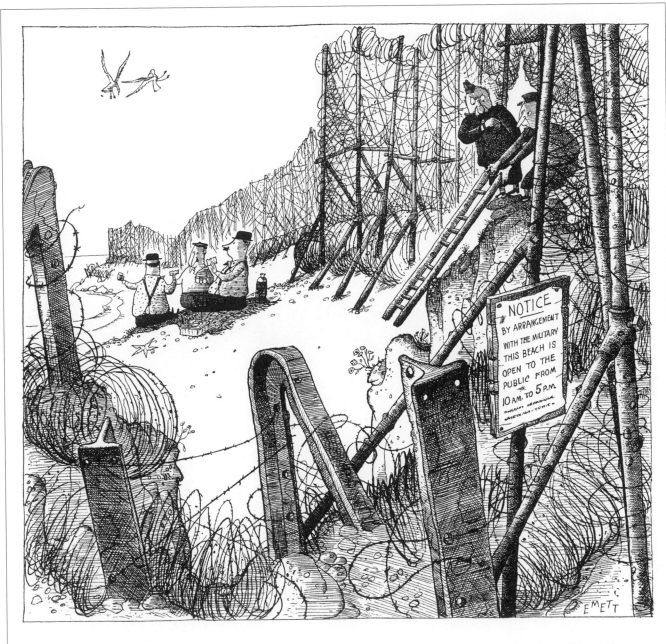

"Well, if they don't come in three minutes, they'll just 'ave to storm the defences."

Rowland Emett was a builder
of whimsical kinetic sculptures
whose cartoons were regularly
published in *Punch* magazine

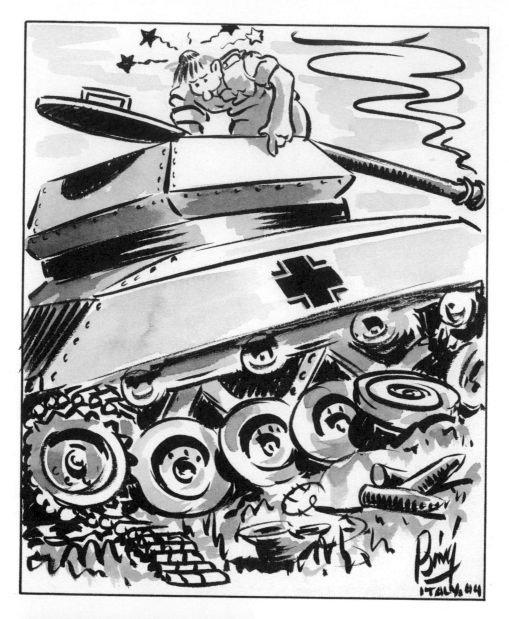

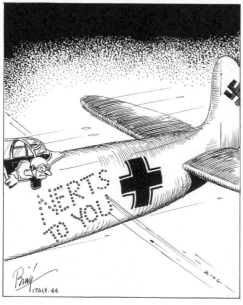

Ex-advertising illustrator William Garnet 'Bing' Coughlin served with Canada's 4th Princess Louise Dragoon Guards (*aka* 'The Plugs' or 'Piddly-Gees') during WWII and fought in the Italian campaign. Like Bill Mauldin, his work spoke up for the enlisted man against the officer class which led to its immense popularity during the war years. Herbie (above) was Coughlin's answer to Mauldin's Willie and Joe. Regular soldiers in the Canadian army became known as 'Herbies' after this singularly heroic chinless fighting man

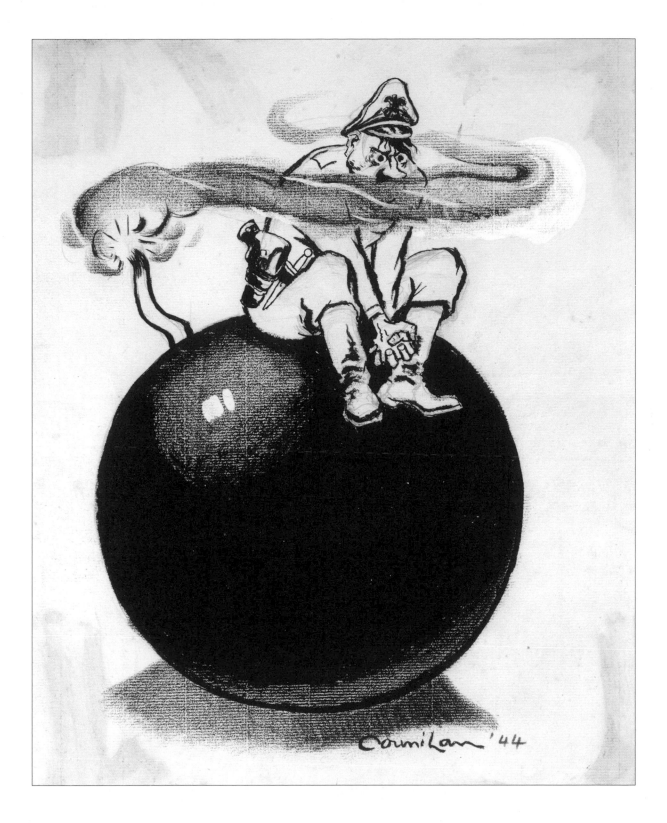

'What's Cookin'?': Australian artist Noel Counihan pictured a frustrated Hitler astride a bomb which is about to go off. The situation seems to imply that Hitler lit the fuse himself

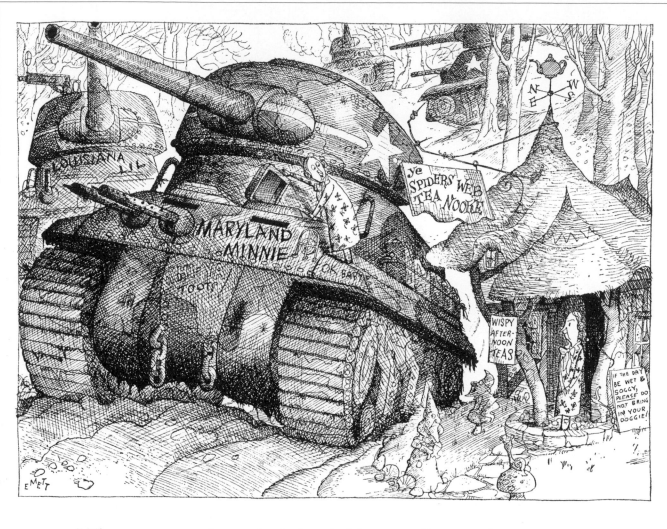

"They say, can we do two hundred and eighty-seven Dainty Afternoon Teas?"

Rowland Emett liked to produce
cheerful cartoons of a familiar
everyday England even though
the country was at war

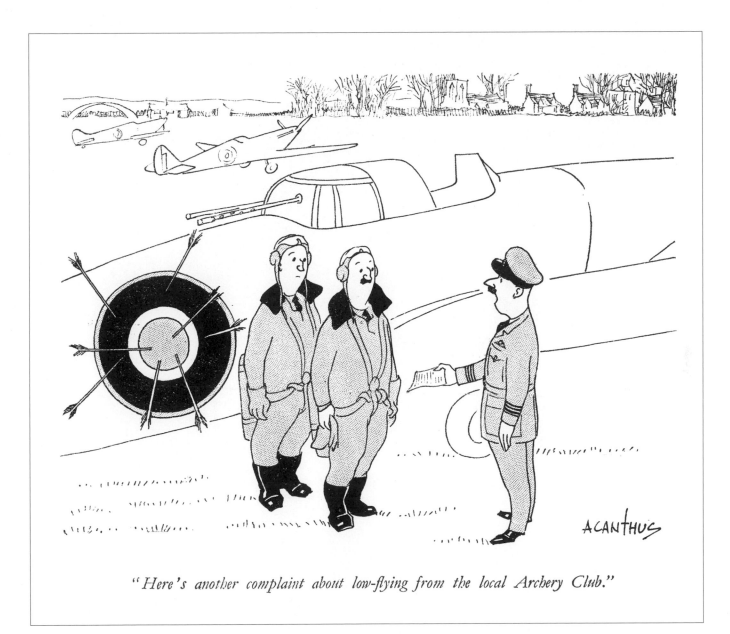

"Here's another complaint about low-flying from the local Archery Club."

Similarly, Acanthus kept the
jokes coming as wartime
England began at last
to see the light at the end
of the tunnel

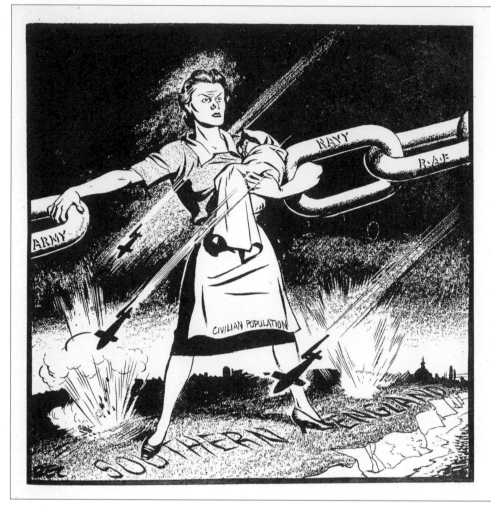

There is no weak link.

The end approached. Hitler launched his flying-bombs in swarms on battered South-eastern England. But London could still take it.

(July 4, 1944)

61

Above: Hitler's last throw of the dice against Britain after the D-Day landings was to launch the V-1, *aka* the Buzz Bomb or Doodlebug, at the south of England from the French and Dutch coasts; opposite above: V-1s as viewed by the Nazis in *Das Reich*; opposite below: at this point in the war, Allied bombing of German cities was taking an increasing toll, as noted by Philip Zec

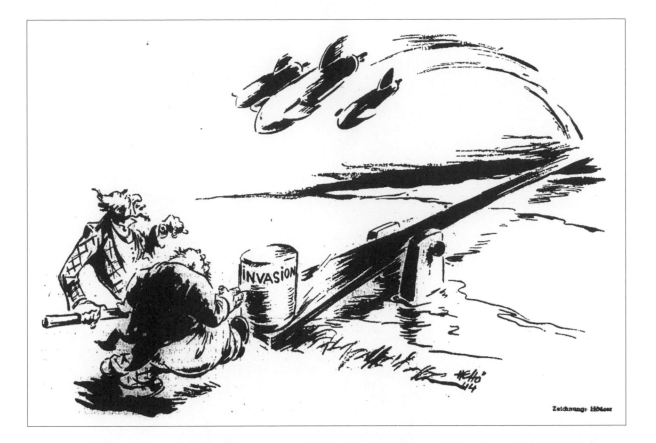

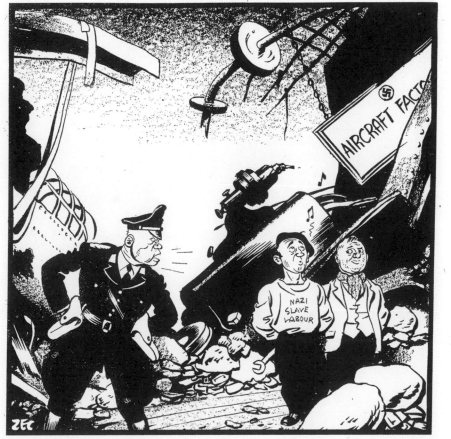

"... and stop whistling 'Night and Day'!"

All the slave-workers that Germany could muster could not stop the round-the-clock bombing offensive which softened-up her war factories.

(March 13, 1944)

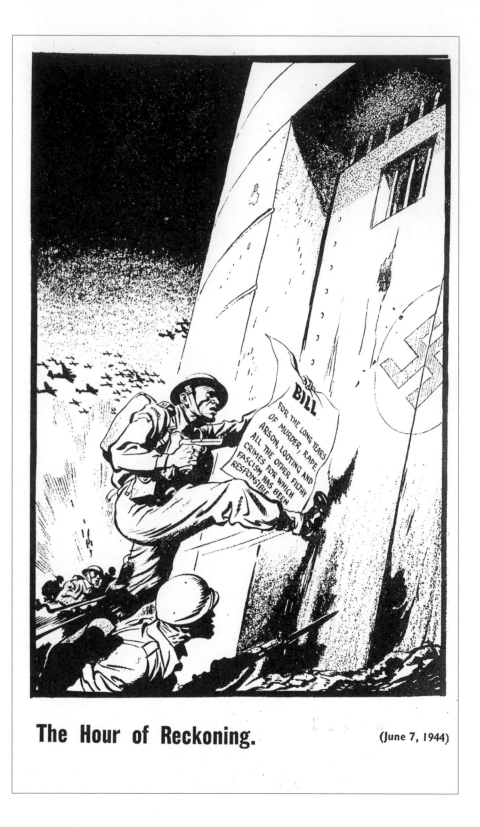

The Hour of Reckoning.

(June 7, 1944)

Allied forces were on Germany's doorstep and they were not in the mood to knock before entering – by Philip Zec in the *Daily Mirror*

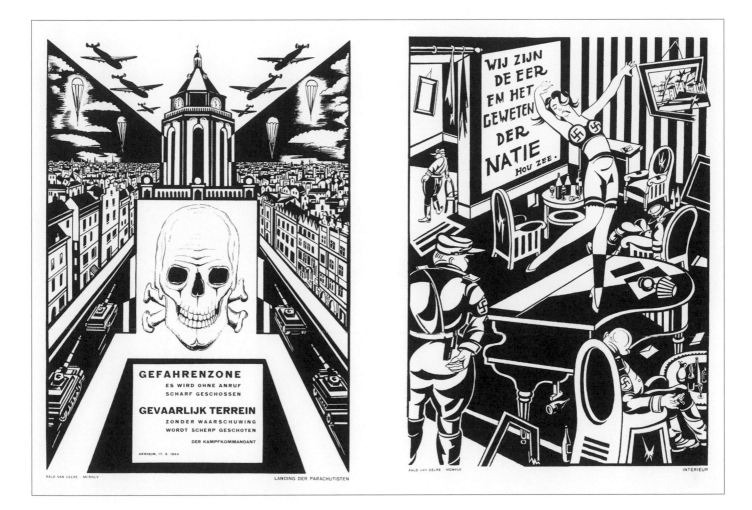

An anti-collaborator cartoon
from Holland in mock-Russian
Constructivist style shows two
scenes side by side: Allied soldiers
landing at Arnhem by parachute
during their disastrous raid
(Operation Market Garden);
and a woman dancing on a piano
to entertain Nazis. Behind her
is the inscription: 'We are the
conscience of the nation'

1945
AND ON

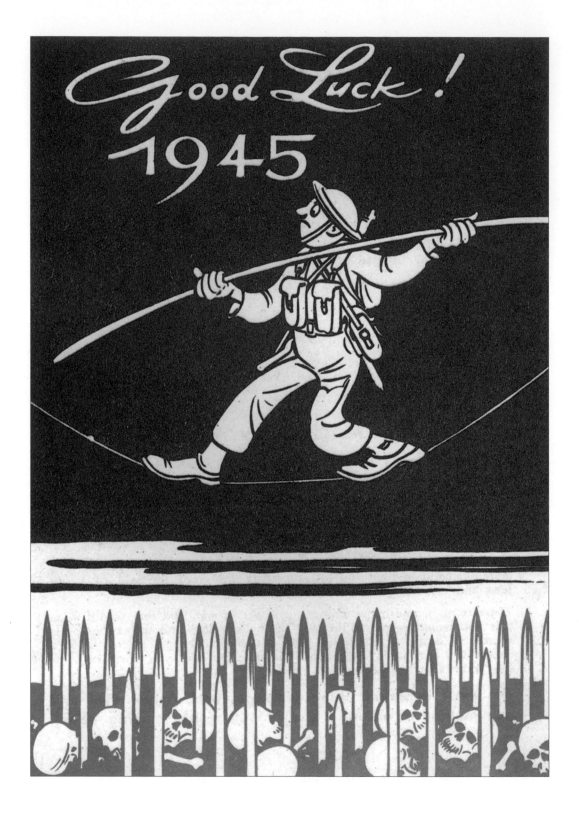

A German leaflet cunningly designed to demoralize British troops who might not wish to risk their lives with the end of the war in sight. Accompanying text said: 'Why walk the tightrope between life and death in 1945, become a prisoner of war'

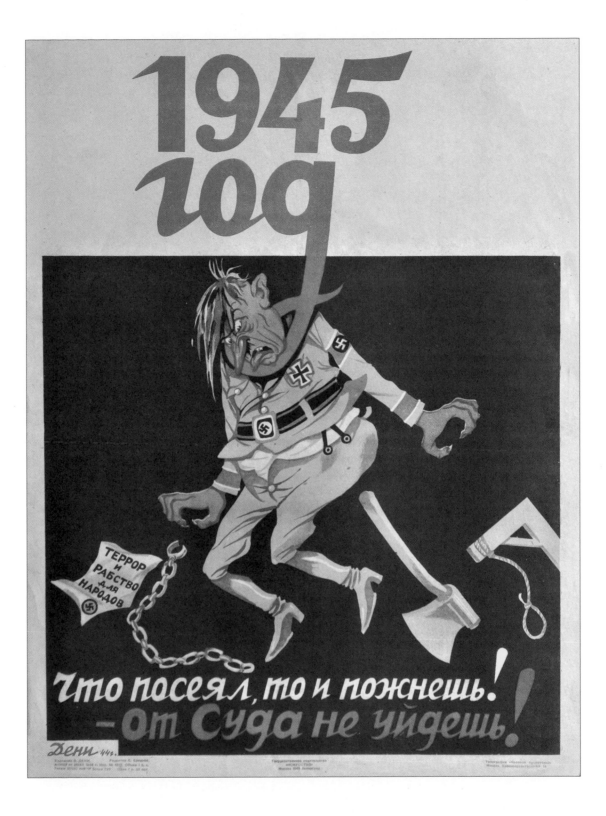

'Reap as You Have Sown!': Viktor Deni's
poster was not averse to kicking a man when
he was down, not if that man was Adolf Hitler

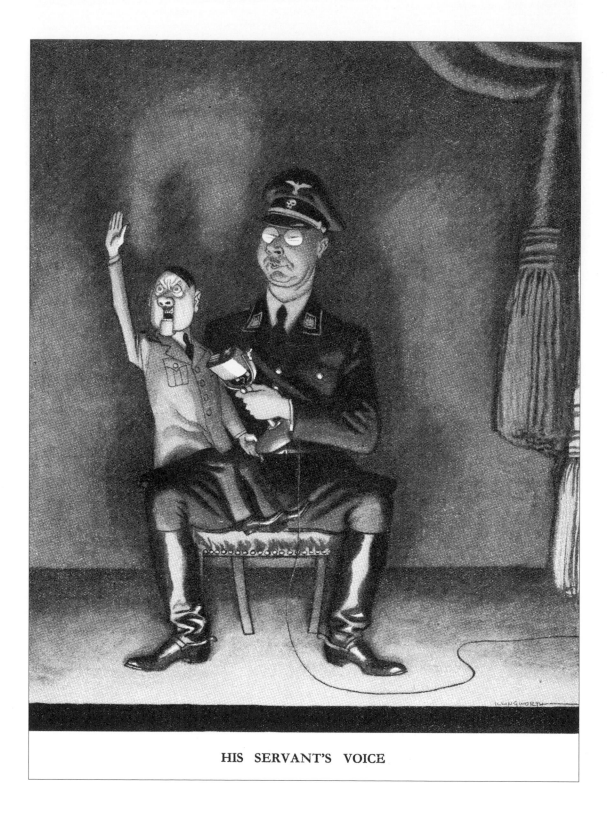

HIS SERVANT'S VOICE

Leslie Illingworth's brilliant drawing of Hitler as Himmler's puppet
was designed to reinforce the growing perception that Himmler had
taken over the reins in Germany, with Hitler a spent force

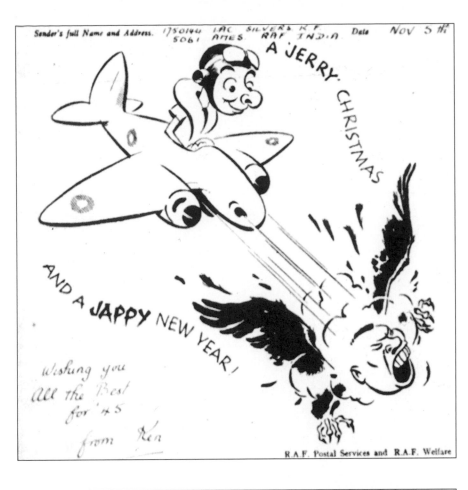

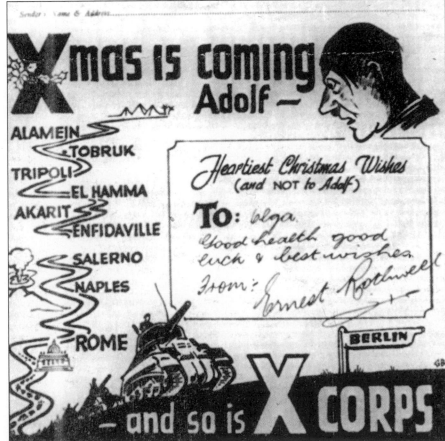

British triumphalism led to a new breed of greetings card being churned out for use of those on the front line

"This trick will have to be ruddy marvellous."

As defeat loomed, and up till the last weeks, Hitler still threatened more and more frightful secret weapons. They came too late . . . but only just.

(March 1, 1945)

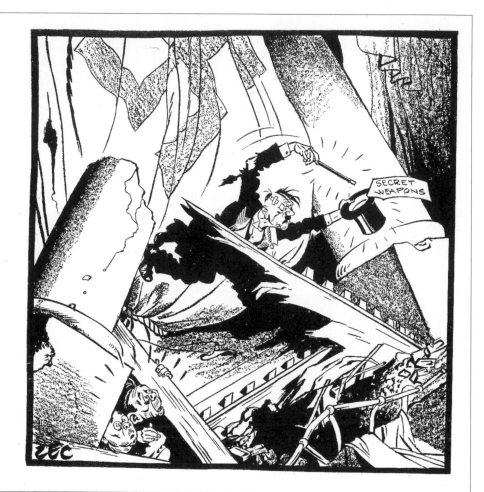

Goebbels and
Himmler look on
ratlike and aghast as
demented conjuror
Adolf Hitler runs
out of tricks – by
Philip Zec in the
Daily Mirror

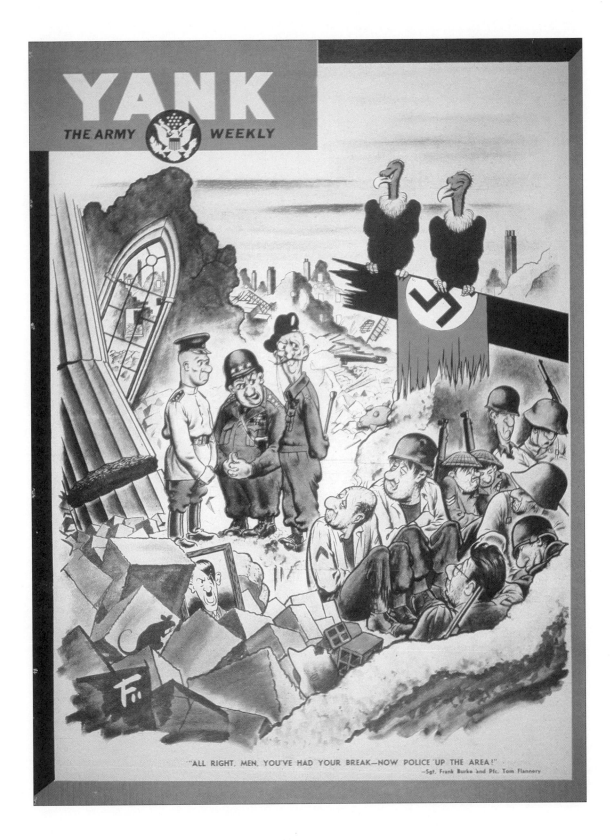

The cover of *Yank* magazine, designed and produced by serving soldiers Sgt. Frank Burke and Private First Class Tom Flannery, shows the Allies as they face up to the necessity of making decisions on the future of Europe

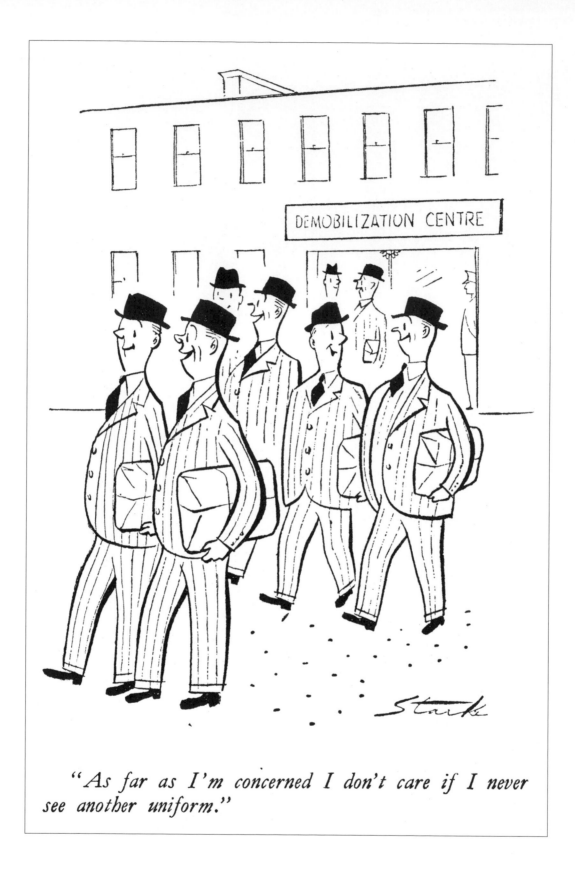

"*As far as I'm concerned I don't care if I never see another uniform.*"

In Britain, returning soldiers stepped out of army uniforms into the familiar garb of Civvy Street. Every man was issued with a 'demob suit' that was virtually identical to the suit given to everyone else. The suits were made en masse by the tailoring company Burton and were renowned for being hard-wearing but ill-fitting…

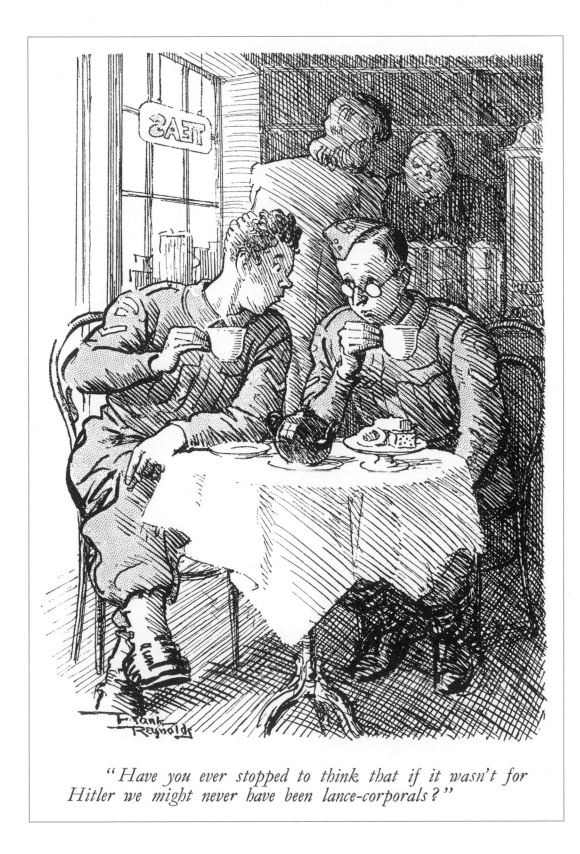

"*Have you ever stopped to think that if it wasn't for Hitler we might never have been lance-corporals?*"

Old hand Frank Reynolds produced cartoons for *Punch* in World War I and continued to do so throughout WWII

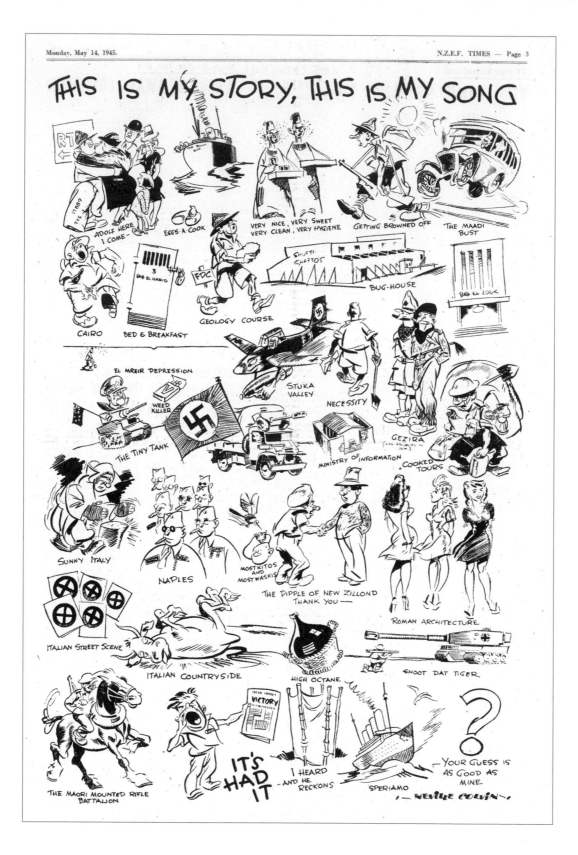

A series of vignettes of life in the New Zealand Expeditionary Forces in Egypt and Italy during World War II – by Neville Colvin. Colvin was a cartoonist with the *Wellington Evening Post*. He moved to London after the war and drew the *Modesty Blaise* strip from 1980 to 1986

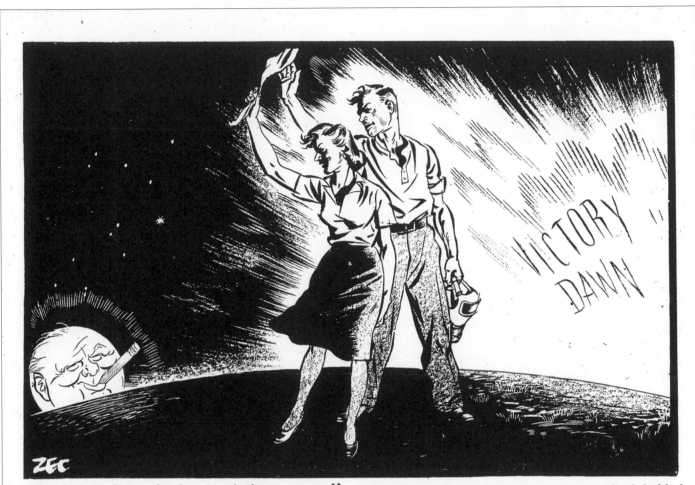

"Thank you for light in the darkest hours." *Britain showed by an overwhelming Labour vote that it had had enough of Tory rule. But Churchill's personal war leadership will never be forgotten.* **(August 16, 1945)**

Philip Zec's tribute to
Winston Churchill in the
Daily Mirror after Britain's
great wartime leader lost
the 1945 general election
to Clement Attlee and the
Labour Party

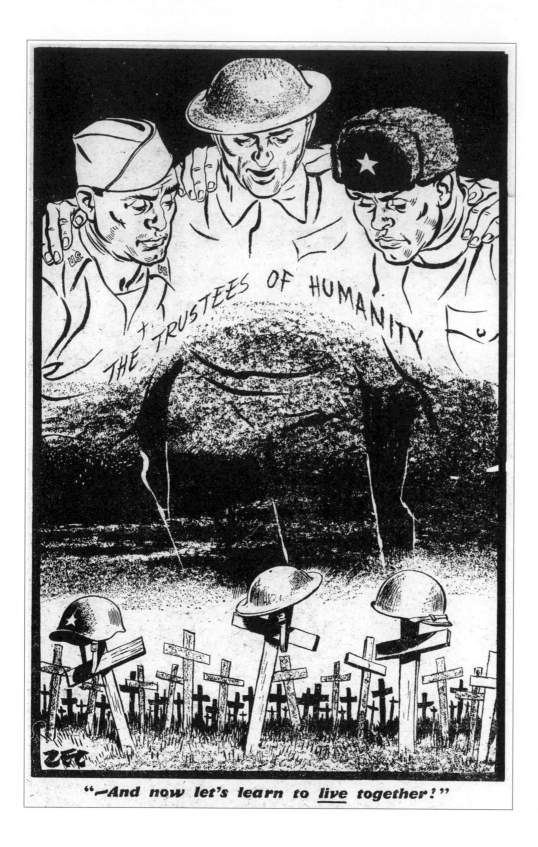

"—And now let's learn to live together!"

The end of the war marked the beginning of a period of
idealism with people united in their determination to forge
a better future - by Philip Zec in the *Daily Mirror*

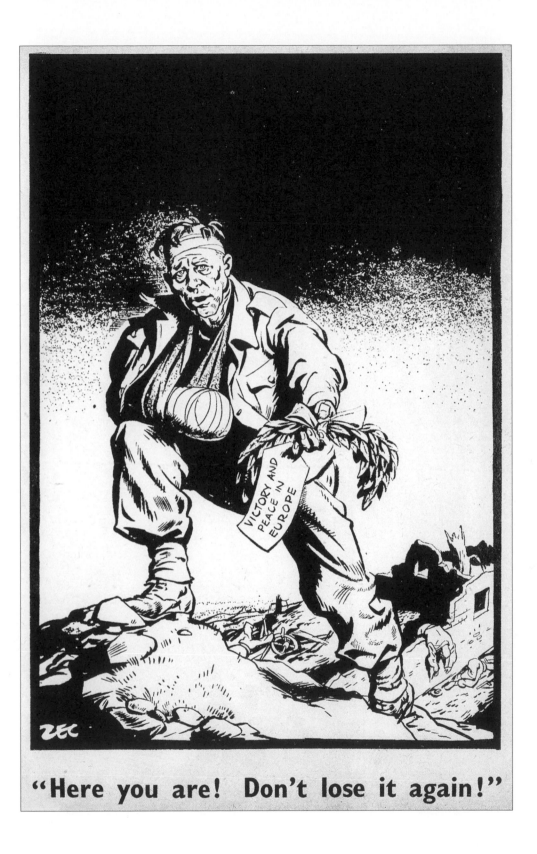

Philip Zec repeats his message of hope

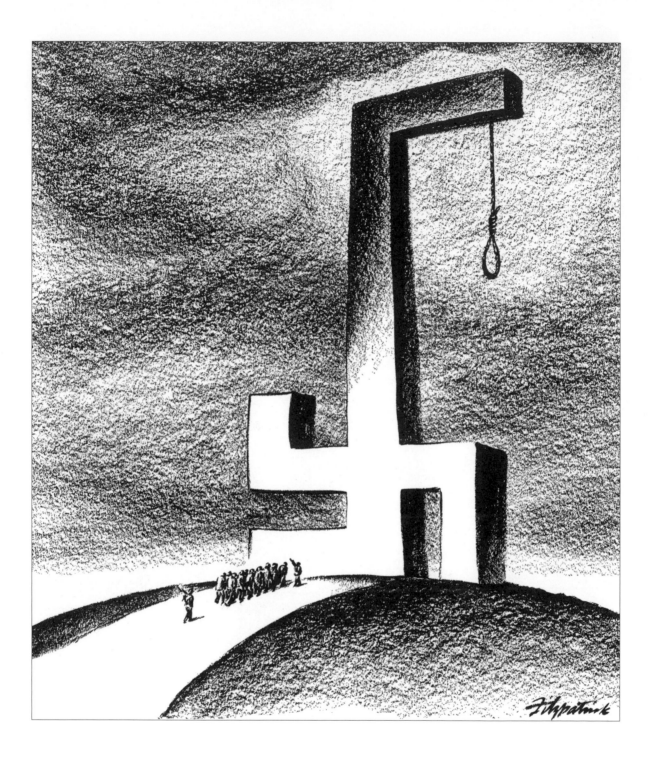

'End of the Road': in the US
Daniel Fitzpatrick offered cold
comfort for those who were up
before the judges at Nuremberg

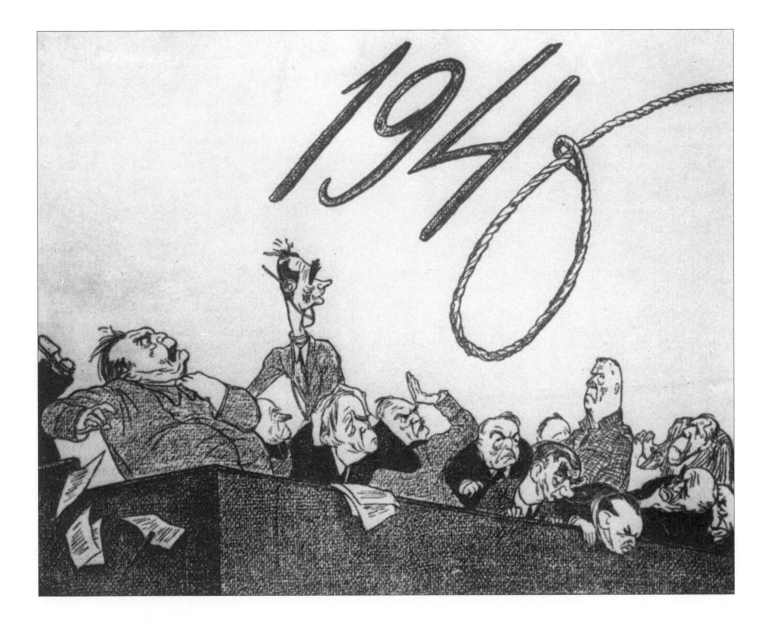

'The Last Figure': a courtoom sketch by
Kukryniksy from the Nuremberg Trials: the
most important criminal hearings ever held,
they established the principle that criminals
will always be held responsible for their actions
under international law. This brought closure
to World War II, allowing the reconstruction
process to begin

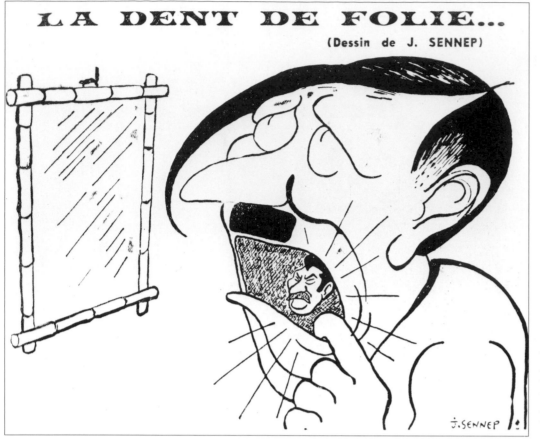

LA DENT DE FOLIE...

(Dessin de J. SENNEP)

J. SENNEP

'Maddening Toothache': Adolf Hitler discovers the source of the pain – by Sennep, 1939-40

PICTURE CREDITS

We have made every effort to contact the copyright holders of the images used in this book. In a few cases, we have been unable to do so, but we will be very happy to credit them in future editions.

Alamy: 14 (Photos 12), 18 (World History Archive), 19 (Mary Evans Picture Library), 21 (Photos 12), 22b (Photos 12), 24 (INTERFOTO), 27 (Photos 12), 28 (Mary Evans Picture Library), 29 (Photos 12), 45, 48 (Pictorial Press Ltd), 52b (INTERFOTO), 62t and 62b (INTERFOTO), 65 (Photos 12), 68b (Photos 12), 78 (World History Archive), 79 (Photos 12), 92 (The Art Gallery Collection), 101 (Mary Evans Picture Library, 117b (Mary Evans Picture Library), 120 (moss), 125b (Mary Evans Picture Library), 127 (Pictorial Press Ltd), 130 (World History Archive), 139 (Photos 12), 145, 152b, 165t

Alexander Turnbull Library, Wellington, New Zealand: 44, 86, 186

Atlas Van Stolk, Rotterdam: 71, 88

Australian War Memorial: 150b, 169

The Bridgeman Art Library: 72 (Archives Charmet), 131, 183

Corbis: 10-11 (Bettmann), 95

ED Archives: 181t, 181b

Getty Images: 63 (Popperfoto), 102, 115, 144t, 147, 160, 163, 166, 178

Library and Archives Canada: 133, 168t, 168b

Mary Evans Picture Library: 49, 82 (Illustrated London News Ltd), 100, 175 (Onslow Auctions Ltd)

McCord Museum, Canada: 121 (M965.199.3456)

Mirrorpix: 52t, 94, 122, 123, 128, 146t, 146b, 149, 150t, 152t, 153, 155, 172, 173b, 174, 182, 187, 188, 189

Ohio State University Library Special Collection: 37

Reproduced with permission of Punch Limited (www. punch.co.uk): 8, 9, 26, 30, 32, 33, 34, 35, 38t, 42, 43, 46, 54, 55, 58, 59, 66–67, 73, 80, 81, 83, 84, 85, 108, 109, 110, 111, 116, 132, 134, 135, 138, 148, 154, 167, 170, 171, 180, 184, 185

RIA NOVOSTI: 6, 22t, 93, 96, 97, 114, 140, 141, 142, 143, 161b, 179, 191

State Historical Society of Missouri: 69, 70, 190

TopFoto: 16, 20 (The Granger Collection), 23 (ullsteinbild), 25, 31 (Artmedia/HIP), 47, 64 (The National Archives/ Heritage-Images), 89t (The Granger Collection), 103 (Topham Picturepoint), 104 (The Granger Collection), 105 (World History Archive), 106, 107, 125t (Topham Picturepoint), 144b (The Granger Collection), 162

US Library of Congress: 192